LUCKY KUNST

Gregor Muir is the director of Hauser and Wirth (London), one of the world's leading art galleries. Muir curated YBA group shows such as 'Lucky Kunst' and 'Liar', as well as seminal video programmes including 'Speaking of Sofas' and 'Drugs' with Carsten Höller. He has been a critic and writer for various cutting-edge publications such as *Dazed and Confused*, *Parkett* and *Frieze* magazine.

'Muir makes this book a pleasure from start to finish'
London Lite

'It's a brilliant journey into the political landscape of the time and I passionately enjoyed not only the descriptions of my fellow artists' work but also many of the hilarious anecdotes'
Tracey Emin

'Every other page has an anecdote to make you cringe'
New Statesman

'Very funny . . . a must read for anyone interested in contemporary art and culture'
Books Quarterly

'Engaging and highly insightful . . . essential reading!'
Super Super Magazine

LUCKY KUNST

THE RISE AND FALL OF YOUNG BRITISH ART

Gregor Muir

Maura

First published in Great Britain
2009 by Aurum Press Limited
7 Greenland Street
London, NW1 0ND
www.aurumpress.co.uk

Published in paperback 2010

This revised edition first published in 2012 by Aurum Press

A catalogue record for this book is available from the British Library.

ISBN 978 1 84513 766 3

10 9 8 7 6 5 4 3 2 1
2016 2015 2014 2013 2012

Typeset in Trade Gothic by SX Composing DTP, Rayleigh, Essex
Printed and bound by CPI Group (UK) Ltd, Croydon, CR0 4YY

Contents

Introduction

THE PALAZZO PISANI Moretti was packed. An impromptu stage had been erected in front of the elegant windows overlooking the Grand Canal where a multitude of water taxis could be seen bobbing up and down, waiting their turn to deliver tonight's guests. A broad spectrum of the international art world was assembling on the marble steps, welcoming one another with smiles and kisses under the frescos and chandeliers. No one was paying much attention to the wall of dark cloud crossing the lagoon, heading right towards us. It was 1999 and this was Gary Hume's after-opening party at the Venice Biennale.

Finally, after much anticipation, a cheer went up and the Venetian blinds shielding the stage lifted to reveal Jarvis Cocker perched on a high stool wearing a thick polo-neck sweater, an unusual choice given the stifling heat. Pulp played an exhilarating set finishing with their latest hit 'Hardcore', which starts with a sampled string arrangement weighed down with ominous significance. Just as the grinding guitars reached fever pitch and the melody came to a climax, a burst of lightning filled the palazzo. Perfectly on cue, a shockwave of thunder boomed across the night sky, raising hairs on the back of my neck. As the electrifying display synchronised with Jarvis' performance, the crowd went crazy, everyone jumping up and down, revelling in the moment. I looked around me, and realised how far we had come. Pulp were playing at the height of their powers before an audience of young British artists, gallerists and collectors, all key figures of the day, celebrating

their enormous success, and gearing up for another night of hedonistic excess.

British art hadn't always been this cool. The last time there had been a buzz in town was in the Sixties when David Hockney bounced out of the Royal College wearing his gold lamé jacket. We seemed destined to live in the shadow of America, often adopting its latest trends through a process of transatlantic osmosis that remained unchallenged, as though influence itself was something that left port in New York and headed east. From the Fifties right through to the Seventies, America had cultural dominance. During the post-war period it had launched Abstract Expressionism, then Pop, followed by Minimal and Conceptual Art. These were not just lucky moments of brilliance, but entire movements laid out with each passing decade like a winning hand at poker, one card trumping the next.

It wasn't until the Eighties that heads slowly turned toward Germany, where Georg Baselitz and Anselm Kiefer were gaining recognition for their huge canvases heaving with slabs of paint. As the German economy went into overdrive, a flurry of artists came to the fore. Rainer Fetting, Hans Haacke, Jörg Immendorf, Markus Lupetz, Albert Oehlen, Sigmar Polke, Gerhard Richter – the list goes on. Along with the rise of the 'Neue Wilden', or 'New Wild Things', German artists started to establish an art scene, focused around their bars and restaurants, such as the infamous Paris Bar in Berlin and the Chelsea Hotel in Cologne. Baselitz turned a castle into a studio while Martin Kippenberger, an artist whose career would later resonate with the YBAs, pickled himself on alcohol running a Berlin nightclub where he performed Nazi salutes on stage and was nearly beaten to death by his own clientele.

While Sylvester Stallone featured on the big screen killing everything in sight, German artists came to be seen as the Rambos of their day. They were all-powerful, all drinking, and all men, but for all their sins, they, along with the Italian Transavantguardia movement, succeeded in offering some respite from America's cultural onslaught. Meanwhile, London was languishing in

the doldrums. Culturally uninspired, the capital seemed sapped of strength, jaded and overcast. There was a sense of inertia, of the old world playing itself out, as tired old Sirs sold late-career work to fading Lords. Little Britain's longstanding derision of all things foreign had rendered it out of kilter with international trends. With its smattering of contemporary galleries, London was simply not plugged in. To make matters worse, at the end of the Eighties Britain's economy crashed, and across the nation the lights began to dim.

Yet it was out of this environment of low employment and inner-city neglect that a generation of young British artists began to emerge. These were the bad boys and girls of British art. Swaggering provocateurs, throwing themselves about town and flaunting their talent in front of high-powered collectors. While businesses buckled under the weight of recession, young artists played the situation to their advantage, achieving initial success through a series of group shows held in derelict buildings and independent spaces, scouring the industrial wastelands of the Docklands and South London for studios and exhibition venues, relentlessly promoting themselves at a time when contemporary art had little hope of popularity.

As the Nineties progressed, Britain began to shake off recession. Along with political reforms and the promotion of a so-called 'classless society', prosperity in Britain began to shift. Inherited wealth went into decline as creative industries started to grow. The quality of food improved. Property prices rose dramatically, along with credit card debt, violent crime and drug abuse. With the Nineties came the affirmation of post-war free enterprise and the dawn of globalisation. New technologies shaped the way we went to war and the way we worked. Fax machines and early breeds of computers were followed by email, which completely overhauled our day-to-day business. As information technology started to make its way into our daily lives, many of us battled with the indecipherable jargon of dense computer manuals. At the beginning of the Nineties, the very idea that we might end up owning a mobile phone seemed far-fetched, yet a few years later they were indispensable. Then, of course, came the World Wide Web.

The art scene, too, benefited from a more affluent Britain. The growing sophistication of young artists and their relationship to the market had a marked effect on the manner and scale of art business. Galleries stopped being cosy shops where soft transactions took place in carpeted rooms. The gallery of the Nineties was more likely to be an international brand, employing a bevy of upper-class slaves on reception and airborne sales teams. The price of art soared as galleries became more effective at bringing in new business. They were more corporate in approach and more professional in appearance. The friendly naivety of the Sixties evaporated as hardnosed businessmen took the helm and steered the ship in the direction of high earners, themselves the product of new financial practices. Young British artists broke the mould and transformed the image of the struggling artist dependent on Arts Council grants. Within a short space of time, the phenomenon of YBA had irrevocably changed the public's understanding of contemporary art, and soon it was impossible to reflect on British culture in the Nineties without thinking of pickled sharks and unmade beds.

This is the story of the Nineties, of London's transformation, and the birth and death of an artistic phenomenon that leapt from obscurity to international recognition in just a few years. Much of what follows took place when there was little discussion of Al Qaida, extreme weather or super jumbo jets, just the IRA, rainy afternoons and Concorde roaring over a pre-pedestrianised Trafalgar Square. I refer to a time when red double-decker buses wheeled round Piccadilly Circus with people happily puffing away before smoking was banned from the top deck in 1991.

My recollection of London at the start of the Nineties is of a city approximately half the size and with far fewer people in the streets. Streaks of black pollution ran down the face of St Paul's and other ominous-looking buildings whose purpose seemed vague yet unquestionably authoritarian. I remember tramps wheeling shopping trolleys filled with personal possessions past the Houses of Parliament, their brown faces and rosy red cheeks shot through with split veins. There was litter everywhere and the city was far less flashy

than it is now. During the summer months, the Household Cavalry trotted down The Mall in time-honoured tradition past an indigenous population who truly believed in the unassailability of the monarchy and how the not so distant marriage of Prince Charles to Lady Diana would last for ever. On New Year's Eve, people would get riotously drunk in Trafalgar Square, jump in the fountains and at the stroke of midnight snog one another. Anyone who lived in London during the Nineties will remember how things used to be; it was a far cry from the city of today. They will find themselves, like me, struggling to describe just how fast and total the city's transformation has been.

I had been born in London but, much to my irritation, my parents had whisked me away to eke out my formative years just outside Brighton in a windswept Art Deco town called Saltdean. Our house was located away from the seafront on a steep hill that overlooked an endless vista of rolling downs. Like a living landscape painting, the view from our living room window would amaze and inspire; one day covered in snow, another in flames as farmers burnt stubble long into the night. Squalls blew across the English Channel bringing rain and chaos, before summer came and I fell into the long grass in the surrounding fields. I attended a nearby comprehensive where I struggled with boredom and watched friends beat the shit out of each other during lunch breaks. But for all the enchantment of youth, and days spent leaping into the freezing sea, I longed to be elsewhere. I craved information from the city, snatching my father's copy of the *Evening Standard* as soon as he returned home from his daily commute so I could retain a connection with the capital. As soon as was humanly possible, I applied to a London college and for the next ten years I refused to leave the city, not even for a weekend. To this day, I have yet to revisit the area where I grew up, haunted by the idea that one day I'll be forced to return.

As London changed during the Nineties, so did I, the decade leaving behind the scruffy art student who had first arrived at Victoria Station in the mid-Eighties. I immersed myself in the London scene and was introduced to a generation of young British artists, many of whom became my close

friends. Much of the Nineties was a blur. I rarely spent a night at home, opting instead to run with the art pack. I was both an intimate and a spectator, my entire life given over to art openings and studio parties which seemed a far cry from my innocuous origins.

To suggest that I went on to become a leading figure in the development of YBA would be misleading, especially when compared to the artists and collectors who have etched themselves into memory – Emin, Hirst, Jopling, Saatchi, etc. However, as an occasional spokesman my input was not entirely without merit. Having been a contributor to *Frieze* magazine over a period of years, I was projected through my reviews, essays and subsequent curatorial efforts into the minds of the more curious as someone who might be able to help make sense of what was going on.

I was by no means alone in this. There were others, more high profile figures such as Matthew Collings whose book *Blimey!*, published in 1997, featured numerous photographs of the artists and provided a useful snapshot of the scene. But, whereas Collings was more likely to be seen on TV hosting the Turner Prize, I was completely embedded in YBA. I was sleeping with it, waking up with it. Unlike Collings, who was a widely known reporter, I could move about the art world with impunity, without people standing to attention or putting on an act. My position somehow benefited from not being an artist. I wasn't a journalist or bound to an institution. I didn't work for a commercial gallery and was consequently non-threatening to dealers who didn't wish to see their artists being poached by rivals. I was also a bit of a nerd in that I kept all my press releases, invite cards, catalogues and newspaper articles. I hoarded everything, including people.

To enquiring journalists and collectors, I became a bridge to a world that was otherwise impossible for them to access. They could consult me without needing to hire a babysitter and venture into the world of seedy late-night bars. For a time, my finger was on the pulse and my opinion seemed to matter. I genuinely cared about artists. This was countered by the fact that I could be deeply insensitive and a terrible gossip, priding myself on my ability

to turn art world trivia into something altogether more sensational. I even took sides on things that really didn't concern me, and on reflection there's no question I could be an absolute nightmare.

What seems clear to me now, more so than at the time, is how unbelievably close I was to everything. Too close not to have left a lasting impression on those around me, leading me to believe that more distant observers may have seen me as something of an important player in and promoter of YBA. This view would be supported by the countless interviews that I gave to the press and media during this time, as well as the number of occasions I was cited by significant individuals as playing an important role. In her book *Moving Targets*, which set out to name check some of the leading figures in the British art scene, Louisa Buck described me as 'a friend, confidant and chronicler to the close-knit group of artists that were at the core of the London art world'.

Undoubtedly, there will be those who read this book with a degree of contempt, arguing that they played a far more important role than I. Not that I would wish to argue the point, especially as I was little more than a lone figure in a collective. In order for YBA to succeed, it required people from all walks of life; not just artists or dealers but hangers-on, musicians, barmaids, toffs, you name it. Some would pass through, while others – like me – stayed on.

In doing so, I got to know everyone. I spent countless hours in the company of certain artists and not enough time in the company of others; especially those who understandably chose to steer clear of me. Nowadays, I'm more likely to make connections either as my profession dictates, at my own choosing or not at all, but back then I was just out there, totally swept away by it all. As a consequence, I became an ethnographer of sorts, an observer with a passion for the people who made this period of explosive creativity possible.

The Nineties was an amazing time to be young, and one of those rare moments when a network of people come together to form an incredibly dynamic scene. There were new magazines, nightclubs, ad agencies, stylists,

photographers and pop promo directors. There was a revival of interest in British popular culture from the Sixties and Seventies. Suddenly, the Union Jack and all things British were cool. As the capital started to swing again the most unthinkable things started to happen. An unmade bed became the talk of the town, a head made from frozen blood was snapped up by Saatchi, and a small metallic painting was sent spinning through space aboard a Martian space probe, all to the musical accompaniment of Britpop.

London is presently referred to as the art capital of the world. It boasts Tate Modern and countless commercial galleries, boutiques and dazzling new restaurants. It's the venue for the Frieze Art Fair, started in 2003, upon which upward of forty thousand visitors descend over a four-day period. To top it all, there's even an art market in London, in the galleries and auction rooms, the likes of which has never been seen. Looking back, such a transformation in London's fortunes would have been impossible to predict.

For me at least, the story begins when I was an art student living in London.

80s: Art school

IT WAS A fucking hot day. From the top deck of a London double-decker bus I observed an African woman wrapped in brightly coloured fabric as she passed on the street below balancing a twenty-two-inch television set on her head. Cockney girls from the surrounding estates clacked by in white stilettos past a group of bantering Jamaicans; a swirling vortex of empty beer cans and discarded paper kebab wrappers spooked the drunks in a nearby park. Casuals – a term applied to young lads decked out in the latest sportswear – mooched about the place wearing thin gold chains, drainpipe jeans and Robert Wilson V-neck sweaters. It was 1984, and I was on my way to Camberwell College of Arts in South London, where I was studying for a degree in fine art. This hotbed of creativity turned out to be an uninspired concrete block next to a petrol station on the Peckham Road. Camberwell appealed to me. Not because it was believed to be the country's leading fine art painting course, but because the surrounding area – urban, grey and bleak – reminded me of Joy Division, whose music evoked a mood of perpetual melancholy. Situated on the margins of central London, the area was populated by Afro-Caribbeans, Greeks, Irish and the English working classes.

I had struggled through sixth form in college, where I was made to feel distinctly unwelcome by the ex-grammar school staff. Ignoring their prudent advice, I applied to do a foundation course in art. This would prove to be one of the most productive periods in my life. Having finally found a subject with

which I felt an affinity, never before had I applied myself so attentively, splashing paint about and gawping at naked life models. Towards the end of my studies, my tutors told me that I might want to think about applying to a London college. I sent an application to Camberwell; during my interview, before being accepted, I spoke mostly about the importance of the colour red. As I packed my bags to leave, I could sense my parents' uncertainty. This was the early Eighties, and bringing your parents together to tell them you were going to London to be an artist was tantamount to saying you'd strangled your sister. There was no future in art. Even I knew that.

I tired of art school by my second year. Deeply frustrated with the whole process of making paintings, I tore my final canvas from its stretcher and subjected it to a hot wash cycle in a nearby launderette. As I stared at the bulbous glass window on the front of the washing machine, watching my painting go round, the old lady who worked there asked me if I was a local, and told me that the area had been nice until 'you-know-who' moved in. She was referring to the Jamaican population, who occupied the rows of terraced housing that flanked the Peckham Road. As she muttered to herself in secretive tones, folding laundry, I looked on as my washing machine filled with a dense black solution. This would be the last oil painting I ever made.

I decided to stop painting and moved on to dyeing canvases in the fashion department, where I could spend more time with a girl I had a serious crush on. Art school can attract some beautiful women but I was terrible at asking them on dates. I was better at staring longingly from the corner and hoping to be noticed. No surprise then that my latest crush didn't respond as planned and my attentions began to drift to the outside world. I took to appropriating objects found on the street, like old shop awnings – the kind that burly proprietors would crank out in the rain to protect their goods. Tearing down these tarpaulin sheets from derelict stores, I took them back to college where I'd pin them to my studio wall, looking important, and fooling tutors into believing that I'd created a massive painting exclaiming 'Holly's Fruit and Veg'.

The Friday night disco at Camberwell art school was a hit with all the local colleges, and I was convinced that our art school was far more important than nearby Goldsmiths because we held the best parties. On Fridays, everyone would get completely trashed and dance around the common room to James Brown and Mantronix. Not yet housed in the university building at New Cross to which it eventually moved in the late 1980s, Goldsmiths was a stone's throw away in Myatts Field on the other side of Camberwell Green. In contrast to Camberwell's Friday night bacchanal, Goldsmiths held its disco on a Tuesday evening with dinner ladies serving drinks, including tea, from a service hatch. This indicated to me that Goldsmiths was deeply uncool. Then again, what did I know? Art school was unlike anything I'd ever come across. Seemed to me you could pretty much do anything you pleased, which included drinking, smoking and playing pool all day in the common room without remorse. I certainly wasn't aware at the time that there was a path I should be taking or moves I should be making to start establishing myself as an artist. By comparison, the Goldsmiths students would inherit a gallery-savvy wisdom imparted by a band of sophisticated tutors assembled under principal Jon Thompson. Teachers included practising artists such as Michael Craig-Martin, Yehuda Safran and Richard Wentworth. Craig-Martin in particular would remain close to many of his former students, often serving as an unofficial spokesperson and providing a cultural commentary in the media.

While living in a shared house in Camberwell, I began to explore the local area. In time, I started to piece together its history. The area had been badly scarred by the Second World War: once part of a thriving canal network, Camberwell and Peckham were decimated during the Blitz in the 1940s and by the subsequent waves of V1 and V2 rockets. Post-war, the need to build new dwellings to rehouse the displaced was a priority, giving rise to such utopian developments as the North Peckham Estate, a maze of local author-ity housing blocks knitted together by overground walkways. On my first visit to this bleak modernist housing development, I saw a man relentlessly

screaming through a smashed window. Everything was scorched and blackened, including parked cars, bins and shop fronts. A discarded mattress lay propped up against an industrial wheelie bin in a burnt-out shed. The walkways were in permanent darkness, adding to the very real sense of danger. Students at Camberwell who were allocated flats on the estate had to gang up most evenings just to defend themselves from muggers on the journey home. At night, it was truly terrifying and seemed designed with the express intention of disorientating the public. I broke out in many a cold sweat making my way home from parties on the estate, struggling to imagine how anyone could have envisioned such a project.

In nearby Burgess Park stood the empty shell of a derelict church. While its decaying Corinthian columns and façade were relatively intact, the roof had caved in leaving the interior overgrown with trees and the tombstones cracked with weeds. The shattered metal structure that once supported the ceiling had crashed into the ground and loomed overhead like a giant ribcage. Scattered in the undergrowth, little tinfoil squares smeared with cooked opiates spoke of a secret garden for ritual substance abuse. One rainy day a group of us, bored and with little else to do, broke into Dicky Dirts, a former 1970s jeans emporium at the top of Coldharbour Lane. Inside, we made our way down a damp corridor into the darkness. We used old newspapers to light a fire, and the orange glow fingered out into the room, reaching out so far, but failing to extend to the actual walls. It wasn't until we'd ignited enough rubbish to generate more light that we found ourselves in the middle of a vast, cavernous Art Deco cinema. For a moment, the crackling fire brought back to life a distant Bakelite world.

This was London in the mid 1980s, and life, for many, looked very bleak indeed. Margaret Thatcher had started selling off the family silver, privatising the nation's public utilities. Local hospitals were decommissioned and we soon found ourselves breaking into empty wards and abandoned operating theatres, returning home with bedside lights, wheelie chairs, hospital tables and rotting boxes of pharmaceutical drugs. Civic buildings, once a source of

great local pride, lay forlorn and decaying, transforming the inner city into an empty, destitute playground. I recall on one occasion walking through a London park and coming across the remains of the old Crystal Palace, once the site of the Great Exhibition. Huge decorative urns, left over from the far-off days of Queen Victoria, stood proud in the weeds and rubble, yet another symbol of Britain's past glory left to rot in the elements.

The relics of London's industrial past were being sold off as scrap. The old docks and heavy industries located to the east lay abandoned and without purpose. In the winter of 1985 I took a bus to go and visit one of my tutors in his East End studio, a journey that would take me across the Thames and through the City of London. I climbed up to the top deck and took a seat. It was packed with people tugging away on cigarettes, and the dense cloud of smoke was beginning to leave brown nicotine droplets on the ceiling. As our bus lurched through the City I peered up at the NatWest Tower. The only real skyscraper in London, it seemed eerily tall, and glittered in the late afternoon sunshine. I wished there were more like it. As we turned into the financial district, I observed pinstriped businessmen tilting silk hats at fellow traders. Tucked away in the side streets, philately shops offered rare Penny Blacks as a form of canny investment. This was a fine old world with fine old gentlemen conducting their business in time-honoured tradition. Rattling past Liverpool Street Station, the bus by now practically empty, I began to sense a shift in my surroundings as we started to turn into the East End proper. The change was stark.

Here lay the ruins of shattered industry set in dark, foreboding Victoriana. As I wiped away the condensation from my top deck window, the outside world looked bleak and dead. It was getting colder. Having scavenged for vegetables all morning outside Spitalfields market, a gathering of Hasidic Jews in black coats and homburgs stoked fires in battered oil barrels, the smoke rising vertically into the still winter air. A worn-out canal with muddy banks was strewn with splintered timber and abandoned long boats. Rats gnawed their way through the dripping arches in and around the old goods yard. As we

turned down the Bethnal Green Road and beyond, a sign boasted mock-Victorian furniture; then there was nothing, just concrete, brown brick walls and battered shop fronts. We passed sprawling scrap yards and garden allotments with rickety sheds. Newsagents promoted sun-bleached advertising for 1950s cigarettes: Players, Cadets, Piccadilly. Ruffled pigeons spied the world from the ledges of windows with shredded curtains. Sprawling undergrowth overran bombsites hemmed in by walls of rusting corrugated steel. Victorian terraced housing squinted under high-rise blocks marking the site of German air raids. It was clear that the East End was a wreck.

By contrast, the West End managed to shrug off the gloom and the damp that had settled in the outer zones of London. When I was feeling glum, and desperate to escape a creeping sense of dullness, I'd venture up West in an attempt to lift my spirits, losing myself in the latest trends. Covent Garden and Neals Yard were vegetarian strongholds where people came to refill glass jars with peanut butter and eat quiche. Designer shops sold hi-fi speakers set in concrete blocks or Katharine Hamnett T-shirts proclaiming 'No Trident', the latter an attack on Thatcher's nuclear defence programme. Meanwhile, Soho remained the territory of Francis Bacon and his compatriots; old queens traded insults in the Colony Rooms, slurring 'old cunty' and 'old poof'. There were jaded strip joints, notably one that declared itself 'The Best Review Show of the 1970s' – a sign that made little sense towards the end of the Eighties. Low budget Italian restaurants like Pollo and Centrale served as unofficial canteens for the students of nearby St Martins College, while weary transvestites belted out torch songs in the twilight world of basement piano bars. The notorious hack Jeffrey Bernard propped up the bar in the Coach and Horses while Norman Balon, the rudest landlord in Christendom, beat back the pages of the *Evening Standard*, occasionally eyeing his customers with contempt.

Cork Street, an elegant little street in Mayfair, was then considered to be the epicentre of the London art world. Located near Burlington Arcade at the back of the Royal Academy, it was peppered with commercial galleries with

big glass windows through which one could spy the odd bronze or canvas. Waddington Galleries, run by dealer Leslie Waddington, sold works by modern masters such as Matisse and Picasso, as well as British artists including Peter Blake, Patrick Caulfield and Barry Flanagan. The Nigel Greenwood Gallery, in nearby Burlington Street, had a contemporary focus and young students such as myself thought it was quite cool and trendy. Gilbert & George showed their early videos there in 1971 and by the mid-Eighties the exhibition programme featured painters such as Christopher Le Brun and Ian McKeever. Their large-scale, expressionistic landscapes were aligned to the 'New Spirit' in British painting, which in turn owed a great deal to recent developments that had taken place in German and Italian art.

Anthony d'Offay was one of the few London galleries to stand out. Located in Dering Street, just off Oxford Street, d'Offay represented a number of key international artists such as Anselm Kiefer, Joseph Beuys and Andy Warhol. It was a slick operation with galleries located across two buildings situated just a few yards apart: one an old Queen Anne house, referred to as 'the cottage', the other a suitably foreboding space on the first floor of a modernist office block. The staff wore black and a pretty girl on reception seemed to be perpetually on the phone. Sometimes they took on young art students as interns. During his first year at Goldsmiths, Damien Hirst worked there three days a week, setting up artworks for client viewings or handing out wine at openings. Anthony d'Offay was the biggest and most international of all the London galleries. Its openings attracted limousines and fur coats, as well as impoverished art students such as myself. The first time I spotted Anthony d'Offay himself, he was carrying a clutch of files in a wicker holdall. A mysterious man, he casually walked past wearing a black V-neck jumper and white shirt, making his way through the throng of people gathered outside before stepping into the back of an account car with his personal assistant in tow. Meanwhile, Matt's Gallery, run by Robin Klassnik and located far away in the East End, was loaded with artistic integrity but impossible to get to. Nicholas Logsdail, who represented British sculptors such as Tony

Cragg and Richard Deacon, ran the Lisson Gallery near Edgware Road tube. The Lisson had a reputation for being conceptually cool with interesting exhibitions, if only one could find the entrance in its impenetrable minimal façade.

But despite the blue-chip glamour of Cork Street, at the end of the day there was no escaping it. The London art world of the 1980s was fusty, parochial and dull. Artists and galleries were divided along lines of politics and class, of the commercial concern versus the artist cooperative, the cocktail reception versus nightclub video screening. Snobbery was rife, with experimentation occurring in corners of the art world that could no longer support it, and amateurish conservatism flourishing in parts that could. In all of this there was little in the way of a guiding light.

Nor was it just the art world that was suffering; the whole nation was in the doldrums. There were only four television channels. The BBC usually ended its nightly broadcasts with the roll of military drums as the national anthem played over a fixed shot of a Union Jack fluttering in the breeze. The news showed scenes of Margaret Thatcher becoming increasingly maniacal as the Eighties trundled on. The typical London pub refused to invest in toilet paper and served warm drinks whatever the weather. There was no such thing as Sunday opening, rendering the busiest of high streets dead. To top it all, there were spectacular outbursts of social unrest. My father drove up to see me one day and I had to give him directions so he could avoid the Brixton riots. But above all, I remember being so bored I could cry. This was my memory of London, not people in shoulder pads and champagne swilling Yuppies. This was a city in recovery, a decade with bad breath.

Year Zero: Birth of the white cube

BORN IN BRISTOL on 7 June 1965, Damien Hirst hailed from Leeds. His mother, Mary Brennan, was an unmarried shorthand typist who became pregnant by a man Hirst never got to know. Mary returned to Leeds soon after Damien was born; there she married a man in the motor trade, William Hirst, whom she later divorced. While growing up in Leeds, Hirst would make an unsettling discovery in his next-door neighbour's house. Mr Barnes was a strange man whose comings and goings were marked by the fact he some-times left the house with an empty supermarket trolley. Hirst could hear his television through the walls, but one day the house fell silent, causing concern among the neighbours, who decided to break in to check that every-thing was OK.

As it transpired, the local council had rehoused Mr Barnes, only he had left behind an amazing store of objects: a discovery that still haunts Hirst to this day. Over a period of sixty years, Mr Barnes had amassed a collection that included every toothpaste tube he'd ever used meticulously rolled up and placed in bags. He hoarded letters and heads from statues found in graveyards. There were little parcels of money, as well as collections of alarm clocks, magazines, newspapers, pipes, pens and tools. Entire rooms were filled to the brim with objects, many of them dated. Having made several trips to the house, Hirst started to piece together the life of a man he never knew. Four weeks later, two men from the council visited the house, smashed the windows and shovelled everything out onto the street. Mr Barnes would later

inspire a series of early collages in which Hirst cobbled together items of wood and bric-a-brac to form Schwitteresque panels.

In 1986, Hirst moved to London. Initially rejected by St Martins, he took to working on building sites before finding his way onto the fine art degree course at Goldsmiths College. During his second year, when he was twenty-three years old, Hirst curated the group show 'Freeze', a three-part exhibition that took place during the summer of 1988 in the old Port of London Authority building in Surrey Docks. 'Freeze' will be forever remembered as the landmark show in which a generation of Goldsmiths artists came together for the first time.

Few people remember that 'Freeze' came not long after an exhibition organised earlier in 1988 by fellow Goldsmiths student Angus Fairhurst at the Bloomsbury Gallery of the Institute of Education in Bedford Way, just off Russell Square. This almost forgotten group show included works by Mat Collishaw and Abigail Lane, as well as Hirst and Fairhurst himself. The show would plant the seed for what was to follow, especially as the subsequent line-up for 'Freeze' was a continuation of friendships that already existed or were formed as a consequence of Fairhurst's initiative. The end of year Goldsmiths BA degree show, held that summer in the Millard Building in Camberwell, would be noted for its unusually high standard of presentation. It included works by, among others, Ian Davenport, Gary Hume and Michael Landy, three artists who would show later that year at Karsten Schubert Ltd.

And then came 'Freeze'. As word of the impending group show spread around college, there was a growing sense of unease among the students over who would be included, the feeling at the time being that it was better to be in than out. 'Freeze' part one opened shortly after the Goldsmiths graduation show, and ran from 6 to 22 August. Part two was open from 27 August to 12 September, while part three took the show to a close on 29 September. Artists who took part included Angela Bulloch, Mat Collishaw, Ian t, Angus Fairhurst, Anya Gallaccio, Damien Hirst, Gary Hume,

Abigail Lane, Michael Landy, Sarah Lucas, Richard Patterson, Simon Patterson and Fiona Rae. Not all would graduate at the same time. For example, Sarah Lucas had already graduated in 1987, while Mat Collishaw would do so in 1989. Hirst would later say that if you looked closely enough, you could see a difference between those who took part in 'Freeze' while in their second year at college and those who were in their third: the second year students, including Hirst himself, Fairhurst and Lane, were more casual and unresolved in their approach than those in their final year, who included Bulloch, Davenport, Hume and Rae.

In many ways, 'Freeze' took inspiration from the high-powered Saatchi Gallery, situated in the comparative residential warmth of St John's Wood. One of the first former industrial spaces in London to be converted into a gallery, the Saatchi Gallery could be found behind imposing grey gates on Boundary Road. Walking down a tarmac path, you turned a corner and entered a vast white shed. The Saatchi Gallery was renowned for showing cutting-edge work by artists such as Jeff Koons; his basketballs suspended in fish tanks and stainless steel cast of an inflatable rabbit would influence a generation of art students who attended each opening with missionary zeal, despite its location well off the beaten track. It would be difficult to underestimate the impact of the Saatchi Gallery and its effect on all those who attended exhibitions such as 'NY Art Now', featuring a selection of hot young artists from New York such as Ashley Bickerton, Peter Halley and Haim Steinbach, many of whom were packaged under the banner 'Neo-Geo', one of the last groupings of its kind to emanate from America. What made the Saatchi Gallery even more unusual was that it was completely alone in what it was doing.

The Saatchi Gallery was everything that the boring institutions were not. It provided an excellent space for the display of fresh talent while being of such awesome scale that it literally took your breath away. From very early on, you could describe much of the work on show as sensational, including a permanent installation by British sculptor Richard Wilson entitled *20:50*

(1987) in which visitors were invited to walk down a narrow central aisle into a room filled waist high with a reflective layer of black sump oil. Saatchi was a visionary who, well before the rest of the world was ready, showed London how to present contemporary art in the best possible surroundings. Along with his fellow cohorts, Hirst would look to the Saatchi Gallery as the perfect space to replicate: the trick was to locate a similar venue that could be converted into a showing space with a lick of white paint.

That the Port of London Authority (PLA) building would present itself as the venue for 'Freeze' is largely attributable to the death of the London docks. In 1980, the London Docklands Development Corporation (LDDC) was set up to regenerate eight and a half square miles of neglected industrial wasteland in the boroughs of Southwark, Tower Hamlets and Newham. Established by the Thatcher government and brought into being by the likes of Cabinet minister Michael Heseltine, the LDDC was funded through a government grant as well as the income generated through land sold for housing, industrial and commercial development. During its seventeen-year reign, the LDDC sold 1066 acres of land, raised £9.56 billion in public and private sector investment, built 24,000 new homes and constructed the Docklands Light Railway. During this period, twenty-five million square feet of office space would be made available.

Thanks to the inspired workings of the LDDC, whose portfolio was bursting at the seams with vacant property, Hirst was able to secure the venue for his show. Over the coming weeks the artists, along with an extended network of friends, set about renovating the space, which for the most part was left bare with white walls stretching up to the rafters. From Heseltine to Hirst, the scene was now set.

'Freeze' reminded many at the time of the kind of presentation more likely to be found within the confines of a sleek European Kunsthalle. For a group of young art students, there was no precedent for such a high level of presentation. The exhibition was filled with flashing lights and minimalist wall paintings, with a selection of conceptual sculptures and paintings being given

run of the space. For his contribution, Hirst exhibited one of his earliest spot paintings, a regimented assortment of multi-coloured dots painted directly on the walls. He also showed clusters of multi-coloured boxes positioned high up in the rafters that were known to fall down from time to time.

Angela Bulloch presented one of her signature light pieces in which light fittings located on the wall were sequenced so they pulsed and glowed, or produced a hypnotic display of seemingly randomly generated patterns. Bulloch was already fascinated by systems and the way given instructions might inform the outcome of an artwork. A bombshell of a girl, raised in England but born in Canada, she was Hirst's then partner. Ian Davenport showed the first of his paintings created by pouring tins of paint onto a flat canvas that was then lifted upright, so that the paint slid across the surface in bands of thick, luscious colour. Devoid of any representational imagery, Davenport's paintings were produced without brushes and addressed the material quality of the paint while cocking a snook at the more earnest trappings of 1950s Abstract Expressionism. Angus Fairhurst presented a painting that doubled as a wall-based sculpture on hardboard with holes drilled into a pencil-drawn grid, a mind-numbing procedure enacted by the artist, who seemed preoccupied with mechanical repetition.

During the installation, Anya Gallaccio managed to scald her foot while pouring a ton of hot lead on the floor. Drizzled within the confines of a neatly arranged square, Gallaccio's hot lead would eventually solidify to form a sheet of Pollock-esque drips and splatters. Gary Hume showed three large canvases coated in mint green gloss paint: *Mint Green Doors I–III* (1988). Inspired by the type of swing doors found in hospitals and municipal buildings, the basic format of these paintings consisted of two circles with a dividing seam. The 'door paintings', as they later became known, would mark the early phase of Hume's career. Abigail Lane presented three sculptures made from sheets of cotton that were immaculately starched and draped over chairs. A petite ball of energy, Lane played an important role in helping Hirst to organise the exhibition.

YEAR ZERO: BIRTH OF THE WHITE CUBE

Meanwhile, Sarah Lucas presented a floor-based sculpture made from a large sheet of scrunched-up aluminium, a work that bears little resemblance to the sculptures for which she later became known. After seeing her work in 'Freeze', Lucas would soon change tack and adopt a way of working that allowed her to bring into play objects imbued with sexual innuendo, such as cucumbers and melons, eggs and kebabs. A significant change would also occur in the work of Michael Landy, who for now presented sheets of folded material – originally car covers – pinned to the wall in a manner that recalled the soft-sculpture conceptualists of the 1970s. While Landy's work on this occasion was soon overlooked, he will be remembered for having got so drunk working behind the bar at the opening of 'Freeze' that he had to sit out the rest of the evening being sick in a secluded corner.

Fiona Rae's oil paintings were composed of a series of brushstrokes, recalling a form of private notation or hieroglyphics, challenging viewers to pull all the different elements together in an effort to decode what was being said. In person, Rae was incredibly well spoken and considered, and far less prone to bouts of Anglo-Saxon binge drinking than her contemporaries.

Hailing from Leatherhead in Surrey, Richard and Simon Patterson presented radically different works from each other. At the time, Richard pursued a way of working that might readily be traced back to abstraction, whereas Simon had already embarked on a series of text-based works that would take him through the Nineties. While Richard came to prominence for his role in the 'Sensation' exhibition at the Royal Academy some years later, it was Simon who gained much of the attention at 'Freeze' with a pair of white canvases standing side by side, one reading 'Richard Burton', the other 'Elizabeth Taylor'. This particular work bore all of the hallmarks of the Goldsmiths standard, referencing conceptual 'high art' while at the same time being somewhat irreverent and down to earth.

While much of the work was evidently cheap to produce, the artists had maximised the visual impact of their limited materials. Given the basic ingredients involved in the making of these works, many were punching

above their weight. There were no video installations, no representational paintings or sculptures, but a strong graphic sensibility in which images and text were read in pure terms. There was nothing fancy here, nothing surreal or ornate; the materials on view had been left intact so they rarely appeared to represent something else. Lead was shown as lead, paint appeared as paint. While many of the works shown at 'Freeze' were influenced by the conceptual art of the Sixties and Seventies, there was also an underlying fascination with materialism, process and self-reflection.

One of the more exhilarating works was Mat Collishaw's *Bullet Hole* (1988–93). Simultaneously repulsive yet compelling, *Bullet Hole* shows a photographic close-up of a gaping head wound where the victim's hair is pulled to one side to reveal the point of penetration. It's an image that hits you in the guts. Taken directly from *A Colour Atlas of Forensic Pathology* by G. Austin Gresham, the wound reproduced at such a scale appears so horrific at first sight that it immediately forces you to look away. Contrary to what is suggested by the work's title, the wound is actually caused by an ice pick. Turning back to look again, one becomes intrigued by the slice mark left in the skull, the depth of the wound, and the vagina-like appearance of the glistening point of impact. It's hard not to be sucked in while at the same time questioning the morality that lies behind the decision to present such a grotesque image in full-blown Technicolor, enlarged and in neatly framed panels. Collishaw's work had a significant bearing on the aesthetic of an entire generation.

Such graphic imagery, casually presented within the framework of a minimal white cube, would come to typify the YBAs' use of shock tactics and sensationalism. Not only is *Bullet Hole* often cited as one of the more memorable works shown at 'Freeze', but its influence is also apparent in the exhibition's title, underlined in the first line of the accompanying catalogue, an impressive publication with a stylish new layout by now legendary designer Tony Arefin, who unexpectedly died in 2000: 'FREEZE, the title, comes from Mat Collishaw's light box, dedicated to a moment of impact, a

preserved now, a Freeze-frame.' There is, however, an alternative account that suggests the title took its name from a type of lettuce. To be precise, one sitting on Abigail Lane's kitchen table during a meeting in the run-up to the show.

'Freeze' represents Year Zero in the YBA calendar – the big bang from which all future successes would spring. Commentators often overlook the quality of the work shown at 'Freeze'. It was quite exceptional, especially when compared to all that was taking place around it. It was different from the output of other art schools, such as St Martins and the Royal College of Art, where students were still given to the so-called 'school of mud'; this took its cue from German Neo-Expressionism combined with the influence of London School artists such as Frank Auerbach and Leon Kossoff, whose paintings were caked in thick layers of paint. Colleges such as my own were rife with large dripping canvases where students set about attempting some form of leaden monumentality, as though no one had heard of Anselm Kiefer.

But these were the early days. Other trends abounded during this period, and it was by no means certain that the sensibilities expressed at 'Freeze' would win the day. Being young unknowns, the artists had little in the way of a reputation to trade on and force of character alone was no guarantee of success. Moreover, people simply didn't attend openings as they do now, in droves, at the drop of a hat. At the time, London was still in the grip of artistic paralysis; the work had to be of dramatic interest, otherwise no one would have gone. While 'Freeze' was by no means a smash hit with queues forming round the block, word started to trickle through that something important had taken place that summer, somewhere out there in Surrey Docks.

Building One: A career decision

TO FACE FORWARD after leaving art college in the late Eighties was like standing on a cliff edge while being pushed from behind. Meanwhile, the rear view mirror revealed an education system that was being stripped to the bone. The Thatcher government had set about slashing grants and teaching posts, leaving colleges under constant pressure to generate their own revenues by selling off course places to overseas students. A great many among my generation had come to art school from state-run comprehensive schools and were not from privileged backgrounds, unlike today where the line-up of double-barrelled surnames on graduate invitation cards would suggest an altogether different picture. The last working-class blip was working its way through higher education before the tide would be stemmed with student loans and other charges.

On the Black Monday crash of 19 October 1987, the UK stock market fell a little over twenty-six per cent. Hard to imagine that in the run-up to the crash, chancellor Nigel Lawson was being patted on the back for bringing about a boom that was hailed as an economic miracle. This had been engendered by tax cuts for the rich and the deregulation of the financial sector, which, in turn, led to a rapid rise in credit. After the crash, interest rates were kept deliberately low as a form of damage limitation, resulting in rising inflation. As a protective measure against the surplus of imports over exports, interest rates would then double between 1988 and 1989.

As if the situation couldn't get any worse, 1990 saw the world property

market go into freefall. In March, there were the poll tax riots in London's West End, which saw 70,000 people take to the streets and 340 arrests. Also in 1990, the Tories mistimed Britain's entry into the Exchange Rate Mechanism of the European Monetary System, going in when the rate was too high, which further weakened the national economy as measures were taken to prop up the pound.

In November 1990, Thatcher resigned after growing political pressure and widespread discontent. Her departure was greeted with whoops of joy, something I experienced while standing on the platform of Tottenham Court Road tube station as the news was announced over the public address system. With John Major now at the helm, the remainder of the Tories' years in power would be dogged by a faltering economy brought about by fluctuations in the world economic climate and botched political intervention. Britain was on its way out. The crash in the world property market, combined with zero long-term investment in manufacturing, would bring about a new strain of dereliction, particularly in London's East End where any hope of widespread regeneration was now on hold.

In the wake of wholesale sell-offs by the London Docklands Development Corporation during the Eighties, many abandoned docks and warehouses were already in the process of being redeveloped into apartments and offices. One Canada Square, otherwise known as Canary Wharf, was the UK's tallest building and a shining example of Docklands regeneration. Facing fierce local opposition, Olympia & York set about constructing the first phase of Canary Wharf between 1988 and 1991. Just as the building was nearing completion, with fifty floors of office space to let, the property market crashed and tenant interest evaporated. In a bitter twist of fate, Canary Wharf, once the glint in the eye of the Conservative government, came to symbolise everything that was wrong with the British economy. Rather than pointing to a bright, shining future, it loomed large over a dusty city as a reminder that the good times had gone. Epitomising the instability of the markets, Olympia & York would file for bankruptcy in 1992 with debts of over $20 billion.

Not only did the property market crash in 1990, so too did the international art market. While Vincent Van Gogh's *Portrait of Dr Gachet* would sell at auction that year for a record $82.5 million, the subsequent downturn proved to be lethal. The repercussions would impact on London galleries; several were forced to shutdown, such as the Nigel Greenwood Gallery, which eventually closed its doors in 1992.

The future, for young art graduates of the early Nineties, looked very bleak indeed. Assuming there were jobs to be found, most art students were hardly what you would call obvious candidates for regular employment in the outside world. After leaving art school, there were occasions when I thought I might have to apply to university and start all over again. Looking at what the future held, there really didn't seem to be any opportunities out there, not least because the very idea that contemporary art might take root in Britain seemed ludicrous.

In order to be young and make it in the art world, something had to give. And sure enough, opportunities started to arise, thanks to the tenacity of a new generation of aspiring young artists. Fresh out of college, these artists began to turn the situation to their advantage, seizing the initiative and opening up group shows across the East End, 'Freeze' being one of the first. As more and more property became available, artists were confronted by a world of possibility and a mini-explosion of temporary exhibitions took place, not just in old factories and warehouses but in brand new office buildings too. They were awkward spaces with low ceilings, empty desks and neutral grey carpets, but they gave emerging artists access to that elusive thing: an exhibition.

Strength came in numbers. To survive, young artists had to work together – setting up their own shows and promoting themselves as though they were the next big thing. After leaving college, many of the so-called 'Freeze generation' stuck together where most graduates might otherwise drift apart. There continues to be an extraordinary affinity between those who left Goldsmiths in the years between 1987 and 1990. The entrepreneurial spirit

that gripped many young artists of the day has subsequently been aligned with the influence of Thatcherism, but this doesn't give the artists enough credit. The fact remained that, fresh out of art school, young artists had to find a way to navigate the rigidity of the existing art establishment, otherwise they had no hope of carving out a career.

Soon after the Freeze generation graduated, the fine art course at Goldsmiths College relocated to the main university in New Cross, with its white-columned façade and gold university crest, and it was from this building that subsequent generations endeavoured to leave their mark. While their immediate predecessors were taking their first tentative steps in the big wide world thanks to 'Freeze', Goldsmiths students left behind stood accused of being over-expectant while preening themselves for future success as though fame were guaranteed. They weren't quite getting their heads down in the time-honoured way and were clearly getting up the nose of their older tutors, many of whom were still struggling to earn a crust. So Jo told me, flicking back her long dark hair while chewing gum.

A student at Goldsmiths, Jo worked alongside me selling postcards in the Royal Academy bookshop. Young and bubbly, she was a hotline of information and was ultimately responsible for bringing me into close contact with the emerging art scene. As I punched the buttons of a cash register, she told me how the final year students in 1990 had been rounded up and given a serious talking to. In no uncertain terms they were told that the ultimate aim of being an artist was not to feature in *Vogue* magazine, but required years of dedication; that it simply wasn't possible to become a successful artist just after leaving college. Such were the anxieties surrounding the immediate aftermath of 'Freeze', where a number of artists had already sold works to a handful of collectors and could claim a certain amount of success. Jo told how one young student, Sam Taylor-Wood, had gone out and spent a tidy sum on fabricating two chrome heads of Mike Tyson and Frank Bruno: a gleaming, stylish sculpture that would sit comfortably in the glossy pages of any contemporary art magazine.

As much as I liked the idea of being an artist, I was coming to terms with the realisation that I'd been in the wrong place at the wrong time. Had I not spent so much time partying at Camberwell and defected to Goldsmiths, a mere stone's throw away, I'd be up there with the best of them. What was I doing with my life? Being an artist wasn't going to be easy and in many ways I'd already given up.

During quiet moments in my dead-end job, I'd flick through art magazines such as *Art Monthly* and the soon-to-be defunct *Artscribe*, which were in tune with recent developments thanks to their writers David Batchelor, Kate Bush and Adrian Searle. It was also possible to track the progress of the young Goldsmiths artists through a smattering of reviews and articles written by the likes of Sacha Cradock in the *Guardian*, Andrew Graham-Dixon in the *Independent*, Sarah Kent in London's *Time Out* and Andrew Renton, who wrote an incisive column in the lifestyle magazine *Blitz*. One of the more influential publications at the time was a book called *Technique Anglaise: Current Trends in British Art*. Edited by Renton and Goldsmiths artist Liam Gillick, *Technique Anglaise* consisted of two hundred pages of black and white images provided by artists including Mat Collishaw, Damien Hirst and Sarah Lucas, as well as a recent addition to the scene, Rachel Whiteread, a graduate from the Slade School. This publication was among the first to bring together a line-up of artists that was to become increasingly familiar; many of them had participated in warehouse shows. Flicking through the various international art magazines, such as *Flash Art* and *Artforum*, it was also possible to see how young British artists were starting to reach a wider audience. The Goldsmiths graduates certainly had strength in numbers, I thought, feeling utterly hopeless. Standing behind a cash register in the Royal Academy bookshop, the future looked uncertain. No doubt sensing my desperation, my friend Jo reached into her handbag and slipped me an invitation card saying something about a show called 'Gambler' at Building One.

Part of an old biscuit factory in Bermondsey, Building One turned out to

be an old industrial warehouse with a high raftered ceiling and pristine white walls; the exhibition space had once again been refurbished by artists and friends to resemble the Saatchi Gallery, only it was a little rougher around the edges. 'Gambler' opened in July 1990 and featured works by artists including Angus Fairhurst, Damien Hirst and Tim Head, the latter being a much admired artist from an older generation. Inside, I encountered Hirst's medicine cabinets lined with pharmaceuticals, reminding me of the old hospitals that I used to break into in Camberwell. It was also the first time I encountered Hirst's fly piece *A Thousand Years* (1990), which literally stopped me in my tracks. Even from a distance, Hirst's sculpture – a large glass box divided by a single sheet of glass with holes to allow the passage of real flies from one half to the other – looked intensely foreboding. The structure was held together with steel beams that gave it a weighty feel in keeping with its purpose. Tin trays positioned on the floor inside were filled with squirming maggots and sugar cubes to create a self-contained ecosystem. The maggots would hatch into flies, then eat the sugar and fly from one half of the vitrine to the other, lured by the stench of a half-burnt cow's head lying on the floor in a pool of blood. On the other side, a fly killer lay in wait. Zap! A fly spun down to the ground. Zap! And another. Heaps of dead flies littered the floor.

Experiencing *A Thousand Years* in the flesh for the first time had a profound effect on me. It was suddenly clear that this wasn't just a flash in the pan, but a work of art produced by someone of my own generation that would outlive us all. The combination of dead flies and rotting flesh produced a deathly odour, which might ordinarily suggest an air of repulsion, and yet it remained totally compelling as a conceptual artwork where living creatures doubled as minimal art objects floating around a scientifically controlled environment. It was beautiful, unforgettable, but more than that it radiated a kind of certainty about its place in art history. I stood there and reflected on what I was going to do with my life. As someone who had been to art school, yet couldn't hope to compete with what I was seeing that day, what could I do to get involved? What promises did the future hold?

Shortly after graduating from Camberwell in 1987, I had been diagnosed with cancer and hospitalised for the best part of a year. I was so young at the time, but for months on end my life was little more than an endless round of painful injections and trips to the operating theatre. The doctors had told me there was a very real possibility that I might die. Sitting one night in the now defunct Westminster Hospital, overlooking the Thames from a connecting bridge that linked the two buildings, I saw my life coming to an end. Not long after, my luck turned. I was fortunate enough to avoid chemotherapy and went into remission. Now on the mend, my outlook had been irrevocably changed thanks to my brush with death. Taking each day at a time meant I had lost touch with all but the idea that simply being alive was enough. Now I had to work out what to do with my life, something I hadn't banked on. As I stood there contemplating Hirst's sculpture, it suddenly dawned on me that this was where I wanted to be. Up until then, the only idea I'd had about my future was some half-baked desire to run off into the sunset in pursuit of acid house. Had I chosen this path, I could easily have ended up spending the Nineties in Ibiza. Instead, I made what felt like a radical decision: even if I couldn't create art, being a part of it was enough. I wanted to spend the rest of my life surrounded by art and artists. As I watched the flies drifting around their glass capsule, I found myself at the beginning of a new episode in my life: my own Year Zero.

Three exhibitions were held at Building One in 1990. 'Gambler', held in July, had been preceded in March by 'Modern Medicine', curated by Carl Freedman, Damien Hirst and Billie Sellman. Hirst would quit his role as curator in order to concentrate on his art after the first show, leaving 'Gambler' to be curated by Freedman and Sellman. The first two exhibitions at Building One proved to be an enormous success, but with a three-month rent-free period coming to an end it required a sell-out show to keep the ball rolling. In October 1990, Michael Landy stepped into the breach with his solo exhibition 'Market'. Revered in art-world folklore as one of the best shows at Building One, it would also be the last. Consisting of a single large-scale installation, 'Market' was

inspired by the kind of temporary stalls set up by shop owners outside their stores. Stacks of upturned plastic bread crates and carefully constructed wooden units covered in artificial grass were neatly positioned about the space. There were videos of real shop-owners setting up stalls in the early hours of the morning. While the plastic crates and outdoor stalls were familiar objects that had once lined many a London high street, Landy's presentation at Building One doubled as a minimalist sculpture that acknowledged Donald Judd as much as it paid homage to the local vegetable store.

'Market' was an impressive exhibition. I attended the opening, and there was a great air of excitement as people sauntered down the aisles between the individual sculptures. First there had been 'Freeze' and now there was Building One, which opened itself up like part two of an unfolding story. People were starting to get to know each other and there was a growing sense that something was in the air. There just hadn't been exhibitions like this before in London, certainly not by recent graduates. Strange, then, to reflect that Landy's installation never sold at the time. Much of it was eventually destroyed by the artist as part of a project in 2001 when he took over the old C&A store in Oxford Street and built a machine to shred everything he owned, including his car and all his unsold work. Contrary to popular belief, not everything was being snapped up by Charles Saatchi; many young artists would continue to face an uphill struggle well into the Nineties.

Another ambitious group show was held in May 1990 at East Country Yard in South Dock, Docklands. Curated by Henry Bond and Sarah Lucas, it featured huge installations by Gary Hume and Anya Gallaccio, and could claim to have taken place in a space four times the size of the Saatchi Gallery. It soon became clear that this particular generation of artists was incredibly driven. There was a certain kind of energy about them, and their work seemed to be going from strength to strength. The crowd that attended these openings was unprecedented, so much so that at the opening of 'Modern Medicine' the police arrived thinking it was an illegal rave. The excitement was infectious. I would wake up in the morning and ring people in a

desperate attempt to find out when the next opening was. I couldn't wait to get to the next private view, even if it didn't include the Goldsmiths artists but just happened to be a contemporary art show with free beer.

The early round of artist-initiated warehouse shows broke the mould and were worthy of the attention they received. They were inspired and thought provoking; one imagined dynamic gallery operations in New York, not the former trappings of old Cork Street. The accompanying invite cards and catalogues had a sleek designer edge, while the artists themselves were being talked about as young and daring, as well as drunk and petulant and less reverent than their forebears. The artists were also seen as entrepreneurs, working alongside property developers and playing the dealers at their own game. Left to their own devices they had shunned the system and claimed the hallowed white cube as their own, along with all the marketing and promotional devices associated with more commercial galleries.

Carl Freedman, one of the founders of Building One, once told me how important it was to wear a suit and look the part in order to coax property developers into handing over the keys to a vacant property. Meanwhile, the young and fearless Billie Sellman turned getting stuff for free into an art as she strode into corporate offices wearing a bright orange trouser suit, swiftly securing sponsorship for the next catalogue. Persuading people to bike over some cash was the order of the day, and no matter how cheap it all seemed given that the rent was initially free, there were still exhibition costs, such as the construction of large white walls and an endless list of extraneous hardware.

While no one was immune to the economic turbulence of the late Eighties and early Nineties, the young British artists would blithely ride out this period. As the entire nation tightened its belt, young artists just wanted to show their work, and now seemed as good a time as any. Spurred on by each other's energy, their ability to be without income yet somehow self-propelled would see many of these artists through the worst of times – while not exactly oblivious to their surroundings, they had no money anyway an

In any case, this soon began to change. Although the vaca

BUILDING ONE: A CAREER DECISION

took a long time to shift as the property market crawled its way out of a pit, there was growing interest in the new art being produced in London, and a small number of collectors started to pick up their work. One could sense the power beginning to shift away from the plodding institutions and a class-riddled Cork Street.

Once a dejected graduate, I too could sense the sea change. I was gripped by a very real enthusiasm for what was going on around me, something I had rarely encountered at college. Many of those I met at openings were also under the impression that something important was happening, that the buzz surrounding young artists might ultimately end in something concrete.

Founder Members: Hirst, Jopling and Saatchi

THROUGHOUT THE LATE Eighties and early Nineties, the Goldsmiths artists continued to exchange ideas, advice, information, cameras and sometimes partners. They stuck together while other graduates were drifting apart. The first three years after leaving college are decisive. With little or no money to rent a studio, and no visible means of support, any commitment to remain an artist is sorely tested. Having achieved so much early on, the Freeze generation were certainly doing well but future success was by no means guaranteed. A coherent scene had yet to emerge and the key players hadn't yet made themselves known. In the early Nineties there was a sense that the burgeoning scene in London might fizzle out and die. It needed an injection of new life and outside support, which would eventually come in the form of collector Charles Saatchi, coupled with the coming together of Damien Hirst and Jay Jopling.

Charles Saatchi was born in Baghdad on 9 June 1943. A large Jewish household, the Saatchi family left Iraq in the aftermath of the Second World War and moved to London in 1946. Charles grew up with his older brother David and younger brother Maurice in a house on the edge of Hampstead golf course. They would be joined by the youngest of four brothers, Phil, who became a singer-songwriter and once supported a tour by Joan Armatrading. Having fuddled his way through university, Charles set up a creative consultancy with then partner Ross Cramer. In 1970, Charles and his brother Maurice established the advertising firm Saatchi & Saatchi. Throughout the

Eighties the Saatchi brothers ruled the waves. They consistently helped secure election victories for the Conservative government with ground-breaking advertising campaigns, one of the more memorable being a long queue of people lined up under a sign reading 'Employment Office' with the heading 'Labour Isn't Working'. Saatchi & Saatchi helped define Margaret Thatcher's political image.

In 1972, Charles had married Doris Lockhart, whose longstanding interest in contemporary art would match his own. The two started a collection of contemporary art that would later be housed at the Saatchi Gallery in Boundary Road. By the end of the Eighties, Saatchi already owned a smattering of works by the Goldsmiths artists, including a set of paintings by Gary Hume bought from the 'Freeze' exhibition and Damien Hirst's fly piece *A Thousand Years*, which he acquired for £4000. As the nation's economy staggered through the early Nineties, Saatchi found an explosion of talent on his own doorstep. What was more, the artists were producing reasonably priced work. As his attentions turned from New York to London, Saatchi started to buy up the block. Enter Jay Jopling, the perfect dealer for the Saatchi era – and what better artist to take on than Hirst? The Holy Trinity had arrived: artist, dealer and collector, all destined to become key figures in the history of young British art.

Sporting his trademark Clark Kent glasses, designer suit and slim black tie, Jay Jopling cut a dash through a world full of nondescripts. He exuded power and big-house confidence, partly engendered by the fact that his father, Michael, was a Yorkshire landowner, former Conservative chief whip and Minister for Agriculture under Thatcher. Born in 1963, Jeremy (forever to be known as Jay) grew up on the family farm before being packed off to boarding school in Scarborough. From there he went to Eton before studying art history at Edinburgh University, where he helped organise 'New Art, New World', a charity art auction, during his final year. Coinciding with the Band Aid events of the late Eighties, the auction aimed to raise money for the poor and starving in Africa. With missionary zeal, Jopling hopped on a plane and

flew to New York where he managed to persuade big name artists, such as Jean-Michel Basquiat, Keith Haring and Julian Schnabel, to donate works. The auction raised $500,000 for Save the Children.

After Edinburgh, Jopling moved to London. Bearing no discernible signs of a man brought up in the North of England, Jopling set his sights on the young scene burgeoning in the wake of 'Freeze'. When I first met Jopling, he seemed a determined, kind, generous and hysterically funny man. He was always working the room. Underneath the pinstriped persona was an individual obsessed with Leeds United Football Club and John Lennon. He could recite entire poems by punk rocker John Cooper Clarke in a mock Mancunian accent and stick the arm of his glasses up his nose. By some divine intervention, Jopling was inching his way closer and closer to Damien Hirst.

Hirst was a big, bold, belligerent blast of a human being. Unstoppable in his ascent, he would bellow at unsuspecting well-wishers in a strong northern accent, 'I fooking hate art!' Hirst had little time to waste. He was always on to the next exhibition or next big production, never still for a minute. Scratching his hair, vodka and tonic, fag, constantly feeding a fruit machine, playing pool, ordering more drinks, on the phone. An expert hedonist with a wicked sense of humour and an instinctive talent for self-promotion, he was once photographed playing a penis party-trick by inserting a cigarette into his foreskin. As someone remarked to me at the time, if Damien hadn't become a big artist, he would have started his own business and probably become the biggest plumber in Leeds.

In 1991, Hirst and Jopling would finally meet up in a crowded bar, where they got on famously. At one point Hirst asked Jopling, 'Do you know what I most like about life?' Before Jopling could find his answer, Hirst piped up with gusto, 'Everything!' They agreed to follow up their encounter by meeting at their respective places of work for fifteen minutes. The rest is history.

In the early Nineties Hirst lived in Brixton, South London, in a block of flats known as The Barrier, originally built to shield the area from the noise

of a later abandoned ring road. From his window at night he witnessed cars being torched and police chasing youths round the block. His studio was situated just off nearby Coldharbour Lane in Minet Road, behind a huddle of light industrial units that were constantly being turned over by thieves, duly ignored by a guard dog that would otherwise show its fangs at visiting collectors. There was a pub nearby called the Hero of Switzerland where Hirst would get drunk with his studio assistants. That he even had assistants was impressive. Having just left college, no one hired technicians, not at that age. While I found myself on the dole claiming unemployment benefit, Hirst was spending over £200 a week on taxis, a huge sum at the time. Jopling lived close to Hirst's studio in a Victorian terraced house in Shakespeare Road where his project coordinator, Julia Royse, worked from a small room on the top floor. The walls of Jopling's house started to fill with Hirst's medicine cabinets and spot paintings. From time to time Jay would throw drinks parties for potential clients and offer medicine cabinets for a couple of hundred pounds or a large spot painting for near a thousand.

In many ways, Hirst and Jopling were playing catch-up. Hirst was one of the last of the 'Freeze' generation of Goldsmiths artists to secure gallery representation. Very early on, Julian Opie, who graduated in 1982, was widely tipped as the golden boy of Goldsmiths College. Opie went directly to the Lisson Gallery. By the end of the Eighties, Goldsmiths artists such as Angela Bulloch would go to galleries such as Maureen Paley's Interim Art, subsequently renamed Maureen Paley. Born in New York, Paley graduated from Brown University before attending the Royal College of Art in 1977 where she studied photography. In 1984 she started putting on shows in her East London home, a Victorian terraced house in Beck Road. For the majority of the Nineties and beyond, Paley staged a number of important exhibitions by gallery artists, including Paul Noble, Wolfgang Tillmans, Rebecca Warren and Gillian Wearing. In many ways, Paley seemed the antithesis of Jopling, who was more the upwardly mobile businessman by comparison, but her operation had clout and Interim Art would assume legendary status. Despite

having had a well-documented run-in with Hirst regarding the sale of works from the 'Freeze' show, Paley occupied a dominant position in the minds of young artists. She was, after all, one of the few gallerists in London whose focus was contemporary art. Hard to imagine nowadays, but at the end of the Eighties the number of galleries willing to show work by emerging artists could be counted on one hand.

Meanwhile, Gary Hume, Michael Landy, Angus Fairhurst, Anya Gallaccio and Rachel Whiteread would assign themselves to Karsten Schubert, a young German dealer who, like Paley, was perceived to be an obvious receptacle for the latest talent. Schubert, a smartly dressed young German gentleman, had worked at the Lisson Gallery before deciding to go it alone. At the age of twenty-six, he had one of the hippest galleries in town and went on record as saying he wanted £1 million in his pocket by the time he turned thirty. His gallery, Karsten Schubert Ltd, was situated directly opposite the headquarters of Saatchi & Saatchi on Charlotte Street, but his dream would flounder as the recession started to bite, and the inevitable slump in sales combined with incessant overheads would bring about the gallery's demise. Not even his secondary market operation would drum up the necessary funds. Many galleries still operate such a system, whereby works by established artists are sold at auction for high prices in order to help fund loss-leading younger artists who have yet to prove themselves in the market. The primary artists would bear the brunt of Schubert's need to resize. Rumours abounded of a letter from Schubert referring to 'dead wood' – which certain artists took to refer to their work and themselves. When word got out, it caused turmoil among a number of artists. With limited primary sales and an insignificant income from the secondary market, Schubert's Charlotte Street operation would eventually close in 1992. His backer, Richard Salmon, would later claim to have lost an investment in excess of £500,000.

Meanwhile, Hirst was beginning to edge to the fore and his gregarious nature was starting to gain him recognition. At the beginning of his career,

Hirst's work was by no means shocking. His early Mr Barnes collages, cobbled together from scrap material, or the arrangements of coloured boxes shown at 'Freeze', were far from jarring or offensive. While the fly piece was a shock to the system, they were only flies. It wasn't until his first solo show in June 1991 that this obsession with living creatures, soon to be dead, would become more apparent.

Held in a temporary exhibition space in Woodstock Street, just off Oxford Street, *In and Out of Love* was spread across two floors of an empty shop unit. On the ground floor one encountered a series of white monochrome paintings coated in a sugary solution with brightly coloured flowers at their base in a row of small plant pots. Chrysalises were attached to the surface of each canvas from which a number of exotic butterflies would eventually hatch, mate and lay eggs before dying either of natural causes or having been trodden under foot. As with Hirst's earlier fly piece, one was confronted with the idea of a lifecycle being acted out as part of a conceptual artwork. In turn, this would lead to a certain sympathy for the butterflies, whose fleeting existence was entirely determined by the artist. Whereas Hirst had earlier used a glass vitrine to contain his swarming flies, the box in this instance was the room itself. Occurring alongside the development of the spot paintings, this was also an environment in which to observe brightly coloured butterflies randomly settle on empty white canvases . . . or someone's head.

Downstairs was a separate installation comprising eight square canvases coated in household gloss paint; each canvas having been painted a bold colour: orange, blue, pink and so on. Attached by their wing tips to the gloss paint, a handful of exotic butterflies were arranged across each canvas as though they had landed on the wet paint and died in situ. In the centre of the room stood an arrangement of functional office tables on which clear glass ashtrays filled with cigarette butts were placed. While the upstairs installation provided a firsthand encounter with life and death, the downstairs paintings were more fixed and calculated, speaking of the desire to defy the limitations of human existence through science.

It was from these paintings that the now iconic image of a single butterfly floating on a monochrome blue surface would later appear on the front cover of the pilot issue of *Frieze*, a new London-based magazine launched in 1991 which would document the latest developments in contemporary art. It was also the moment when Jay Jopling thought it best to make his move and pursue Hirst for his gallery. London dealer Richard Salmon would eventually acquire the downstairs installation, buying all eight butterfly paintings for £8000.

Hirst's medicine cabinets, dead flies and pickled animals all touched on themes relating to mortality and death. As a consequence his public persona, increasingly aligned with dark and sinister themes, became more attractive to the media. According to the nominative imperative whereby people's names predetermine their careers, any mention of the word Damien is readily associated with the devil himself, and the youthful Antichrist in *The Omen*. Another film reference recalled the kind of image that Hirst may have wished to project during his formative years: in a particular scene in *The Silence of the Lambs*, Jodie Foster enters a serial killer's lair filled with caged butterflies and medical supplies, an interior that conjures up an image of how one might imagine Hirst's studio to be. And then, of course, would come the inevitable reference to *Jaws* with its sinister soundtrack.

Over time, Hirst constructed an image of himself that would bring him into direct comparison with that most disturbing of all post-war artists, Francis Bacon, who openly declared he would like to shag Colonel Gaddafi. Hirst's association with dark and demonic forces was duly reinforced soon after he joined Jay Jopling, when an early photograph was published of the artist posing next to a severed head in a morgue. This unnerving image of Hirst laughing in the face of death – although he's actually grimacing – would herald the next phase of his career. Hirst had certainly found the right dealer. The two performed as a perfect double act: the bespoke Jopling, on the one hand, was conversant with money and the establishment, while Hirst represented the bullish wing of the avant garde.

FOUNDER MEMBERS: HIRST, JOPLING AND SAATCHI

Their collusion was an altogether British tryst, not unlike Beatles manager Brian Epstein representing the interests of a wayward and confrontational John Lennon.

Icons: The shock of the new

WITHIN A YEAR of each other, three of the most iconic works ever produced by young British artists would hit the headlines in rapid succession: Rachel Whiteread's *Ghost* (1990), Damien Hirst's *The Physical Impossibility of Death in the Mind of Someone Living* (1991), and Marc Quinn's *Self* (1991). Each would have a far-reaching impact. Produced by artists in their mid-twenties, these artworks would indelibly etch themselves on the public imagination. Their combined effect would effectively launch the phenomenon of young British art and see its projection onto faraway shores. While they may seem commonplace now, when they were first unveiled they were like little media explosions. They changed people's perception of what was possible in art. It's rare to experience such a profound shift in the creative process at the best of times, but to see three works of such potency come along in such a short space of time was all the more astonishing. From now on, there was no turning back. The combined energies of these young artists had taken art to the next level.

Rachel Whiteread was born in London in 1963. Unlike her YBA contemporaries, Whiteread studied at the Slade School of Fine Art. Always seemingly smoking roll-ups, she was considered a thoughtful artist. Throughout the Nineties, Whiteread remained both an insider and an outsider. She knew everyone, but was never into the scene. Not one to court media attention, she nevertheless remained in the public eye throughout the decade. She produced objects that represented a remarkable transformation

of the ordinary, but was never sensational in her choice of subject matter. In an attempt to reveal spaces that we're not used to seeing in solid form, her sculptures were invariably casts of basic, everyday objects such as chairs, tables, mattresses and bathtubs; she once cast the inside of a hot water bottle. That was how she worked, casting the space inside and around, above and below things, her casts taking with them an indelible impression of the object's surface, down to a groove or scratch.

Whiteread's *Ghost* is a groundbreaking work, a cast of an entire room taken from a derelict Victorian terraced house at 486 Archway Road in North London. After stripping the room back to its bare essentials, she spent three months casting sections of the walls and ceiling before piecing them together again using an upright metal frame. Encountering the work for the very first time, it resembles a large block of plaster, like a monolith, only there's an inverse fireplace with a window on the opposite side. On closer inspection, one becomes entranced by familiar details, such as the tiles around the fireplace, traces of soot, a light switch or the impression left behind by a door handle. A freeze-dried moment in domestic history, *Ghost* resembles a room that has been cracked open by solidified air.

Everyone knows Hirst's *The Physical Impossibility of Death in the Mind of Someone Living*, the tiger shark in a glass tank filled with water and formaldehyde. Otherwise known as 'the shark', it has embedded itself in the public imagination to such a degree that it might be said to be the contemporary equivalent of the Mona Lisa. Commissioned by Charles Saatchi for £50,000, it caused a public outcry when it was finally unveiled at the Boundary Road gallery. This wasn't art! At best, it was inhumane. More importantly, how much did it cost? The *Sun* newspaper paraded the headline '£50,000 for Fish Without Chips'. Needless to say, thanks to the ensuing furore, Hirst broke through the barrier of an otherwise clandestine art world and became a household name.

While the shark remains a remarkable sculptural effort, it also confirms the importance of a single telephone call. While Hirst was working on

'Freeze', he was also working at MAS Research, a telephone research agency where he learned how to put on a tone of voice that would ensure he was connected to company directors at the touch of a button. A master of disguise, Hirst found he had the ability to get pretty much anything he wanted, as was proved when he started raising money over the phone for projects such as 'Freeze.' Some years later, after a botched attempt to order a twelve-foot shark at Billingsgate fish market, Hirst ended up calling post offices in the coastal towns along the Great Australian Bight, who put up posters giving Hirst's and Jay Jopling's contact details. Hirst vetted the ensuing flood of calls, employing a similar system to that he used at MAS Research in an attempt to wheedle out the more serious candidates. Scott Blyth, who worked at art handlers Momart, then called Hirst to suggest he contact Vic Hislop, a shark-catcher in Sydney. Convinced this was the perfect man for the job, Hirst offered Hislop £4000 to reel in what he was looking for. Before long Hirst's shark would materialise in North London, where people went to see it in droves. One of the more memorable visitors during its run at the Saatchi Gallery was Francis Bacon, leaving a lasting image of the artist's puffy ham-like face peering through the sculpture's azure waters.

Born in London in 1964, Marc Quinn studied art history at Cambridge University before starting to work as a sculptor in 1984. Like Whiteread, Quinn would never run with the art pack, yet can claim to be one of the founding fathers of YBA. He continues to make work that is essentially about himself and his own physicality. Having sourced a medical facility with a device that could lower temperatures to minus seventy-five degrees, Quinn had the idea that he wanted to make an artwork using the equivalent of all the blood in his body. *Self* is the result of the artist pouring eight pints of his own blood into a mould of his head and then freezing it. However, one problem remained. *Self* was to be exhibited as part of Quinn's show 'Out of Time' at Grob Gallery and he had to transport the finished cast from a remote laboratory to the heart of the West End without it melting.

On the morning of his exhibition, Quinn stepped into the back of Jay

Jopling's black Citroen, head in hand. Jopling then tore his way up to Dering Street until they finally reached the gallery, ran up the stairs and took the mould out of its cast before placing it in a refrigerated display unit. It was a coup and the whole thing worked in the nick of time. Charles Saatchi bought the blood head, as it later became known, for £12,000. It was Quinn's masterpiece, recalling ancient death masks while looking a little, as Damien Hirst would have it, like sorbet. A meditation on mortality, Quinn's sculpture is an eerie work that invites you to move closer to inspect the frostbitten nose and the thick mass of congealed crimson under a soft shell of ice. It's a work that has gone down in history, not least when in 2002 it was widely rumoured that the blood head had melted after builders attending Saatchi's home accidentally unplugged the freezer. As testament to his own ageing process, Quinn systematically makes a new *Self* every five years.

All three works would form the backbone of consecutive displays by young British artists at Saatchi's Boundary Road gallery from 1992 to 1996. It was an incredible turnaround for these artists to have been first inspired by, and then exhibited at, the Saatchi Gallery. Having associated himself with hot New York art, Saatchi was now committed to showing works by artists such as Hirst, Quinn, Sarah Lucas and Whiteread, with later shows by Gary Hume and Gavin Turk. In the years ahead artists would find themselves splashed across the red tops with increasing regularity. For the time being, the seeds had been planted. First 'Freeze', then Building One and now the Young British Artists shows at the Saatchi Gallery.

In August 1991, there was an exhibition at the Serpentine Gallery selected by Andrew Graham-Dixon, Julia Peyton-Jones and Andrea Schlieker, the first showing of its kind in a major public institution. The exhibition's title, 'Broken English', was itself a reflection on the breaking down of conservative views in the art world, the press release claiming that the 'proverbial national distrust of new developments has been shed'. The exhibition featured an increasingly connected group of young artists: Angela Bulloch, Ian Davenport, Damien Hirst, Gary Hume, Anya Gallaccio, Michael

Landy, Sarah Staton, Rachel Whiteread. As the culmination of that year's activities, three of the four nominees for the 1991 Turner Prize held at the Tate Gallery were artists from the younger generation: Davenport, Whiteread and Fiona Rae. But as some may have predicted, the award went to the more established artist, in this case Anish Kapoor. For the time being at least, the younger generation would have to wait their turn.

Penetration: The emerging scene

IT WAS IN 1991 that I first got to know Carl Freedman. I recognised his beady eyes, wiry hair and thick cracking lips. Like a hawk, he'd spotted me smoking outside an opening at the Anderson O'Day gallery in Portobello Road, where a group of us had gathered to see a show curated by Andrew Renton that included works by Abigail Lane and Sam Taylor-Wood, alongside two young artists from the Royal College, Jake Chapman and Alex Hartley. I knew that Carl, along with Damien Hirst and Billie Sellman, had co-curated the shows at Building One. He walked up to me and, in a thick Leeds accent, asked for a cigarette. He continued to ask me for cigarettes throughout the Nineties.

I admired Freedman for having been at the centre of things. In art world terms, he was a made man. Like Hirst, he grew up in Leeds before moving to London. He went to University College London to study anthropology, which is where he first met Billie Sellman who was studying ancient history and social anthropology. He liked drinking, playing tennis, films by John Cassavetes and check jackets. From now on, meetings with Carl would fill my days, usually in tired old pubs where we could play endless rounds of pool. We became good friends. Occasionally prone to bouts of bickering, our friendship was usually rescued by Freedman's incredibly dry wit and his ability to cut through the crap.

At the time Building One was coming together, Freedman, Hirst and Sellman were living together in a derelict backwater of London called River

Way, not far from Greenwich, an area renowned for its associations with maritime history and Greenwich Mean Time. By the time I got to know Carl, soon after Building One wound down, he had the house all to himself. To get to River Way meant driving through acres of flat toxic wasteland before ducking under an old viaduct and emerging into a street that seemed so isolated, so in the middle of nowhere, that it looked like a stage set. River Way consisted of a one-sided row of small terraced houses originally built to accommodate the old gas workers. At the end of each garden was an alley, which led directly to a pub on the corner. It wasn't hard to imagine the former inhabitants bumbling their way home down this passage at the end of the night. Beyond the alley lay a vast area of polluted industrial scrubland that would later house the Millennium Dome. Threatened with demolition, River Way became the site of subsequent resident protests. But for now, this tiny community, cut off from the rest of the world, basked in the heat like a sleepy harbour. Hidden away from the stresses of urban life, the inhabitants tinkered with their cars as though repairing fishing nets.

Off the back of the success of Building One, Freedman attempted to set himself up as an independent commercial gallerist with the opening of the Carl Freedman Gallery in Soho Square. His first and last exhibition at this venue in May 1992 featured the artistic collaboration of David Pugh and Toby Morgan, both just turned twenty and otherwise known as Critical Décor. The pair had recently featured in a two-page article in *Artforum*. This was no small thing, especially as *Artforum*, published in New York, remains one of the most important contemporary art magazines of our time. That this level of interest was being applied to a young London-based duo relatively fresh from college provided yet another example of just how seriously young emerging artists from Britain were being taken, especially in America. The tide was turning; word occasionally went round that such and such a collector had flown in from America and bought something.

In the meantime, I was spending more and more time hanging out with

Carl, and this in turn brought me into the company of the Goldsmiths artists with whom he had worked. I found myself sliding towards the centre of the art world, without even noticing it happening. Little by little, each opening brought a new friendly face, someone I had met earlier and now knew well enough to escort to the pub.

In the early days of YBA there was a noticeable northern contingent descending on private views and causing mayhem. With their thick Leeds accents, Hirst and Freedman were among the most prominent, but several other characters came to the fore. David Pugh from Critical Décor – a skinny, white northerner, with a balding head that earned him the nickname Moon Boy – made it his mission to shock people with his chaotic behaviour, often spilling beer everywhere and occasionally being a tad irritating. Hailing from Rochdale in Lancashire, the young Pugh took an aversion to absolutely anyone who wasn't from up north.

In those days it wasn't uncommon to encounter a certain amount of antagonism between the North and South of England. Throughout the Eighties, the North had been plagued with industrial strikes, layoffs, redundancies and, as a consequence, mass unemployment. Thatcher's incandescent rage at the trade unions had culminated in pitched battles between striking miners and mounted police. While the South was associated with middle-class affluence, the North remained a poor, working-class nation within a nation; the North and South were politically, socially and economically at odds.

To hail from 'up north' in the early Nineties meant something. Most of the northerners I was meeting on the art circuit came from working-class backgrounds and had strong affiliations with the kind of politics spun out of Marxism. Along with being a member of the northern working class came an aura of personal suffering under Thatcher and her abhorrent distrust of organised labour. In turn, being a northerner seemed to suggest you were more likely to be in tune with the political resistance movements of the day. Many of these movements found their voice in circulars such as *Class War* or

Socialist Worker, which had cool associations with the punk movement and shared a general loathing of the affluent classes. At art school, to be middle or upper class had little cachet and set you apart as being a bit of a nonce. Being from the South labelled you a Conservative, which in turn aligned you with Thatcher and the snotty right. By the time I'd left college, the very idea that art could come from a Conservative position, as it has done occasionally, was unthinkable. For a brief moment it was entirely desirable to be an artist with a northern working-class background. It came with the right credentials and dovetailed neatly with the image of the rebel, the enfant terrible.

Emerging out of Borough tube one evening, invite card in hand, I made my way down a bleak urban highway past wet speeding juggernauts, before darting down the cobbled side streets towards the river. I turned a corner and entered an area where stevedores once heaved on ropes and pulleys, hoisting dark brown sacks from distant ships. A powerful blast of cumin and turmeric wafted round the corner, harking back to a time when spices were hoarded in the surrounding warehouses. After all these years a sweet perfume still lingered in the sodden air. The opening I was going to smelt amazing.

It was 1992, and I had become addicted to private views; the thought of missing out was too much to bear. I was totally broke and would leave my flat with a handful of coins scraped off the kitchen table and a few cigarettes. Whatever the weather, I made my way from one end of London to the other on public transport and then by foot. My socks had huge holes below the shoe line, in the toes as well as the heel, so they were like old-fashioned spats. But it didn't matter to me what I wore so long as there was free beer at the opening. Beck's sponsored all the private views back then and the possibility of free drinks was a major bonus to an impoverished soul like me. I had recently been made redundant from the Royal Academy bookshop and was now on state support, aka the dole, signing on for something like £60 a fortnight.

The Clove Gallery was tucked behind London's Design Museum, a temporary space in a refurbished warehouse on the south side of Tower Bridge. I had arrived in Borough that evening to see another exhibition with

artists Jake Chapman and Sam Taylor-Wood, only this time it included Jake's brother, Dinos, and young artist James White. Dinos showed a highly complex text-based painting of ambiguous words with letters missing, while Jake showed an appropriated Silk Cut advertisement presented in sections. The exhibition also included James White's photographs of newsreaders freeze-framed on video with their eyes shut, and Sam Taylor-Wood's photographs of herself moving over camouflage material as though making an action painting. At the time, Jake was going out with Sam, who was always fun to be with and much liked by everyone.

Sam Taylor-Wood was full of energy and had a sense of humour that stopped all the boys from being so super-serious that they became dull. Although Jake, her then partner, was a tall, hulking man who towered above most people, she – petite by comparison – could take charge if need be and would throw him a look that suggested, if you continue being a prat I'm going to kick you in the balls.

More than anything, Sam wanted to get things going. At no point was she ever going to be a complete nobody. Her drive and willingness to succeed often resulted in projects that benefited everyone. Entire shows would be up and running within weeks as her mardy male counterparts brushed themselves down and rose to her tune. She was an absolute tonic. Fresh out of college, Taylor-Wood would later become known for her videos of naked men dancing, actors throwing fits in kitchens or friends miming to opera, and for stretched panoramic photographs showing groups of people, some sitting and staring, some engaging themselves in a frozen argument, while others are having sex or standing around doing not much at all.

Notably, the cover of the exhibition catalogue for the Clove Gallery show sported a dated-looking photograph of naked men and women cavorting around a 1970s pub. The photo had been found in the space during the installation of the artworks and was typical of the kind of image being used to sex up the young scene (the word 'sexy' seemed to abound at the time: was the art 'sexy' enough? Was it a 'sexy' show?). A few beers later, catalogue in

hand, I walked back through the maze of cobbled streets and found myself filling with an air of disappointment. Things weren't going to plan. I was neither involved nor connected enough to feel any real affinity with what was going on.

The following week, I attended an opening at Karsten Schubert, hung around for a bit and went home. A few weeks after that, I went to an opening at the old Wapping Pump Station where Anya Gallaccio exhibited a number of whistling kettles fuelled by compressed air. As had become the norm, I went to a nearby pub before returning home – on this occasion the Prospect of Whitby on Wapping Wall, whose interior resembles a creaking old ship. I was starting to get bored and I wondered if this was how things would be, just one opening after the other with not much going on in between. I certainly wasn't doing much with my life and I was struggling to survive. Had I made a big mistake with my so-called career path? My experience of the London art world would have been short-lived had it not been for one memorable occasion.

It was in 1992 that Jay Jopling staged an exhibition by young artist Marcus Taylor in an old warehouse in Farringdon. The show consisted of minimalist interpretations of household objects, such as fridges and stoves, whose basic form was reductively transcribed in Perspex. That something as ordinary as a fridge might be reworked into a high-art object was typical of the way young British artists were working at the time. After the opening, everyone made their way to the nearest pub, the Coach and Horses at the bottom of Back Hill in Farringdon.

When I arrived, I spied Jake Chapman propped up against the bar on crutches. He looked pained and uncomfortable. Jake was twenty-four years old; Dinos was four years his senior. Both grew up in Hastings before coming to London, where their artistic paths crossed at the Royal College of Art. Aside from being an artist, Dinos was also a family man with kids. He could be extremely quick-witted and sharp, his bespectacled face rarely revealing a trace of an intended joke, only letting on with a sudden tilt of the head and a wisecrack smile. Meanwhile, Jake leaned toward a more puerile and

surrealist wit. In the most brilliantly perverse manner, he took great pleasure in taking things as far as they would go. Both were extremely well read, and often espoused the wisdom of Nietzsche or Bataille. Neither would be at a loss for words if the conversation strayed into psychoanalytic theory, least of all Jake who seemed to relish a philosophical debate, often becoming physically animated and grabbing friends by the scruff of the neck.

Physically, the Chapmans were very tall and very skinny. There was definitely something striking about the two when seen together and for the most part they towered above everyone else. Both had close-cropped hair that lent them the appearance of skinheads, which they were not – through a chance encounter with a photographer Jake was later to feature in an advertising campaign which pictured him sitting in a car and waving his fist as though undergoing a severe bout of road rage, his contorted face plastered all over London. To the uninitiated they looked outwardly hard, but any confusion with right-wing thugs was largely undone as soon as one got to know them. Moreover, there came a time when Jake decided to dye his hair bright red, which put paid to any further confusion. In a statement entitled 'We Are Artists', the Chapmans describe themselves as 'sore-eyed scopophiliac oxymorons' who have created a 'scatological aesthetics for the tired of seeing'. This more intense side of their artistic persona was often countered by a far less serious and comical interaction between the two. They seemed to enjoy egging each other on and were the kind of brothers who might suddenly start wrestling one another until – utterly exasperated – one held the other in a headlock.

Looking around the pub that night everyone seemed uneasy, eyeing each other over their pints. Nothing unusual about that, I thought, as the art kids started to file into the pub and joined the scrum at the bar. The Coach and Horses was tucked away in a back street well off the beaten track. The landlord was delighted, if not amazed, to be pulling a big crowd in an otherwise deserted area. By about nine o'clock the place was heaving. Towards the end of the night, at around eleven, the landlady went to pass out

a tray of free beer by way of thanking her new-found customers when, out of the corner of my eye, I noticed a dark-haired young man walk in. He was looking for the Chapmans. There followed a terse exchange with Jake Chapman, who was still propped up at the bar. Dinos stepped in between the two to try and calm things down, but refused to shake hands even when pressed to do so by the latecomer, whose behaviour had become increasingly erratic. The dark-haired stranger then picked up a beer glass and whacked it over Dinos's head.

All hell broke loose, turning the otherwise sedate pub into a Wild West saloon. People were dragging each other in and out of the front door. The drinks tray brought out by the landlady went flying and there was a spontaneous and seemingly unrelated attack on Tom Gidley, one of the editors and designer of *Frieze* magazine. It's difficult to recall what happened next, other than that there was blood, and Dinos was seriously hurt. Up until that moment, the pub owners had thought we were utterly charming, but now they wanted us out. The police arrived and an ambulance took Dinos to hospital. Those of us presently gathered outside dispersed into darkness.

All of this would have seemed farcical, a pointless pub brawl, except for one thing. At the expense of the Chapmans' well-being, everyone now had something to talk about. Finally, there was something to share in the form of art world gossip, and as ridiculous as it may sound it brought people together. Over the coming weeks various post-mortems were conducted at openings across town. People simply hadn't bonded like this before. Everyone was talking to each other and the various cliques, until then completely separate, dissolved. Even the hallowed 'Freeze' artists were talking to the likes of me to find out what had happened. And everyone was asking the same question: who was that man? No matter how murky the details may have been in the run-up to the latest conflict, a twisted sense of excitement surrounded this particular evening, not unlike hearing the word 'fight' ring out across the playground. The art world was imbued with a sense of danger that would see

off the politeness that had been threatening to drive it back into its cosy, middle-class box. Suddenly, there were other artists to consider and more personalities involved. This little skirmish would mark, for me at least, the end of the 'Freeze' monopoly. Something new was coming round the corner, something larger in scale.

Soon after the pub brawl, the Chapmans started to work collaboratively. They left behind any overt reference to the minimal and conceptual art of the Sixties and Seventies and started to produce new work that was altogether more jaw-dropping. This would become apparent when they opened their show *The Disasters of War* in 1993 at the Victoria Miro Gallery in Cork Street. The exhibition centred on a single work: a collection of delicate figurines placed in a circular arrangement on a large white plinth. *The Disasters of War* apes Francisco de Goya's etchings of atrocities committed during the Spanish War of Independence. Each carefully rendered toy-like miniature recreates one of the scenes of untold violence depicted by Goya, whose original etchings sought to illustrate war crimes in an attempt to lay bare the horrors of conflict. The Chapmans trod a less reverential line, rendering Goya's highly charged imagery as a nerd-like collection of scale models. The shock value lies not only in the nature of the subject matter, with images of captured soldiers being brutally dismembered, but in the manner whereby the Chapmans reinterpreted Goya's efforts to incite a shared sense of moral indignation. In repositioning Goya's outrage and supplanting it with an innocuous collection of trivialised objects, any moral purpose is rendered null and void. Referring back to subject matter dating to the early nineteenth century, the Chapmans had found a strong position from which to attack the pathology of moral righteousness and the aesthetics of death. They continue to do so, and *The Disasters of War* would set the tone for much of their subsequent output.

The Chapman brothers soon became prominent members of the emerging London scene, *The Disasters of War* dovetailing neatly with an aesthetic that seemed to be prevalent among young artists of the day:

sensationalism. With this and subsequent works, such as a sculpture of a small boy with a penis nose entitled *Fuck Face* (1994), they gave flesh to the idea that the art being produced by the younger generation was highly likely to cause offence. Not that this was without precedent in the history of contemporary British art. During the late Eighties and early Nineties, the Chapmans worked for the artistic duo Gilbert & George, often helping to colour in their photographs with photographic dyes that sometimes left Jake and Dinos with multi-coloured hands at the end of the day. Gilbert & George were much admired by the younger artists. They wore tailored suits that made them look like part of the establishment, while simultaneously exhibiting images of dicks and rectums. They showed videos of themselves getting drunk on Gordon's gin and photographs of street graffiti saying 'cunt' and 'scum'. While young artists were just discovering the East End, Gilbert & George had been living there since 1968 in an old Huguenot house on Fournier Street. In many ways, Gilbert & George had helped pave the way for the YBAs. They had set the bar, one that the younger artists would have to raise in order to turn heads. At the very least they helped to prepare the British public for what they were about to receive.

Closing Down: Recession

ON TOP OF the counter stood eight Holsten Pils beer bottles. Red letters sprouted out of the top of each bottle on wire stalks, spelling out the word ROSEBUSH. Sarah Lucas looked up from her creation, pulled a cigarette from her mouth, brushed back her dark straight hair and said, 'You can have that for ten quid.' Lucas was a North London girl, the real deal.

Slightly androgynous in appearance, Lucas didn't care much for regular women's clothing, opting instead for jeans, T-shirts and a bit of leather. She smoked like a trooper and had a working-class accent so that she came across as bit of a toughie. Underneath it all, was a mercurial and compelling character who could juggle ideas so lucidly that it was hard not to become transfixed by her many and splendid rants. Like a market-stall holder on a good day, she could come out with a laugh-out-loud observation that kept everyone's momentum going during an otherwise bland and tedious day. But for now, as Lucas looked down at her latest creation with curious satisfaction, there was a silent pause.

Ten pounds was the exact amount of money that Fenella, my then girlfriend, had given me to buy a rose sapling to present as a gift to our dinner hosts later that evening. 'I just don't know, Sarah . . . I don't think Fenella will understand my bringing these beer bottles back instead of a real rosebush. I'm in her bad books as it is.' I mulled over the possibility of parting with Fenella's hard cash, the same angry girlfriend who only a few hours before had been screaming down the phone at me for not having returned her car.

It's not that I didn't appreciate Sarah's artful interpretation of a rosebush, but the story I'd have to concoct to justify bringing back this artwork would be akin to Jack and the Beanstalk. I could imagine the look of horror cast over Fenella's face at the sight of, not a lovely little sapling in a plant pot, but eight empty beer bottles, reeking of spent alcohol, with red cardboard lettering stuck out the top. No, it wasn't going to wash. I politely declined Sarah's offer and returned home empty handed.

Driving from East to West London that evening, as Indian wholesale shops gave way to posh houses, Fenella and I finally tracked down a real rosebush sapling in a home improvement store. The dinner went OK, but I was haunted throughout. A gulf had opened up between my previous circle of friends and my new life in the art world. Old acquaintances simply didn't hold my attention in the same way, and I found myself aching to break away to rejoin a carousing bunch of artists somewhere in the depths of the city. As much as I tried to relax and enjoy the civilised conversation over dinner, I wanted to be where the action was. My mind kept drifting, and there were times during the evening when I couldn't speak or was caught off guard. How could I have turned down an original Sarah Lucas for £10? I remain haunted to this day and will be for the rest of my life. In much the same way that Citizen Kane's last words were 'Rosebud', mine will be 'Rosebush'. I can't stop thinking about the work itself, which I love. It not only captures the spirit of the time, but also Sarah's ability to pluck something out of the English ether and fix it in reality. It's the kind of work I really like. It's not flashy, it's not showy; it is what it is and then some. I knew then, as I know now, that I'd missed a great opportunity. Later that year, Sarah exhibited *Rosebush* at the Museum of Modern Art in New York.

Prior to opening The Shop in 1993, Lucas had staged two exhibitions a year earlier. In February 1992, she held her first ever solo exhibition at City Racing, an artist-run space in a former betting shop tucked away behind the Oval cricket ground. While the interior was painted white to resemble a gallery, the original sign remained above a windowless shop front that

retained the air of a beaten-up old bookie's. City Racing originally opened in 1988. Its founders – Matt Hale, John Burgess, Keith Coventry, Peter Owen and Paul Noble – were artists who, rather than wait to be offered a West End show, decided to pursue their own agenda and in doing so established one of London's foremost independent spaces. Before its doors finally closed in 1998, a great many artists would show there, such as Gavin Brown (who eventually set up a gallery in New York) and Gillian Wearing (who at the time of her exhibition showed photographs of a man and woman masturbating).

With artists at the helm, the exhibitions at City Racing could always be counted on to be more experimental than those taking place across the river in upmarket Cork Street. For her show, Lucas exhibited *Penis Nailed to a Board* (1992), which featured a page from a tabloid newspaper mounted on cardboard with the photographs cut out so they could be reinserted like pieces from a puzzle. The title of this particular work also served as the exhibition's title, the wording having been taken directly from a tabloid headline that read 'Penis Nailed to a Board in Sex "Game"'. In keeping with the sexual double standards encountered in the gutter press, what was striking about the article – centred on a group of 'evil slave sadists' who apparently had their 'testicles sandpapered' – is that it was accompanied by two adverts, one for 'Hot Sex-Talk', the other declaring 'Can You Become A Better Lover'.

In March 1992, Sarah Lucas opened her show 'The Whole Joke' in a small vacant shop in Kingly Street, situated behind Carnaby Street in Soho. The work she eventually showed there, *Two Fried Eggs and a Kebab*, would become one of the most memorable ever made by a young British artist. Having secured a temporary space, the next thing was to think up what to put in it. The idea for *Two Fried Eggs and a Kebab* started out with a table, which Lucas had to hand and wanted to use in some way. At the same time, she was playing around with the notion of making an artwork out of a whole egg (hence the title of the show, a pun on the phrase 'the whole yolk'). At one point, the idea was to show an unbroken egg between two slices of bread.

CLOSING DOWN: RECESSION

Then, during a sleepless night spent racking her brain, the inspiration struck to combine the two, thus integrating the egg and the table as one.

As well as being the artist, Lucas was the sole invigilator, which meant having to open up her space every morning. The exhibition opened at 11 a.m., around the same time that the kebab shops were opening. Hard to say what the people behind the counter made of the young Lucas, by now a regular visitor, casually pulling her hair to one side before ordering a large doner with no salad. She would then make her way back to the space carrying a wrapped kebab and a box of eggs.

Once inside, she would proceed to fry some eggs on a small Primus stove and slip them onto the table. She then unwrapped the kebab and inserted it into a small slot in the tabletop. Both the eggs and the large doner were still steaming hot.

Lucas has a very pragmatic way of dealing with the patently absurd. For all the jokes that have been levelled at it, *Two Fried Eggs and a Kebab* remains a work of transformative genius. The table offers itself up as a brutal reduction of female form, while the work in its entirety recalls a woman arching her back, her breasts on open display and her vagina thrust forward. The piece also includes a small colour photograph taken from above that further enables a near pornographic reading of the work.

Rooted in misogynist slurs and foulmouthed slang, *Two Fried Eggs and a Kebab* would later be snapped up by Charles Saatchi, who rolled up one day just as Lucas bit into a doughnut and a dollop of jam rolled down her jacket.

With the money she made from the sale of this and other works, Lucas took over the lease of a ramshackle house at the top of Brick Lane and reopened it as The Shop in January 1993. As is sometimes the case with Sarah, she was looking for a partner to bounce ideas off and share her latest caper. In this case the partner turned out to be Tracey Emin, who up until then was relatively unknown in art world circles.

Conceived by an English mother and Turkish father and born in London in 1963, Tracey Emin grew up in the seaside town of Margate in a

southeastern corner of England. Tracey's parents lived separate lives; she and her brother Paul were brought up by her mother, who suffered the indignity of locals calling her 'nigger-lover'.

Emin moved to London where in 1982 she met punk poet Billy Childish, with whom she would have an on-off relationship over the next five years. A year after meeting Billy, she started a degree course at Maidstone College of Art before attending the Royal College of Art in 1987. In 1990 she became pregnant and had an abortion that went drastically wrong, owing to the fact that everyone was unaware she was carrying twins. After another abortion in 1992, she went on to befriend Sarah Lucas, who was instrumental in introducing her to the Goldsmiths set.

My first encounter with Emin was at a party in King's Cross in 1991, two years before she started working at The Shop. Prancing around in white pop socks and a short skirt, she struck me as utterly bonkers. Her idea of dancing seemed to be to jump up and down on the spot while smashing her shoes into the wooden floorboards. She was joyously shouting at everyone to join in, which had the opposite effect of making people cling to the walls. She reminded me a little of Sandra Bernhard, the American comedian and star of Scorsese's film *The King of Comedy*. She had big breasts, but was quite scrawny. While seemingly feminine and cute from afar, what came out of her mouth was a quasi-Cockney accent that made her quite threatening and punk-like. Fag in mouth, she also came across as quite a toughie and not one to mess with.

Among the first items to appear in The Shop were snapshots of Emin and Lucas in the Dolphin, the pub next door, toasting the signing of the lease. By now I had begun contributing articles on the burgeoning scene to a number of periodicals, and I interviewed Emin and Lucas for *Frieze* magazine shortly after The Shop opened.

My entrée to becoming a contributing writer for the magazine started with a highly critical letter sent to one of its youthful editors, Matthew Slotover, soon after the pilot issue was launched in 1991. I initially had an aversion to *Frieze*

and was stunned when I received a reply asking me to come in to the magazine's modest office in Denmark Street to discuss the matter further. Matthew, who always looks younger than his years, struck me as being about fifteen at the time. He was super smart and very patient. After that, we saw each other again, mostly at openings, and before long I started writing essays and regular reviews. I dare say this had a bearing on the number of phone calls I began receiving from artists and gallerists who wanted to know me now I was writing for a new and successful magazine entirely dedicated to the activities of a young generation of artists. Exquisitely designed, *Frieze* did look beautiful.

As I prepared myself to conduct my interview with Emin and Lucas, Sarah occasionally thumbed the side of her nose, which had become red and irritable. She was wearing cut down jeans, T-shirt and thick leather builder's boots. Tracey eyed me from behind a cigarette and sunglasses, wearing a knotted denim shirt and mini-skirt. Both were drinking beer. During the course of the interview, Lucas would hold her hand up to the side of her head and scratch at her hair, momentarily staring at things lying around the place as though she had no idea how they got there. As we toured the empty house, from floor to floor, she told me more about the project. 'What we're doing here is a lot of fun, we giggle a lot. We have ideas and we laugh. The main thing about a shop is that we're open to anyone, whoever they are. Anyone can drop by. We're also able to get on with a lot of stuff that may seem trivial in a studio context. When you go into a studio, especially when you've made a certain amount of work, it's quite tempting to get pernickety about everything. Beavering away in a studio thinking this piece is not as good as the last one – that kind of business – which is alleviated by opening up a shop. The actual fact that we might make some beer money is nice, but irrelevant.' Lucas resisted the idea of taking her own studio, where she would spend much of her time in isolation. For Sarah, ideas are out there, they inhabit people and float around in social exchange.

At first, The Shop contained very little in the way of products. Formerly a dentist's surgery, the house had been left as an empty shell with no furnishings or fittings to speak of. There was a small, unattractive basement that Sarah and Tracey referred to as 'The Think Tank', while the ground floor shop unit had bare, uninviting walls. At first sight, it was a bit grim, and the whole building felt old and dilapidated. On the first floor, Sarah stored her work in one room while Tracey claimed another as her studio where she made figurative woodcuts from old floorboards. The room at the top of the house had been named 'The Detective Office'. It had a noticeboard, a desk and a typewriter, where Emin could write. At the time, Tracey saw herself as a writer. The only thing being she couldn't type.

Early on in the development of The Shop, a large counter appeared downstairs and was promptly covered with images from tabloid newspapers. Soon after the arrival of the counter, visitors began treating the space like a shop. Emin and Lucas took to calling themselves 'The Birds' and started to fill the shelves with bits and pieces of their own creation. There were items knitted together from whatever happened to be lying around, such as beer cans and scraps of fabric. On the empty shelves were cigarette packets shaped into origami animals and sold on for exactly the same price as a fresh pack. Any sales from the shop went into sustaining the business, which often meant a trip to the newsagent's or the off-licence, or to the Dolphin where one could obtain a pint of Guinness for fifty pence during the bleakest of happy hours in this Victorian pit. The Dolphin also became the venue for so-called 'life drawing classes' where people were invited to sit around a sticky pub table and discuss such critical topics as 'Is there such a thing as genius?'

Some pretty surreal products started appearing in The Shop, including 'Rothko Comfort Blankets' made from tiny squares of burgundy-coloured fabric with embroidered text by Emin. You could also acquire 'Damien Hirst Ashtrays', a regular glass ashtray with a cheap black and white photocopy of the artist's face stuck to the base. It was always a little strange that these ashtrays invited you to stub a cigarette out on Damien's head. There were

newspaper cuttings of David Hockney, who Emin saw as cuddly, mounted on small squares of cardboard with a safety pin so you could wear the artist on your jacket. They also sold cream-coloured ribbon by the yard; this could be cut into small strips to resemble fashion labels with handwritten slogans in black marker pen saying things like 'Help, Help' and 'Here Come the Bears'.

Most items were pretty cheap and cost only a few quid; other items were more highly prized, such as Lucas' penis sculptures made out of beer cans. A range of white T-shirts emblazoned with bold, black hand-painted slogans also started to appear. Initially cheap to buy, they rose in price as sales increased. I once asked Sarah to explain this to me. 'All the T-shirts are hand painted and go up in price every time we sell one. "Complete Arsehole" is now selling at £40. They start off at £12, go up to £15 and then they go up in fivers until they get to £50. We haven't decided what happens after that.' Emin casually added: 'And then the next most expensive one is £35 and that says "Fucking Useless".'

Sitting behind the counter, Lucas would carefully cut around photographs of herself having a mug of tea, or a beer, or smoking a cigarette. She'd then attach these images to wire stalks and arrange them like flowers in a vase. Across the room, a large floppy octopus made from black tights stuffed with newspapers straddled the radiator, looking like a forlorn pantomime prop. I recall one occasion when a gregarious Norman Rosenthal, exhibitions director at London's Royal Academy, put the octopus on his head and started dancing with it.

Collectors started turning up out of curiosity, by which time The Shop was brimming with objects, including a 1970s Raleigh 'Chopper' bike and a dark green plastic hexagonal fish tank with goldfish inside and the word 'Ken' painted on the side in bright orange paint. You could lie on a hammock while talking to the artists as they toiled over some triangular bunting that would eventually adorn the shop window. The best time to go to The Shop was on a Saturday night. It was perfect. Weekday openings were fairly straight-forward, but the weekend hours were brilliantly absurd: 11 p.m. Saturday night until 4 p.m. Sunday afternoon. Some hefty drinking sessions ensued,

Sarah laughing her head off throughout. It was great to arrive after midnight, just as the rest of London was closing down, and find the place alive with people. Everyone brought their own alcohol, and at some point the cassette player would snap into action and we'd all prance around to Bowie, the Beatles and indie group St Etienne.

Eventually I became such a regular at The Shop that I would stay overnight in a drunken haze, waking up in an upstairs room surrounded by huge photo-copies from the *Sunday Sport* and photographs of Lucas sitting wearing her trademark brown leather jacket and jeans, her legs wide open in a deliberately unladylike manner. The Shop soon took on its own momentum, causing Sarah to comment with glee, 'Things are really starting to go on!' While Lucas was the better known of the two, Emin would begin to assert her own brand of notoriety. Originally in 1992, she had an idea for a pen-friend project; an opportunity for people to invest in her 'creative potential'. At The Shop, a sign went up saying that for a nominal fee she would write a personalised letter to her subscribers once every month for a year. Jay Jopling signed up and, over time, they became acquaintances. By now, Jay had opened his gallery, White Cube, and before long he offered Tracey a show. Her first one-person exhibition, at the end of 1993, was entitled 'My Major Retrospective'.

One of the highlights at The Shop was Tracey's birthday party, entitled 'Fucking Fantastic at Thirty'. The Birds had managed to get drinks sponsorship from a designer beer called Space. There were buckets of the stuff everywhere and, reading the label, I noticed this particular brew had an unusually high alcohol content. Along with the young scene, such notables as Gilbert & George arrived and everyone got completely hammered on an endless supply of free beer. Having had very little sleep myself that night, I remember Lucas clomping downstairs in her boots the following morning and making her way over to a black plastic bin filled with ice water. She rolled up her shirtsleeve and thrust her arm into the murky depths. Much to her surprise, she hoisted out a tin of Tennent's Extra, the preferred choice of hardened alcoholics. 'Great!' she announced as she cracked open the tin and gulped back the contents.

CLOSING DOWN: RECESSION

For many reasons The Shop proved to be an important development in the history of the London art world, not only because it helped further Sarah's and Tracey's careers, but because it brought people together. Nothing could beat talking shop with Sarah and Tracey. Many people must, like me, have dropped by and poured their hearts out over the counter, or simply engaged in a little tittle-tattle. I first met Angus Fairhurst sitting on the 'Chopper' bike, which by now had become a permanent feature of The Shop and functioned like a chair. Fairhurst was wearing a white T-shirt and one of the dark winter coats, a Crombie, which everyone seemed to wear back then, including Lucas. Born in 1963, Fairhurst was a key figure within the Goldsmiths set. Along with Damien Hirst, he was very much at the centre of things. On first impression, he was well spoken and mild-mannered, a remarkably cool guy, both handsome and considered.

Sat on the Chopper, Angus was coming to the end of a process of reflection with Sarah, about what exactly I didn't know. He was partially looking at me but also into space. He seemed far away. 'So, um . . .' With a slight wince, he paused, looked down at the ground, then, raising his slender chin, he proceeded to wiggle his little finger in his ear. Having returned his long pale fingers to his coat pockets, he pursed his lips and slowly nodded his head. 'I'm going to head off.'

For a time, Angus remained a mystery to me, but as I got to know him better I began to realise he was not only very sharp of mind, but was also an incredible dancer who could pull off some extremely fancy footwork. Like a particularly gifted athlete, he could move his feet with such speed and agility that they seemed to dissolve into a blur. With sweat dripping from his thick dark hair and fingers held in a clicking position above the waistline, Angus reminded me of a reserved Austrian philosopher who, by night, had learnt to dance like James Brown.

Through day-to-day encounters such as these, I found myself increasingly plugged in to the art world. My daily life was becoming inextricably linked to private views and studio parties. Carl Freedman later referred to the

phase I was going through as part of an induction process, a form of baptism that would take me through the next three years. All the while Emin and Lucas must have found these impromptu encounters an inspiration, a humorous take on the more orthodox approach of the studio visit. Like it or not, The Shop was responsible for bringing a great number of people together, including artists and curators, collectors and institutional types. Seemingly, one way to bring about a collective, at least for the British, is to open a small going concern serving the local community – a nation of shopkeepers indeed!

While such a project might speak of the joys of running a store, it also served as a reminder of the downward path of the nation's economy. I went to see Emin and Lucas on the last day of The Shop. By now they had amassed so much stuff they were at a loss as to what to do with it all. There were boxes of framed photographs, books, posters, tools and general shop ephemera to contend with, let alone the Chopper bike, hammocks and fish tank. Earlier that day Emin had experienced her first row with Carl Freedman, her new boyfriend. Before they officially went out with each other, Emin had deemed it necessary to present Freedman with a contract detailing the terms and conditions of their relationship; they would become partners for several years. I found her with her arms firmly crossed, puffing away on a cigarette. Meanwhile Lucas was suffering from too much excess. Wearing a checked shirt with her long hair split by a centre parting, she reminded me of Warhol superstar Joe Dallesandro. We sat around drinking tea, mulling over what we might do with our lives. Emin wanted to pack it all in and hang out at Heathrow Airport where she might eventually encounter the 'International Man'. Meanwhile Sarah was thinking of moving to Oxford, partly because it was the location for the *Inspector Morse* series, which she loved, partly because she had come under the impression that the accumulation of intelligence in one place might rub off on her. In passing she added that she worried that she'd probably not see anyone again, not even me. I'm grateful to say that that wasn't the case, and we went on to become great friends.

CLOSING DOWN: RECESSION

Artists with a keen eye for the everyday, such as Lucas, would not have been oblivious to the number of retail outlets being forced to close down during this period. Oxford Street was particularly badly hit, with shopfronts boarded up in preparation for the economic storm. Once-respectable high street stores now provided temporary outlets for wide-boys selling dodgy stock in auction-like scams that enraptured small crowds of bargain hunters who were eventually fleeced. Michael Landy was sufficiently inspired by the downturn in the fortunes both of his own gallery and the surrounding neighbourhood to stage the exhibition 'Closing Down Sale' at Karsten Schubert Ltd in 1992. By way of mimicking the fate of the shops on nearby Oxford Street, just a short walk away, and drawing attention to the shared aesthetic evident in the way they advertised their remaining days, he presented an installation consisting of shopping trolleys piled high with marked-down goods and day-glo signs reading 'Recession Sale', 'Out of Business' and 'Gone into Receivership'.

Gillian Wearing also captured the mood of the day with a series of photographs entitled *Signs that Say What You Want Them to Say and Not Signs that Say What Someone Else Wants You to Say* (1992–3), a project that involved asking people in the street to write down anything they wanted on a sheet of paper. 'A lot of people told me to fuck off, especially in South London,' she once told me in a piece I was writing for *Dazed & Confused* magazine. It was immediately clear that Wearing was a considerate artist whose deep fascination for the workings of everyday people extended to her watching an inordinate amount of reality TV shows. Born in Birmingham in 1963, she had a slight Brummie accent even though she'd lived in London for many years; her long black hair was cut into a fringe that stopped above her eyebrows.

'At first I felt like a bit of an idiot approaching people with my clipboard and camera, but when people actually stopped and listened, they took it quite seriously.' The resulting photographs show her subjects holding up their handwritten message. At the time, she was surprised at how forthcoming

people would be, and at the confessional nature of their response: something that seemed out of keeping with the perception of the British public as somewhat reserved.

One particular photograph in Wearing's series would stand out, if only because it somehow summed up the times. It shows a young businessman, wearing a suit and tie, holding up a sheet of paper that reads 'I'm desperate'. I asked how this particular moment came about. 'People are still surprised that someone in a suit could actually admit to such a thing, especially in the early Nineties, just after the crash. I literally had to chase him down the street. He only had time for one photograph and what he scrawled down was really spontaneous. I think he was actually shocked by what he had written, which suggests it must have been true. Then he got a bit angry, handed back the piece of paper, and stormed off.' The sentiment expressed in this particular image, of a man desperate to retain his job and make a living, recalls the hard times that people were going through.

The early Nineties were a period of widespread despondency. The entire nation was desperate and for once in my life it wasn't just me who was broke. While politicians would take each other to task over the debatable use of the term recession, there were times when it felt like an out-and-out depression. Everything was closing down and London was, by now, completely dead. Unlike anything I'd seen before, there was no rush hour. Even so, while London's economy bumped along the bottom during the first quarter of the decade, the fortunes of young artists were undoubtedly on the rise.

White Cube

A FULL-PAGE ad in the summer issue of *Frieze* magazine showed a naked child standing in an immaculate white space designed by minimalist architect Claudio Silvestrin. The heading declared that this was 'A Temporary Project Room for Contemporary Art', while the small print indicated that it was 'coordinated by Jay Jopling and Julia Royse'. Exhibiting artists were to be invited to show an important artwork or a coherent body of work in a room no bigger than a domestic interior. No artist would be invited to show more than twice. White Cube opened in May 1993 and would subsequently change the course of young British art forever.

Turning the corner off Piccadilly and walking down towards White Cube, it was possible from afar to see the small huddle that had gathered outside 44 Duke Street, St James's. Like other well-heeled galleries, White Cube was located in an area more commonly associated with antique picture dealing. Lining the road were boutique-styled art galleries with old masters propped up on mini easels; next to the entrance of White Cube hung a sign for a neighbouring business selling 'Rare Coins and Medals'. It all seemed at odds with the image of struggling Goldsmiths artists putting on group shows in derelict East End buildings.

Having arrived early, a small crowd was hanging around the doorway clutching bottles of Beck's beer. After a moment of shaking hands and checking out who might be lurking in the doorways on the opposite side of the road, it was time to join the inevitable jam on the small flight of stairs

leading up to the gallery. Once inside, the space – which was incredibly small by today's standards – was invariably busy, making it one of the few London galleries whose popularity assured that no one could actually see the art.

The first to show at White Cube was young Israeli artist Itai Doron. His work centred on a mythical alter ego Mr D who could be identified as the young boy superimposed in a series of airbrushed photomontages next to a host of cinematic idols including Sean Connery as James Bond and Jane Fonda as Barbarella. In addition to Doron's West End show, entitled 'The Secret Life and Archaic Times of Mr D', Jopling staged a much grander exhibition, 'The Immaculate Stereoscopic Conception of Mr D', in the Passmore Building; a massive East End warehouse where visitors were greeted by a cosmic soundtrack and video displays based on cheesy B movies of people fleeing tidal waves. The exhibition also included mutant plastic trees and a giant painting of a UFO, adding to the theatrical aura of a fantasy world populated by superheroes whose job it was to save the world from imminent catastrophe.

With Jopling's backing, Doron's star was set to shine very brightly. He was heavily promoted throughout the year, but it wouldn't take long before his electrifying career would short circuit. His name would eventually fall from the list of White Cube artists – which initially consisted, apart from Doron, of Damien Hirst, Marcus Taylor, Gavin Turk and Marc Quinn.

Jopling's new gallery would eventually herald a shift from the inspired mayhem of his former East End outings and the collector no-go zone of his Brixton home to a more grounded operation in the heart of the establishment. St James's suited the young bespoke Jopling. With the Royal Academy at one end and Christie's at the other, Duke Street had found its Young Turk.

Entered via a turning at the top of the stairs on the first floor, the gallery at White Cube was a tidy space with polished parquet flooring and immaculate walls. The two oblong floor-to-ceiling windows were covered with white blinds that glowed from the light of the outside world. At a crowded opening, it was impossible to escape bumping into people and stopping to

say hello. Jopling invariably stood tall among the crowd, adjusting his glasses as he pointed out to a prospective client something previously unseen.

Just across the staircase was the main office where Julia Royse worked behind a thick plane of dividing wood that allowed a certain amount of privacy from the visiting public. With my hands clasped round the top of the divide, I sometimes endeavoured to strike up conversation with the gallery girls; in due course I got to know the thoroughly adorable Honey Luard and Daniela Gareh, both of whom continue to work at White Cube to this day, and Annushka Shani.

The Duke Street openings were like being in a washing machine. You went in and spun around upstairs before exiting onto the street, which was itself busy by the end of the opening. A period of standing around outside was followed by a trip to the Chequers Tavern across the road with its dark wooden interior where, as I recall, the framed photographs of Thatcher that remained long after her reign were enough to leave you feeling queasy.

And then came that point in the evening when there was talk of a White Cube dinner. This would leave everyone wondering exactly who was invited, or, seeing as certain individuals were on the edge of inebriation, whether they could gatecrash. Unless you were invited, the details remained a tightly guarded secret – and if you didn't know where the dinner was, then you weren't invited, which meant you were of little consequence. You were on the outside while others, more important than you, were on the inside. My paranoia increased as I got used to hearing people mutter under their breath 'Let's go,' before abruptly slipping off into the twilight, leaving me stranded at the bar, alone.

White Cube would become *the* defining gallery of the Nineties. While its reputation advances into this century, no other gallery could remotely claim to have the same connections with the key figures in the history of recent British art. Over the next decade, White Cube would find itself at the epicentre of YBA.

In all, seventy-five exhibitions were held at the White Cube gallery in Duke Street before the keys were finally surrendered in September 2002. Artists

who exhibited there include Jake and Dinos Chapman, Tracey Emin, Marcus Harvey, Damien Hirst, Gary Hume, Gavin Turk, Sam Taylor-Wood, Marc Quinn and Cerith Wyn Evans. The work of artists from the older generation, such as Anthony Gormley, Mona Hatoum and Lucian Freud, was also included in the programme, as was that of artists who later joined other galleries, such as Angus Fairhurst and Sarah Lucas. Its international outreach was unparalleled. Throughout the Nineties, White Cube introduced the work of Nobuyoshi Araki, Gary Hill, Karen Kilimnik, Thomas Ruff, Doris Salcedo, Richard Prince, Hiroshi Sugimoto, Luc Tuymans, Jeff Wall and Terry Winters. The list goes on.

While certain artists chose to exhibit discrete standalone works, others opted to engage with the space more directly. In 1997, Glen Seator created an exact replica of the main gallery entrance – down to every detail, including the doorway, the façade and the exterior signage. As you entered the upstairs gallery you found yourself dramatically confronted with the same street entrance as downstairs. In 1996, Cerith Wyn Evans presented a large con-cave mirror whose reflection distorted the appearance of the room along with that of everyone who took a peek inside. In 1995, Mona Hatoum constructed her sculpture *Socle du Monde*. At first sight, this large brown box in the middle of the gallery looked as though it was covered in fur. The cube's surface was rippled with strange intestinal patterns that appeared to be made of fur. Up close, these worm-like designs had in fact been produced by millions of iron filings that were following the field produced by magnets hidden inside the plinth. If touched, it appeared as though these bristling iron filings might immediately disintegrate and what was once a solid object would fall flat on the floor.

The opening of White Cube was an essential staging post in the con-solidation of YBA. From the word go, it was bold, brazen and sexy. The shows – featuring artists who had rarely been seen before – were new and exciting, while the gallery's image was confident and exuded a youthful energy. Even the press releases came with a small colour photograph that made them look

snazzy. The gallery had its detractors, naturally, but it was also targeted by a number of young artists who saw it as a beacon of light and something to aim at. Jopling was giving the old guard a run for its money and in so doing he was upping the ante. Like it or not, everyone went to White Cube. It was a hip London phenomenon that refused to be ignored.

Lucky Kunst: Writer and curator

'WHAT ABOUT "LUCKY KUNST"?' said Gary Hume. Jane Wilson paused for thought as her twin sister Louise burst out laughing. Both had identical long dark hair, long leather coats and very strong Newcastle accents. Sam Taylor-Wood loved the title, as did Don Brown and James White, the other artists in the show. So did I. 'Lucky Kunst' was to be the title of the first exhibition I ever worked on. Now all we needed was a space, a mailing list, stamps, invite cards and beer sponsorship. Our initial meeting took place at Hume's studio, a freezing cold shed that once stood in the north-west corner of Hoxton Square.

The first time I'd been to Hume's studio was after a surprise call from the artist inviting me over. Before I went round, I told Carl Freedman, and he humorously pointed out that I must truly have arrived on the scene in order for such an invitation to be extended.

When I arrived at the graffiti-covered gates of Hume's studio, I was incredibly respectful and a little nervous. I pressed a buzzer and waited for Hume to come and fetch me. 'Hi-ya!' he said, peering through a gap as he unlocked the smaller tradesmen's door within a larger steel entrance. I ducked through into a derelict yard, directly behind what had once been a Victorian power station, before entering a large brick shed. As always, Hume was covered in paint, his jeans caked with various shades of emulsion. He had a broad, friendly grin and always insisted on greeting visitors with a brief kiss on the lips. Hume's studio contained a bath, as used in his video entitled

Me As King Cnute (1992), a king-size sofa, paint-splattered furniture, a stepladder leant against a painting that resembled someone peering out from behind a curtain, and a plastic children's slide. There was also a small kitchen in the corner where Hume filled a kettle. A four-panel door painting leant against the wall, which had been corrupted from left to right with an undulating band of pink paint. There were five new works in the space, including Hume's interpretation of the classical Madonna and Child and two of his *Lung/Leaf* paintings. There was also a yellow figurative painting, one of a series called *Egoist*, that derived from Mussolini's state-approved statues in Rome. As I looked more closely I noticed the smile had been taken from a magazine and stuck on. There was also another *Egoist* painting sculpted from black gloss paint with raised outlines of exotic flowers. This work in particular was extraordinarily beautiful.

Since graduating from Goldsmiths, Hume had made his reputation with his so-called door paintings, made from household gloss paint. However, in typical Hume fashion, he tired of making door paintings after five years. Since 1988, he had produced nothing but; while they were selling, this nonetheless left him feeling empty, as if he was some kind of reluctant formalist pre-ordained to produce the same works over and over. New work started to appear in the studio at about the time I arrived. Many of the paintings were no longer abstract but figurative. Compared to the door paintings, they looked awkward and strange. Jazzier and more freestyle, the new paintings had lost all their rigidity and conceptual cool. His latest sculptures were even more perplexing. There were balls in bin bags suspended from the ceiling, chicken-wire figures and handmade paper tubes raining down from an assortment of plastic buckets.

None of this was to Karsten Schubert's liking and he told Gary as much. Hume presented Schubert with an ultimatum: either the dealer would commit to showing these new works or Hume would go elsewhere. Hume left Karsten Schubert Ltd in 1993. The great white hope of geometric abstraction, Hume had deposed himself; some might have said it was a

reckless move, but others – such as myself – celebrated his artistic integrity. Hume was left with only one gallery, Matthew Marks in New York. He had done well to secure a New York gallery, but his work wasn't selling much in America and he desperately needed representation in London. After much song and dance, Hume would finally have his first solo show in 1995 at White Cube, his new London gallery. During his time in the wilderness, Hume had little or no money and a son to support. When I went to visit him that day in his studio, Hume was in the middle of a truly unnerving episode in his career.

In 1993, as autumn blended into winter and the trees in Hoxton Square were stripped bare, I often stayed up late with Hume and his neighbour, artist Don Brown – a deeply considered young man with a dark wedge of long hair. We became good friends and would often discuss Hume's work as he painted, encouraging him to make unapologetically beautiful paintings rather than doing something to make them look ugly just for the hell of it. Arguments about beauty versus ugliness raged through the night. During the day, the studio was flooded with light from the overhead windows. Hume's large multicoloured paintings on aluminium panels lined the interior, each painting propped up on tins of paint. The lifts and dips in daylight as clouds passed overhead were picked up by the reflective surface of his paintings and the entire interior of his studio seemed to pulsate with colour. There was something truly magical about Hume's studio, a grey rust bucket surrounded by council estates and a depot piled high with old bank safes. The winter brought freezing cold temperatures – it was warmer outside than in – and it was here that we met to discuss our upcoming show. In the run-up to 'Lucky Kunst' we would consume vast amounts of vodka, primarily to keep warm.

Sam Taylor-Wood called me the following day from Soho. Both she and James White were in the West End looking for an empty space that we could use as a venue for the show. Property developers and estate agents were suddenly understanding of artists' needs, knowing full well that the number of people passing through an exhibition might lead them to find a new client.

Moreover, artists would often make improvements to the properties they occupied, painting the walls and cleaning the place up. (They also drove nails willy-nilly into walls and cracked the plaster, as we did, but this was a small price to pay.) I was at home when the phone rang. 'We just saw a shop in Silver Place, that little alley off Lexington Street,' said Taylor-Wood, as she slipped another ten pence piece into the coin box.

Our exhibition had been planned as a two-way exchange with a group of artists in New York, an idea originally hatched by Sam. Later, we'd be flying to New York with the support of the British Council to stage an exhibition in an artists' studio block near Times Square. But to keep our part of the bargain, the first half of the show, featuring all the London artists, had to open in two weeks' time. The pressure was on. I knew the alley Sam was referring to. It was just round the corner from a wall on which was pasted what I had always thought was one of the last surviving Sex Pistols posters, until someone pointed out that it was a fake used as a publicity still for the film *Sid and Nancy*. We liked the location and the space. Formerly a florist's, this elderly little shop had a dank basement and a rather quaint ground floor with slatted wooden walls. It was a wreck, but we felt it was perfect for a group show that would feature works by Brown, Hume, Taylor-Wood, White and the Wilson twins.

The next day, I went to see the estate agents, who asked me to sign a contract before handing over the key. Ben Craze at Pale Green Press, a printer in the East End, printed our invite cards for free, thus eliminating a major cost burden. We pulled in every favour we could. One night Sadie Coles, then a young director with the Anthony d'Offay gallery, brought us some takeaway pizza just to keep us going. We tried to get free beer sponsorship, but were offered Beck's at a knock-down price. Finally, we discovered we could get it cheaper though Vic Naylor's, the bar in St John Street, Farringdon where Taylor-Wood worked. We decided against painting the walls and making the space look neat and tidy. Instead, we wanted to retain the grunge aesthetic of the original interior. We didn't have any money

and kept the receipts of our shared expenditure on slips of paper. In addition to beer for the opening, our outgoings included money to recharge the electricity key and the stamps we'd have to buy for the mailings. Then there was the cost of calls from the coin-operated phone box round the corner.

Looking back at the original budget, it seems funny to see how we kept tabs: 'Sam owes Gary £8.40'. We spent hours sitting on splintered floor-boards drinking tea from Styrofoam cups and smoking all of Don's tobacco while trying to work out what course the art world would take over the next few years. One afternoon, Gary got up and nailed a potato to the wall, asking 'What do you think about that?' After much consideration, we decided against the inclusion of this particular work. There was the usual round of late night phone calls, the usual bickering over details – this person thinks we should paint the walls white, this person doesn't. These things always happen but, disputes aside, we were getting there. The private view invitations – big, pink cards with 'Lucky Kunst' in bold lettering – went out at the last minute. Until then I'd been working so closely with the artists that it hadn't occurred to me I wasn't going to be in the show. I found myself sitting in the space for hours, and it wasn't long before someone described the process as having something to do with being a curator. The term continues to perplex me to this day; at first I would brush it aside, finding it embarrassing, although that would soon change.

Hume's painting arrived just before the opening and blew us away. A noticeable departure from his door painting series, his latest work was extremely well received. *Tony Blackburn*, a large glossy painting, resembled a black four-leaf clover with a pink and yellow background. Taylor-Wood exhibited a wonderful film entitled *16mm* that showed a girl dancing in the dark to the sound of machine-gun fire, while Jane and Louise Wilson presented large-scale photographs of seedy-looking interiors and a video showing them in white outfits engaged in some form of forensic examination of a King's Cross bedsit.

Somehow we'd pulled it off and the show was deemed a success. On the

opening night we all got totally drunk. Over the coming days we received some positive reviews, which helped increase visitor numbers and made the task of putting on the show seem all the more worthwhile. It had been a trawl, but an unforgettable experience, and many of us would remain close friends long after it was all over. Putting on an exhibition with a team of people makes for long-lasting relationships, and it was clear to me that I wanted to do it again. I liked the idea of putting on shows. Even though the period that follows the close of an exhibition is reminiscent of postnatal depression, there really is no better way to get to know an artist than working on a show together. Moreover – possibly as a result of all the adrenalin expended in the run-up to the opening – there is an addictive side to curating. Once a show is over, you want to move on to the next one immediately. And so it was that I entered a new phase of my life: as well as being a writer, I was now a curator.

The second part of 'Lucky Kunst', featuring a group of young artists from New York, opened some weeks later. We seemed to lose Sam shortly after the opening of part one, later finding out that she had split with partner Jake Chapman for artist Henry Bond, a well-known Goldsmiths graduate. In the early days, Bond had formed part of a clique with fellow Goldsmiths artist Liam Gillick; his then partner, Angela Bulloch, had gone out with Damien Hirst before Hirst went out with Maia Norman, Jay Jopling's former partner. Taylor-Wood would eventually split with Henry Bond and marry Jopling, while Liam Gillick went on to marry Sarah Morris, one of the American artists featured in part two of 'Lucky Kunst'. Morris arrived in London with Ricardo de Oliviera and Mariko Mori, who had gone out with David Pugh before she moved to New York.

Another artist whose work was to be exhibited in part two was Rita Ackermann, a mysterious Eastern European woman whom we warmed to immediately. Like us, Rita was totally broke. When compared to us Brits, de Oliviera and Morris seemed incredibly organised and upwardly mobile. As soon as they arrived at the space, the American artists painted everything white.

The second part of the London show went very well indeed. In time-honoured tradition, we left the opening once it was over for the pub around the corner. A few hours later someone had the bright idea to return to the exhibition and polish off the remaining case of beer stashed in the basement. A crowd of us bumbled back through the dark, rain-soaked streets. As Gary reached the front door he inserted the key, only for it to snap. There were all those lovely bottles of beer inside with us stuck outside in the freezing cold. Dave Falconer, a young artist from Newcastle, had a plan. He went round the corner, climbed a wall and somehow managed to break in round the back. He was now inside, but the broken key wouldn't budge.

Jake Chapman opted for drastic action. He smashed one of the glass door panes with his bare fist and lacerated his hand. Blood spurted up the inside wall in a perfect arc, just missing Mariko Mori's painting. At that moment it struck me that the London art world I was now a part of was prone to bouts of complete craziness. Jake seemed to be forever losing blood and we were forever running around town in search of free beer like a bunch of demented monkeys. We were quite unlike any other group of artistic individuals operating anywhere else in the world. Not that we knew any better. We were only kids; we had yet to venture abroad and see ourselves in direct comparison with other art worlds, and we naturally assumed they were all as crazy as ours. By the end of the night, the space was completely trashed, the art on the walls only narrowly surviving the onslaught. I thought to myself, shit, how was I going to explain this to the American artists when they returned the next day?

Thankfully, Sarah Morris had left proceedings quite early and had gone back to my apartment. With one of my flatmates away, I'd offered to put her up; in fact, the whole American team were spread out in digs across London, which represented a huge saving in hotel bills. Sarah hadn't witnessed our antics after the pub had shut. As I emerged from under my duvet, I could hear her coming out of the bathroom, washed and ready to head off to Soho. She would soon encounter the nightmarish remains of the previous night,

which must have resembled a murder scene involving a beer-swilling maniac.

I felt compelled to tell her that there had been a problem with the space and she should prepare herself for a shock when she got there. 'Look, Sarah,' I mumbled from my pillow. 'Please don't . . .' In her broad American accent, Morris cautiously asked 'What?' Good point. What exactly was I trying to say? 'Just don't . . . Please don't be angry with me,' 'Er, OK, Gregor,' she replied, her underlying tone suggesting that I was a very strange boy indeed.

I remained in bed, tossing and turning. I was shot through with images of the night before, not least Jake's bloodstained hand glistening under a street lamp. I had developed a fever, so why had I spent the night in the garden of a Soho church, getting drunk, in the rain, wearing a big Russian hat? I remembered lager bottles everywhere, the smeared droplets of blood and beer-soaked floorboards. Not exactly becoming of a pristine white cube, I pondered. The door snapped shut as Morris went out into the day. I breathed a sigh and proceeded to bury my head in the pillow.

Cologne

BEFORE MAKING THE trip to New York for the American leg of 'Lucky Kunst', I decided to go to the Cologne Art Fair, an international event that brought together the world's most important contemporary galleries under one roof. This would be my first overseas outing with the kids from London. There were two fairs to be held at Cologne that year. First was the Cologne Messe, located in a vast exhibition hall that housed a labyrinth of white booths brimming with contemporary art. Then came the aptly named UnFair. The product of a local initiative, the UnFair was a more affordable alternative to the main fair, serving as a base for young galleries, especially those from abroad that might otherwise find the trip to Cologne too costly.

The main fair was located on the Rhine in a purpose-built complex, while the UnFair was held in the city centre in a disused department store – a relic from the 1970s with chrome furnishings and slatted Perspex lighting. In 1993, 283 galleries descended on Cologne Messe, while the UnFair housed some twenty stands featuring aspiring young galleries such as 303 Gallery from New York and Regan Projects from Los Angeles. There was a buzz in the air that seemed like a calling to the hedonistic tribe of artists that was forming across the sea. The previous year, Damien Hirst's installation *Marianne, Hildegard* (1992), a spot painting flanked by elderly female twins knitting multicoloured balls of wool, had been extremely well received. Word got back to London that the international art crowd were out in force and had been seen kicking up their heels. On hearing this, everyone wanted to go the following year.

An unprecedented number of London galleries attended the 1993 Cologne Art Fair. In the main exhibition hall there were ten galleries in all, including Gimpel Fils, Frith Street, Lisson, Victoria Miro, Anderson O'Day and Anthony Reynolds. Meanwhile, the UnFair hosted four London galleries: Interim Art, White Cube, Cabinet Gallery and Karsten Schubert. Slap-bang in the middle of the main hall was an exhibition titled 'Junge Britische Kunst aus der Sammlung Saatchi, London' (Young British Art from the Saatchi Collection), including works by Damien Hirst, Langlands and Bell, Sarah Lucas, Marc Quinn, Mark Wallinger and Rachel Whiteread. The highlights included Hirst's *The Physical Impossibility of Death in the Mind of Someone Living* – the infamous pickled shark in formaldehyde – and Whiteread's *Ghost*. To crown it all, there was a major Damien Hirst solo exhibition at Jablonka Galerie, a swanky blue-chip commercial gallery in the heart of town. Several of the sculptures exhibited by Hirst featured glass vitrines containing office furniture, whereby the entire vitrine had been sliced in half. The show was entitled 'The Acquired Inability to Escape, Divided. The Acquired Inability to Escape Inverted and Divided. And other Works'. This was a step up in the world for Hirst. It proved to be a great show and further evidence of his rapid development, confirming his status as an international art star.

Back in London, artists were still struggling against the headwind of British conservatism. The British public, along with its museums and institutions, continued to frown upon contemporary art. Even as a child I remember my parents warning me that Andy Warhol was a sick man, so how was anyone expected to make the leap from Turner to Mat Collishaw's *Bullet Hole* or Hirst's shark? In Britain, contemporary art was most likely to be something that came from America. It simply wasn't British. Fox hunting scenes, yes, Constable, of course – but anything after Henry Moore or Lucian Freud was met with widespread derision. The nation just wasn't buying it, in every sense of the word; whereas the assumption might be that powerful institutions, namely the Tate, were busy amassing the work of young British artists, this was simply not true. In every aspect of public and institutional life

there was a sense of resistance from within to the new breed of British art, which was viewed with a great deal of scepticism.

In many respects the public had yet to forgive the Tate's 1972 purchase of Carl Andre's dastardly bricks, *Equivalent VIII* (1966), and they certainly weren't going to approve of a younger generation of British artists getting up to no good. However, in Cologne that year it would become apparent that the new crop was breaking through internationally. While many of the artists who travelled to Cologne were still receiving state benefits, the international art scene was beginning to take note, and there was a growing sense that more seasoned collectors were about to move in.

The work of young British artists suddenly seemed very convincing in Cologne, especially next to the acres of stands promoting tired old sculptures and off-the-boil painting. By comparison, young British art looked fresh and exciting, while the artists themselves exuded a market savvy beyond their years. In retrospect, some may tire of British art from this period, but its originality and the impact it had at the time shouldn't be underestimated. Not since the 1960s, when artists such as Peter Blake and David Hockney last caused a stir, could Britain rightfully claim to be producing artists who might be of interest to the world. The international art market was looking for something new, and young British artists were looking very interesting indeed.

Given that many of the New York galleries were still reeling from the art market collapse of the early Nineties, there was enough respite for the British presence to seem even more profound. Ultimately, this year's fair would prove a litmus test for young British artists. The Saatchi show in particular boasted several iconic works from a canon that had yet to be formally identified. Aside from Hirst's shark and Whiteread's cast interior, the display contained Marc Quinn's infamous *Self*, Mark Wallinger's four-part series of horse paintings, *Race, Class, Sex* (1992), and Sarah Lucas' tabloid photocopies bearing titles such as *Fat Forty and Flabulous* and *Sod You Gits* (both 1990). The Saatchi display would be the first overseas show by this particular group of artists.

COLOGNE

I hitched a ride to Cologne with *Frieze* magazine, the deal being that I'd man the stand at the fair and try and get subscriptions. Having driven all the way from London in a cramped car with magazine editor Matthew Slotover at the wheel, my first impressions of Cologne were of a city that was falling apart. I was surprised to see empty office buildings and litter everywhere. There were tramps on the street and an overall sense of gloom. While I somehow expected this of Britain, or America for that matter, I really hadn't expected it of one of the most industrialised regions in Europe. Even Germany seemed to be in the grip of economic turmoil, I mused, as we headed into the centre of town after the long drive.

The first person I bumped into was Jake Chapman. Together, we witnessed Skip Arnold, an American artist, being unpacked from a crate that had been shipped in from Italy, or so he led us to believe. Having emerged from his box, Arnold delivered a thigh-slapping proclamation that he would continue to live in his crate for the duration of the fair and proceeded to invite everyone to join him for round-the-clock parties.

The fair's official opening party took place at a nightclub called Gloria, which occupied a vast converted theatre with a raked floor. Gloria had the most bizarre drinks policy. Upon entering, everyone was handed a scorecard to be presented upon receipt of a drink. It was a cash-free bar, the idea being that we'd pay at the end of the night, presenting our scorecards to a row of glum young ladies at a supermarket-style checkout. If we lost our card, we'd have to pay a fine of around $150. After much head scratching we hatched a plan whereby a gang of us agreed to chip in so we had enough money to pay the fine. We then proceeded to tab all our drinks to a single card that we planned to lose at the end of the evening. Decision taken, we embarked on notching up as many drinks as possible in the knowledge that we could order whatever we wanted. The atmosphere was exhilarating, everyone dancing to the thumping beats that reverberated through the vast interior. I looked up from my triple vodka and tonic and saw Anthony Reynolds, an otherwise reserved London gallerist, boogieing on the dance floor, something he did every year to mark the occasion.

Utterly inebriated, we staggered out of Gloria's onto the rain-soaked streets. Jake and I thought it would be a great idea to go to the UnFair to take Skip Arnold up on his offer of late night drinks. We arrived at the front door covered in pastry flakes and cream from the collection of cakes we'd stuffed in our mouths after passing a bakery preparing for the day ahead. It was freezing. Pressing our faces against the glass entrance, it became apparent that no one was at the fair – not surprising seeing as it was four in the morning. We banged on the door until two elderly security guards waddled out of the gloom. Neither of us could speak a word of German but somehow we managed to persuade our inquisitors that we were very important art dealers who needed to attend to our stands.

To our amazement, we managed to blag our way in and went to the basement where, in the gloom, we could make out someone huddled in a sleeping bag. Skip Arnold was asleep. By the time we returned upstairs, the security guards were nowhere to be seen and it dawned on us that we had the entire UnFair to ourselves. As I started pouring glasses of Kölsch at the bar, I noticed Jake in the corner of my eye wandering back and forth across the central aisle carrying a selection of paintings. After a while, I realised he was swapping artworks from the Cabinet Gallery with those from Christian Nagel Gallerie. Seeing as members of the Cabinet Gallery had clashed with Cologne gallerist Christian Nagel earlier that evening, this all seemed very unwise indeed. By the time I made it up the central aisle carrying two beers, he'd practically rehung both booths.

Martin McGowen and Andrew Wheatley from the Cabinet Gallery were relatively new to the scene. McGowen was a mysterious-looking man with swept-back hair and a grey streak. Wheatley had a large frame with broad shoulders. He wore a heavy dark coat and had short back and sides. He was good fun to be with and would frequently emit an infectious, booming laugh. The Cabinet Gallery was based in Brixton in a converted first floor flat opposite the Prince Albert pub, an ex-punk haunt where everyone ended up after openings. Two small rooms had been converted into a gallery, while the

makeshift office was lined with shelves filled, not with the usual racks of bureaucratic black binders bearing artists' names, but with art-historical tomes. Cabinet had a unique vision partly informed by Viennese Actionism and West Coast slacker art. They clearly admired transgression and this was born out in the work that they showed by artists such as Pierre Molinier, a Frenchman who infamously wanked over his sister's corpse and designed a shoe with a heel fashioned into a dildo so he could fuck himself up the arse. In the eyes of many young artists in London, Cabinet Gallery had a certain kudos. It was quite singular and unorthodox, not holding back when it came to exhibiting a suitcase bomb by Gregory Green in 1996, much to the consternation of the local constabulary. And so it was that one night in Cologne, Martin and Andrew rubbed up against one of the more serious players of the day.

A rotund gentleman with a constant frown, Christian Nagel remains one of the most important gallerists in Germany. The previous night he had come upon the Cabinet Gallery duo in the Paff bar, the art crowd's regular haunt, and criticised their stand, saying they had let the UnFair down. This was a serious accusation coming from a member of the UnFair committee who could get them kicked out. Without question, Martin and Andrew got the message that it was unlikely they would be invited back next year.

Admittedly, the Cabinet Gallery was pretty leftfield. Their booth had a display of perfectly wretched paintings by Simon Bill on perforated hardboard. By day, the booth seemed to double as a crèche for hung-over British artists who sat on the floor and fell asleep. Wheatley and McGowen launched into a counter-attack, Jake Chapman chipped in, and the evening descended into farce, with everyone stood up shouting at the top of their voice. A bedraggled Nagel, beaten back by a wave of insults and ridicule, finally removed himself from the bar, leaving behind a group of jeering, boozy Brits.

Admittedly, the thought of Nagel coming to UnFair the following morning

to find all the works from the Cabinet Gallery hanging in his booth, and vice versa, seemed quite amusing. However, I was compelled to remind Jake that we could be deported for this, which would be something of a shame given it was only day two. Begrudgingly, Jake returned the paintings. He looked a little dismayed but would occasionally pause, hold up a painting for me to see from the bar and start sniggering, saying how shit it was. For a moment, I considered the possibility that Jake's intervention was one of the more interesting projects taking place in Cologne that year. Beer in hand, we stomped around the building trying to find a place to crash. We both had hotels to go to, but it was very late and we were incapable of walking any great distance. We bumbled about behind one of the trade stands until we found somewhere to lie down. We found some strange raised platforms covered in a layer of nylon carpet. At such an early hour in the morning, they looked very comfortable and inviting. We took a platform each. Jake wrapped himself in bubble wrap and fell into a slumber. I tried to do the same but my puffy face ended up pressed into the coarse grey material. The world went dark as the hours passed in hushed silence.

When I came round, my first thought was that there was a rather loud German gentleman in my bedroom. I had no idea where I was. What was a German doing screaming at me in my bedroom? '*Wacht auf*! *WACHT AUF*!' I pulled my heavy Crombie coat around me and attempted to go back to sleep. Why had I gone to bed wearing a coat? I could hear another voice, lower in register, resembling a groan. Between bouts of shrill German orders, I could sense there was someone out there in the murky wilderness. It was definitely a friend, speaking English, saying something directed at me. Then I realised it was Jake. He sounded really rough, which amused me in a twisted kind of way. I laughed, or rather grunted, only in grunting I realised that I too felt like death. I was convinced I was at home, but this wasn't my bedroom. I could sense sharp morning rays of light. Again, a voice. Jake croaked something. 'Gregor.' This time I caught it. 'Gregor!' his throat crackled. 'Please could you tell this man to stop shouting at me?' I raised an

eyelid. A grey carpet came into view sideways on. I turned my head to see Jake lying somewhere behind me on a raised platform, a red-faced brute of a man volleying abuse into his ear.

It was beginning to dawn on me that we were waking up in a shop window right in the city centre. What we had both assumed to be a safe place to sleep in the middle of the night turned out to be the front of the former department store. Sitting directly in front of us at a bus shelter, two old ladies and a man carrying a suitcase looked on. From their perspective it must have looked particularly strange; watching us coming round with an elderly security guard screaming at us to move on. I wondered if they could hear him bellowing through the glass. Scrunched up in our coats, we had been on public display in a shop window since early morning. We eventually lifted ourselves off the scratchy carpeting of the wooden platforms, brushed our coats down and made our way outside, our vaporous boozy breath condensed in the sharp morning air. We roamed through the empty streets, cars streaming past in the rush hour, before finally arriving at our hotel. Having missed breakfast, I headed straight to my room and changed my clothes for the day ahead. For me, waking up in a shop window in Cologne would mark the start of the wild years. All that I had experienced before was nothing compared to what lay ahead.

Gavin Turk also slept rough that night, in a quiet German park. Represented by Jay Jopling, Turk was obsessed with the idea of artistic personae and artists such as Piero Manzoni who, in the 1950s, declared that everything he signed could be a work of art, including people and tins of his own shit. With reference to this, Turk made paintings of his own signature, as well as reproducing the front cover of a copy of the *Sun* newspaper with his face superimposed on that of a soldier wearing a beret; the accompanying headline read 'Support our Boys', a reference to British troops serving in the first Iraq war. In the most recent edition of *Frieze* magazine, Turk was splashed over the front cover with his latest sculpture, which showed the artist posing as Sid Vicious.

Turk arrived in Cologne wearing a tweed suit and fake moustache, and headed straight to the fair. The look was carefully constructed, an attempt to garner the air of a distinguished artist. Throwing himself into the fray, he decided to forgo checking in with the people he was supposed to be staying with that night and ended up drinking in the Paff bar instead. He stayed until closing time before taking a taxi to the wrong address, his fake moustache bristling against a letterbox as he projected his friend's name into the wrong house. One can only wonder what the occupants thought. By now the worse for wear, Gavin was forced to find alternative accommodation, which turned out to be a public garden. The following morning he opened his eyes to see a young boy staring at him through the park railings. As the child's mother called out, Gavin got to his feet and brushed down his suit. He noticed something strange, like a caterpillar, attached to a nearby tree; as he looked closer he realised it was his moustache. Without any recollection of having put it there for safekeeping, he teased it from the tree, patted it back on his upper lip and set off to the fair.

There were a number of crazy scenes in Cologne. One night, Damien Hirst invited some friends back to the Hyatt Hotel overlooking the Rhine where, it had been rumoured, there was a German brass band playing naked in the pool. Meanwhile, a number of London dealers, including Jay Jopling, were staying on the other side of the river at the Staplehausen, a Bavarian-styled guesthouse where I shared a room with two other people. The corridors were lined with ancient wood panelling and creaking floorboards that always caught people out as they bumbled their way back to their room at night. Every morning I and other art world paupers would raid the breakfast buffet, secretly stuffing bread rolls and slices of ham into our coat pockets for the day ahead. At night, we'd bar hop until closing time. On one infamous occasion Gavin Turk hung some photographs in an old watering hole and held an opening on which occasion we literally drank the bar dry.

Most nights, we'd invariably end up at the last venue in town, a sex bar called the Pink Champagne. We would try to blend in without attracting too

much attention, surrounded by hookers and rent boys who would sway nonchalantly to banging techno music and occasionally proposition us. One night, when it became clear that we were simply using the place as an excuse to carry on drinking, the barman walked up to painter Peter Doig and me and started screaming at us to fuck one of the sex workers or fuck off. The fair lasted six days, but by the third or fourth day people were utterly exhausted. Early one afternoon, just after the fair opened its doors to the public, I spied Jay Jopling from afar walking down the central aisle with something slung over his shoulder. This something turned out to be Tracey Emin, who was so hung over she could hardly walk. As they got closer, Emin's arms started to flail and Jay put her down on the floor. On hands and knees, she proceeded to throw up into a corporate water feature directly opposite the *Artforum* stand, where a seated woman looked on in horror.

Cologne was the first art fair I had ever been to. Walking down the endless aisles from booth to booth under glaring halogens, I was struck by the way that art could be sold like cars or watches. In a matter of days, this would all be dismantled and another manifestation of the luxury market would pitch up to foist its goods on the elite. It was a real eye-opener. Having been so attentive of my colleagues' upward spiral, it occurred to me that artists' careers can go down as well as up. The art market can be a heartless environment at the best of times. But what did I care, preferring instead to lose myself in the throng at Damien Hirst's opening at Jablonka Galerie. Cologne saw a lasting camaraderie develop between the younger galleries from Europe and America; many would meet for the first time at the UnFair. Everything was fresh and exciting, and yet to be worked out. I felt I was having my cake and eating it, and it all seemed rather good.

New York: Us and them

IT WAS NOW the winter of 1993 and I felt as though I were on a speeding train. Everything was starting to happen so quickly, with sudden, abrupt moves from one scene to the next. This was something I would get used to in the coming years, but for now I felt I was venturing into a world that was totally new to me. After a perilous journey across the Channel in a fierce storm, we finally arrived at Dover, and then London. We had driven all the way from Cologne, and within a matter of hours I was at Heathrow Airport. Courtesy of a small grant from the British Council, I was en route to the second half of our 'Lucky Kunst' exhibition in New York.

Having waited for an eternity sitting on my bag, I was relieved when I saw my companions struggling through a swing door with their luggage. Gary was carrying a painting on a piece of wood shaped like a three-leaf clover, while Don held a squeaky bubble-wrap cube containing twenty-one framed photographs. Sam, glamorous as ever, showed up with a neat cardboard tube. We checked in, arranged for the baggage handlers to carefully take the art on board, and said our heartfelt goodbyes to Louise Wilson, who was delivering videotapes at the last minute. Sam was stopped at security. Gary went off to the loo. Don went to look at the planes while I headed to the bar where we instinctively all met up. From my notes of the journey, I get the sense that I must have been like an excited child. I also recall not having slept for forty-eight hours.

No hanging around, no unnecessary amounts of mental space consumed by airport design, nothing of the kind. Instead, we finish our drinks at the bar, proceed directly to the plane and squeeze down the aisle past beaming stewards. Within minutes the plane starts to taxi to the runway. The cabin lights dim as the mini television sets on the back of each headrest come to life. First up, a safety film featuring real actors in a dizzying variety of nightmare scenarios. As the engines kick in, we press back into our seats and ascend through the clouds. Sam appears to be visibly nervous. The seat belt light goes out, followed by the no smoking sign, at which point everyone lights up. Gary attempts to comfort Sam with some pleasant conversation but she clearly doesn't take well to flying. I turn to the TV. First up news, nope, sport, nope, comedy, nope, the Lisson Gallery exhibition 'Wonderful Life' . . . what! Oh my God! Suddenly I'm watching my friends on TV talking about a Lisson Gallery group show. Adam Chodzko appears on screen wearing baggy trousers, talking about LSD and the classified ads newspaper *Loot* where he placed a notice for God lookalikes. The response is astonishing. Seeing one of his own paintings on TV, Gary cheers out loud, as does Sam when she sees her self-portrait wearing a T-shirt with the slogan 'Fuck, Suck, Spank, Wank'.

I'm also reminded that in the period before 9/11 it was possible to board a plane to New York minutes before takeoff, in contrast to today's mandatory two-hour check-in and endless queues at security. There was no Heathrow Express that would deliver you from Paddington Station to the airport in fifteen minutes, and so the likes of me had to get the tube, which meant an arduous and unpredictable journey across London. Moreover, until 1995 you could smoke all the way to New York on Virgin Atlantic; it still amazes me to think that you could actually buy cigarettes and a lighter on the plane.

It felt as though we were leaving the old world behind, not least because New York was the undisputed centre of the art world. London simply bore no comparison. Even though things were beginning to pick up back home, nothing could compete with the level of artistic activity to be found on the other side of the Atlantic. Back then there wasn't so much a rivalry between the two cities as a feeling of resignation that New York had it all. American collectors didn't struggle with contemporary art, as they did in Britain; they walked right in and bought it. The city had the best contemporary galleries, such as Mary Boone, Barbara Gladstone, Marion Goodman, Robert Miller and Sperone Westwater; they showed big contemporary names, such as Roni Horn, Ellsworth Kelly, Brice Marden, Richard Serra and Cy Twombly. Even with the excesses of the Eighties art market, followed by the crash in the early Nineties, there were still new galleries and artists coming out of New York all the time.

Having arrived in Manhattan, we basked in the sun on the roof of a studio block on 233 West 42nd Street, just off Times Square. This was where the second half of our show was being held, and within no time at all we seemed perfectly at home. One of the highlights of our trip was our meeting with Jeff Koons, the American artist whose pornographic images of himself fucking his then wife Ilona Staller, 'La Cicciolina', were the talk of the town. He came to our opening and we were amazed to be having a beer with a world-renowned art star.

Koons' full-blown use of kitsch imagery had made a huge impact on the art world. His sculptures of cuddly bears, Michael Jackson with his pet monkey Bubbles and cherubs playing with a pig were sensationally banal but entirely relevant to the consumer age in which we lived. Koons seemed to take over where Warhol had left off. Even the adverts for his shows became artworks, showing Koons surrounded by seals wearing Hawaiian floral garlands. Artists such as Damien Hirst and the Chapmans would have been struck by the way Koons played the market and made his fortune seemingly overnight. He had certainly helped make the late Eighties art world that bit

more bearable, and had become something of an iconic figure for many young artists both in America and Europe. Koons had a luxurious and well-manicured personality. I remember him saying he had little interest in art theory, preferring instead to flick through the pages of glossy magazines. For us, he represented a form of art without hang-ups. He seemed untouched by any of the angst sometimes associated with artists. It was unspeakably nice of him to come to our dinner in a little Chinese restaurant and make a welcome speech. Here was a man who was selling kitsch to the elite and reaping the rewards in spades. We liked Jeff and we very much hoped he liked us.

My first meeting with Clarissa Dalrymple was in New York. Having moved to the city in the 1970s, Dalrymple was extremely well connected within the New York art scene; she had been instrumental in bringing British artists to the city. A year earlier, in 1992, she curated the exhibition 'Twelve British Artists' at the Stein/Gladstone gallery. The show would serve as a launch pad into America for artists such as Anya Gallaccio, Liam Gillick, Damien Hirst, Gary Hume and Marc Quinn; Sarah Lucas, who also featured, went on to be represented by Barbara Gladstone. While the exhibition may have bamboozled New York audiences, who wouldn't have recognised the roster, it was widely considered to be a groundbreaking show for a generation of British artists.

An extraordinary woman, Dalrymple was extremely glamorous and dressed in a chic black dress. She was very dynamic, and had a genuine interest in history, politics and art that enabled her to hold court brilliantly on most topics. It was easy to see how she had won the hearts and minds of so many young artists whose work lined the walls of her SoHo loft.

One evening, Clarissa invited Gary Hume and me to a restaurant on Houston Street to meet a rising star in the New York art scene. While we waited at the bar, she waved across a sea of diners to a young man. As soon as he got up to leave his table to come and join us, we could hear people nearby turning to one another and whispering, 'That's him. That's Matthew Barney.' Barney sported bright red hair and wore a tight white T-shirt. He was

incredibly well toned and healthy in appearance. In short, he looked nothing like London artists, who were pale and scrawny by comparison.

Dalrymple held a drinks party for us in her loft, inviting a host of New York artists and art world dignitaries such as art critic Roberta Smith, artist Ashley Bickerton and Michael Craig-Martin's daughter Jessica, herself an artist. During the day, we whiled away the hours drinking in downtown bars and hanging out with the other artists in our exchange show, such as Sarah Morris and Rita Ackermann, as well as getting to know rising stars like Rirkrit Tiravanija. We met the painter Elizabeth Peyton, who had a show of her drawings in Room 828 of the Chelsea Hotel. The New York artists seemed so much more sophisticated than us and much smarter at managing their careers. Coming from London, where the contemporary art market was still practically nonexistent, I could never quite grasp why so many of the younger New York artists worked for more established practitioners. Even though it made a certain amount of sense for a young artist to get a job at, say, Jeff Koons' studio, I found it difficult not to view such arrangements with suspicion. To me, it seemed undesirable that younger artists were beholden to more established artists. On reflection, what I was also struggling to comprehend was how New York artists might become so successful that they could run their studios like proper businesses, employing teams of young people. There was another difference. The younger New York artists didn't seem to share an intense, tight-knit scene like the one that had recently sprung up in London. New York struck me as a place where you could buy all your materials on the block, but not see anyone for days. To be a young artist in New York seemed a lonely existence.

Meanwhile, we were getting to know Manhattan and having as much fun as possible. On our daily outings, Sam Taylor-Wood would tremble with delight at the sight of the men of the New York Fire Department, while Don Brown occasionally asked us to pause and observe the beauty of light passing across the face of the World Trade Center towers. After several days, Gary Hume finally decided to hook up with his New York dealer and long-

term supporter Matthew Marks, who had once worked for Anthony d'Offay before setting up his own gallery on Madison Avenue.

Gary and I arrived at Matthew Marks' uptown space. Delighted to see Hume, while at the same time being caught off guard, the gallery receptionist ushered us into a backroom where we sat on two soft leather armchairs facing a beautiful De Kooning painting. It was the first time I'd ever experienced the steely climes of a private viewing room. These backrooms are like small galleries where potential clients are entertained in absolute privacy and a range of works can be brought from storage without causing disruption in the main exhibition space. The sales room represents the gallery's inner sanctum and will only be seen by pampered clients. As I looked across the room at Gary flopped into his seat, I couldn't help but notice a big fat cigar resting in the upright ashtray that stood between us; a rich collector had just passed through. It occurred to me that the De Kooning must have been worth a mint. It can be bewildering when a work of art is worth more than the walls on which it is hung.

Hume knew New York well from his extended visits. Matthew Marks had worked out that it was cheaper to ship the artist than transport the finished paintings from London, and Gary spent periods working in a studio in the meat district. On his first six-month residency, Hume brought Sarah Lucas, his girlfriend at the time. Since then he'd been back and forth often enough to become attuned to the city's lifestyle.

A year later, in 1994, I flew out to New York to attend the opening of Gary's solo show at Matthew Marks, a stunning exhibition that came to represent the complete affirmation of his new style of painting. After the opening, we returned to see the show in the clear light of day. One of the staff called out to us as we were leaving to inform us that Hume had been included in a group show at the Walker Art Center, Minneapolis, called 'Brilliant!'. Gary and I laughed out loud when we first heard the title, thinking how odd to name a show after such a quintessentially British expression. 'Brilliant! New Art From London', to give the exhibition its full title, would eventually open in October

1995 and tour to the Contemporary Arts Museum, Houston, in February 1996. What was unusual about the show is that all twenty-two artists – including not just Gary but Henry Bond, the Chapmans, Adam Chodzko, Glenn Brown, Tracey Emin, Anya Gallaccio, Liam Gillick, Chris Ofili, Steven Pippin, Alessandro Raho and Gillian Wearing – lived and worked in London. It was amazing to see such a transformation in Hume's fortunes. People would even mutter to each other that they now preferred his new pictorial works to the door paintings.

Meanwhile, Gary was being put up in a SoHo loft. As a gift from faraway Britain, I passed him an album called *Definitely Maybe* by Oasis, a relatively unknown band who had gone straight to number one in the UK charts. We sat outside on the fire escape, high up on the top floor, as 'Cigarettes and Alcohol' drifted over a sun-drenched Greene Street.

It was always a little depressing to return to London after New York; the streets were empty, the bars closed early and there simply wasn't the same energy. However, on closer inspection I began to notice a shift in how younger artists were faring on both sides of the Atlantic. New York was still living under the spell of Warhol and the legacy of Pop, which had passed through town with much fanfare. Party now over, there was a sense of weariness with the new. Exacerbated by the crash, most galleries found themselves facing an uphill struggle and were less inclined to take risks. As existing galleries became more concerned with their income, many of the younger generation were locked out. Not only were they struggling to gain recognition, they were also struggling to pay the rent.

Meanwhile, artists in Britain didn't have to worry too much about the basics – they could always claim unemployment benefit. The dole allowed artists to survive without facing eviction, whereas New York presented a far tougher environment for anyone outside of regular employment. You either made it in the world, or you worked for an artist who had. Failing that, you simply moved out of the city and returned home. And unlike London, New York had no centre. There was no core group of young artists as there was in

London, no single bar or restaurant that might be claimed as their own. Already working in isolation, there were few galleries around to promote them, although this would eventually change with the rise of gallerists such as Gavin Brown, Andrea Rosen and David Zwirner. In New York there simply wasn't a support structure like London's vibrant social scene, where artists went to the same places, quickly became acquainted, shared experiences and lent each other cash to get by.

Uptown: The evening before the morning after

BACK IN LONDON, I was earning small amounts here and there writing essays, reviews and articles, although the money still only came in dribs and drabs and I was constantly on the phone trying to chase payment. That there were more young artists to write about and more shows to review reflected either my writing or, more likely, the fact that young artists were doing well, especially those who were showing abroad with accompanying catalogues dedicated to their work. At the time, I was living in a rented room in Elgin Crescent, Notting Hill, sharing with two other flatmates. The flat was tiny, but we could boast a view over Arundel Gardens, a beautiful communal garden with leafy lawns and cherry blossoms.

Writing on an old computer at a cramped desk in my bedroom, I would occasionally get a call from a curator passing through town who wanted to talk about the London scene. At first I couldn't believe that anyone would be interested, but by the mid-Nineties I was beginning to sense that I might be in the right place at the right time. For me at least, the balance was starting to shift. I was starting to enjoy being in London more than New York, which I had grown up to believe was the epicentre of the universe. There was something far more engaging about the emerging scene in London; it was more hands on.

During the winter of 1993, there was never a dull moment. After my transatlantic travels, I would throw my bag down, pick up the phone, find out where everyone was and be with them in an instant. As the cheques came in, everyone started to hit the town. Artists were no longer to be found in the barren waste of Docklands or the backwaters of Bermondsey. They were

heading to the bright lights of Soho and the exclusive drinking haunts that had hitherto been reserved for the rich and/or famous.

Entering the Groucho Club in the early Nineties was like diving into a smoky pool of riotous conversation. It felt especially exhilarating if, like me, you happened to be a non-member who had somehow managed to sneak past reception. As you pushed through the squeaky double doors, a distant piano played luscious cocktail music over a packed room with the odd celebrity scattered about the place. Back then the Groucho Club was a comparatively small ground floor room, a far cry from its present manifestation across several floors. The interior was plush and reserved, like a hotel lobby with a long mirrored bar. Slumped in sumptuous leather sofas, an assortment of advertising executives, television producers, journalists and well-known actors in close communion with their agents, who, in turn, consulted plump Filofaxes.

Traditionally the stomping ground of Soho's media elite, such plush environs were rarely known to be inhabited by young artists. Everyone at the Groucho spoke another language. It was more commonplace to overhear talk of commercials, pop promos, television shows or a possible film in the offing. The Groucho seemed to revel in its exclusivity. Its members were well heeled, with homes in West London and country estates dotted round England.

For a good few years, everyone made it their mission to end the night in the Groucho Club. Once you'd overcome the obstacle of the front door, simply being inside was cause for celebration as copious amounts of alcohol started to flow and bright shining tumblers filled to the brim were ferried across the room on black trays. As the Nineties got into gear, the Groucho came to represent a great confluence of personalities and ideas. There was an extraordinary sense of exchange across the worlds of art and pop, film and fashion. For a brief moment, it was as though every-one wanted the same thing. They wanted to be up and they wanted London to swing again. Having made the Groucho theirs, Damien Hirst and Jay Jopling were adept at working the room. They were in their element. One night, I happened to sit down next to Jay before noticing he was sitting with the band Blur, who looked kind of skinny and cool. The Groucho would become synonymous with

Britpop as the worlds of pop and art collided over a round of drinks. The combined energy of all this creative talent meeting in the same place at the same time would spur everyone on to ever greater heights of hedonistic excess.

One balmy summer's evening, Cerith Wyn Evans arrived at my flat in Notting Hill immaculately dressed in a button-down shirt and vigorously pressed drainpipe trousers. Wyn Evans had made his reputation in the Eighties producing a series of experimental films in collaboration with the likes of Derek Jarman, Michael Clark and Leigh Bowery, working with bands such as The Fall, The Smiths and Throbbing Gristle. Born in 1958, Cerith was an older artist who won over the London art world with his highly intelligent work and piercing wit. A tall skinny Welshman whose hairstyle rarely left 1930s Berlin, his sinuous physique was perhaps best expressed on the dance floor, his inspired gyrations a mixture of Voguing, punk and classical ballet. Throughout the Nineties, he developed a line in conceptual sculpture that included intricate neon works, firework sculptures and dazzling mirror-ball installations. Held in 1996, his first solo show at White Cube – aptly entitled 'Inverse, Reverse, Perverse', like the man himself – firmly planted him among a younger generation of artists who welcomed him with open arms.

Cerith was desperate to go out clubbing, declining an offer of tea for the dregs of a bottle of red wine as he made himself up from the contents of my stationery box, including black marker on his eyebrows, red felt tip for rouge and a quiff whipped up with a can of spray mount. We made our way to Madame JoJo's, the infamous Soho cabaret bar. Inside, we were greeted by a sea of flashing lights and people freaking out to 'Warm Leatherette' by The Normal. Across the dance floor I could see DJ Martin Green wearing an impeccable late Sixties three-piece suit topped with a trilby hat working his way through a selection of gospel, easy listening, electroclash, grunge and pop. Among a smattering of transsexuals, the men sported denims and scraggy Britpop hairstyles, while the girls wore T-shirts and leather jackets with upright lapels.

There was much excitement in the air as the lights suddenly descended on an enormous Leigh Bowery, who stood motionless on stage. 'Boot licking,

piss drinking, finger frigging, tit tweaking, love biting, arse licking, shit stabbing, mother fucking, spunk loving, ball busting, cock sucking, fist fucking, lip smacking, thirst quenching, cool living, ever giving, useless man,' Bowery breathed heavily into the mike, his voice snarling 'Useless man!' He repeated the words more emphatically: 'USELESS MAN!' And then screamed at the top of his voice, 'UUSSEELLEESSSS MMAANN!!!'

One, two, three, four! In crashed Trevor Sharpe, the drummer, Mathew Glamorre on keyboards and Richard Tory on electric guitar. There was a Japanese man tweaking a sampler and someone called Danielle on bass. This was the band Minty and they rocked. Near the end of their opening number, a rip-roaring heavy techno take on the old Pepsi commercial, Leigh went into palpitations. Having hauled himself onto a table, he lay on his back wailing and kicking his heels in the air. Suddenly, the fabric at his crotch burst open and out crawled a petite woman smeared in red paint. Oh my God, it's a baby! All that time Leigh had been carrying Nicola Bateman (later to be Nicola Bowery) upside down in a faux foetal position strapped beneath his elaborate costume. As she crawled out into the world, staring out over people's heads, members of the audience could hardly believe what they were seeing.

Smashing ran from 1991 to 1996 and in its heyday would become the ultimate Britpop club. By the time it relocated to the Eve Club, on Regent Street, with its mesmerising John Travolta dance floor, it became the place to be. Anything and everything seemed to happen at Smashing. I once saw a hipster named Barnzley swinging a woman around by her hair – literally wheeling her around off the floor – to Beck's 'I'm a Loser'. For a while, I went every week, if only to observe people's looks, which were unique to London. For a brief moment, Smashing captured the essence of Britpop; everyone was jumping around to the latest releases by Blur, Denim, Elastica, Pulp, Menswear and Supergrass. Many of the band members themselves were there, sitting in the corner looking dead cool in thin ties. When 'Animal Nitrate' by Suede came on, the crowd went berserk.

Alex James, Blur's wedge-haired bassist, could always be found in the

Groucho sipping on something; he was eventually caricatured in the media as the Champagne Charlie of his day. It was quite the done thing at the Groucho to become completely intoxicated on a nightly basis, very rock and roll for what was supposed to be a sedate members' club. To order a drink you needed to be a member and membership was unaffordable for the likes of me. One night, I piled into the Groucho with a crowd of artists; when asked the member's name for the bar bill we took turns pretending to be Jay Jopling. As the waiters sauntered from table to table taking orders, it went something like this. 'Yes, I'd like two double Stolichnaya vodka and tonics. Many thanks.' 'And the member's name?' 'Erm, Jopling, Jay Jopling.' There must have been about ten of us pretending to be Jopling that night. It was testimony to Jay's generosity that he actually picked up the tab.

On any given night, Groucho notables included gallerist Sadie Coles, who was still working at the Anthony d'Offay Gallery, Cerith Wyn Evans, Abigail Lane, Angus Fairhurst and the young artist and writer Pauline Daly. Grinning from ear to ear in her ripped jeans and a V-neck jumper with gaping holes under the armpits, Sarah Lucas always hailed me as 'Mr Muir!' Other regulars included Jake Chapman, Mat Collishaw, Gavin Turk, Sam Taylor-Wood, Gary Hume and filmmaker John Maybury. Damien Hirst would relay an endless stream of crude jokes; he especially enjoyed telling one in particular, picked up from Leigh Bowery. 'A man wakes up one morning, has a coffee, puts on his suit and tie and leaves for work. Just as he's about to put his keys in the car, he turns back to look at his house, only it's covered in shit, piss, blood, spunk, pus, bile, puke and gob, and he slaps himself on the forehead and cries out "Why, oh why, do I do this?".'

As time passed, Hirst grew more distant from his contemporaries. While he always had time for Fairhurst, Lane, Lucas and Collishaw, he remained belligerent towards those who tried to corner him into a more earnest conversation about art. The more worthy they were, the more likely they were to get it in the neck. Hirst looked to people from outside the art world, such as Keith Allen, a comedian and former punk rocker with a reputation

for being something of a troublemaker. In the Eighties, he had gone to prison for smashing up the Zanzibar club, a forerunner to the Groucho. He was older than Hirst, with dark receding hair and a wild glint in his eye. Piratical, anarchic and truculent, Allen was like a guard dog around Hirst and, as a double act, they made a formidable duo.

Meanwhile, Hirst continued on his upward trajectory. In May 1994, he curated the Serpentine Gallery exhibition 'Some Went Mad, Some Ran Away', a title borrowed from Angus Fairhurst's 1991 solo show at Karsten Schubert. The exhibition included a selection of works by his favourite artists, such as Ashley Bickerton, Sophie Calle and Kiki Smith, many of whom were his contemporaries from far and wide. One of the show's highlights was Hirst's *Away from the Flock* (1994), in which a lamb was suspended in formaldehyde within its own glass box. Positioned by a window, the lamb looked forlornly over the Serpentine lawns. Once again, the press exploded. Writing in the *Sun*, former Conservative politician Norman Tebbit rounded on Hirst, asking if everyone had gone stark raving mad, adding that the so-called works of art on show were nothing more than lumps of meat. Brian Sewell, the renowned art critic for the London *Evening Standard* whose plummy English accent has been much mimicked, would later comment on Hirst's sheep, saying that he found it no more interesting than a stuffed pike over a pub door. The *Sun* came up with the headline 'Baa-rmy', claiming that the work had sold for £250,000. To top it all, the work was attacked by a visitor who threw ink at it, eliciting yet another round of headlines as people made references to the 'black sheep' at the Serpentine. The next time *Away from the Flock* hit the headlines was in 2006 when it sold at auction for £1.8 million. Throughout this period, Hirst could be found holding court at the Groucho. Everyone wanted a slice of Damien and he was rarely seen out without his entourage, which now included Alex James as well as Keith Allen.

I first met The One and Only Sassa at the Groucho. While not an artist herself, she was much liked within the art scene and was always up for a party. She had a deep voice and a penchant for cheap beer and cigarettes. She wore

garish tartan jackets dotted with badges of the Swedish flag and tourist T-shirts from Monaco, a place she absolutely adored. Sassa, not of course her real name, was always amused by the prostitutes' calling cards that appeared in phone boxes across London featuring a drawing of a buxom young blonde with pigtails and proclaiming 'Swedish Blonde'. She was intrigued by the stereotype and fascinated by the way British men in particular related to the idea of the Swedish au pair. Sassa decided to take her interest one step further by making a film about sleeping with every type of Englishman, including a postman delivering a mail-order dildo, a tramp, a taxi driver and a perverted schoolteacher whom she filmed decked out in full Nazi regalia. She would later hold impromptu screenings of her film for all to take note.

Not everyone in the art world needed to be a qualified artist. In many ways Sassa was typical of the sort of person who had become integrated within the scene. One night, I was so broke that I decided to walk home to Notting Hill from the Groucho Club, even though it was freezing cold and the streets were covered in ice. As I said my goodbyes, Sassa kindly offered me a lift. At this point, I had no idea who Sassa was, but I was more concerned by the light snow that had started to drift over the streetlights. As it turned out, Sassa had a huge American automobile the size of a boat, with *Dukes of Hazzard*-style paintwork. Viewing the world from a bucket seat, Sassa hunched up behind the wheel, lit a cigarette and turned the key in the ignition. An almighty roar rattled across Soho as the engine throbbed into life.

As we took a right, Sassa spotted a police van at a junction up ahead. Intending to slow down, she applied the brakes, but the wheels locked and we started to skid on the ice. We were out of control. My fingers gripped the dashboard as the van ahead of us loomed larger and the police inside turned at the sight of the huge American sports car headed straight toward them. In what can only be described as a cartoon moment, Sassa and I looked at each other, our mouths open in horror. At times like this, careering towards a van filled with policemen, you begin to wonder whether things haven't gone a little too far. I didn't feel I had bargained for this.

UPTOWN: THE EVENING BEFORE THE MORNING AFTER

With only inches to go, the tyres suddenly gripped the tarmac and the car lurched to a halt. When I looked up, all I could see was the word POLICE lit up by Sassa's headlights, now only inches away. The One and Only Sassa was promptly asked to step out of the vehicle before being breathalysed, charged and taken to the station. Setting off on foot, I felt as if my life was getting a little crazier by the minute.

While riotous nights at the Groucho would lead to the mother of all hangovers the following day, they would prove tame compared to what happened next. After the Eighties' obsession with ecstasy, cocaine was making a comeback. Where mere alcohol had once been enough to keep revellers in high spirits, patterns of socialising altered with the arrival of vast quantities of white powder. By the mid-Nineties, traces could be found on the surfaces of every washroom in town. Everyone was chomping, chewing and yakking away. Suddenly I was in a world where people were forever exiting toilets brushing their nose or tucking rolled-up bank notes into their back pocket.

Unlike ketamine, the follow-up craze to ecstasy, cocaine didn't send you into a comatose state and leave you dribbling in a quiet corner. Cocaine is designed for social occasions, slicing through the mugginess of alcohol and enabling users to keep their edge and carry on drinking well after bedtime. While the first line might be uplifting, the inevitable comedown can only be softened with lots more cigarettes and alcohol. If the aftermath of the cocaine doesn't leave you feeling like shit, then the forty Marlboro reds you smoked that night without thinking, washed down with a bottle of vodka, should do the trick. Hangovers were no longer episodes in dehydration, but close shaves with Tourette's syndrome. In 1999 a survey revealed that more than ninety-nine per cent of London bank notes tested were contaminated with the substance, indicative of a dramatic rise in consumption that can be traced back to the mid-Nineties. People with expendable energy were now desperate to find somewhere to go after the Groucho turned out its lights. The thought of beating back time and staying up until dawn proved irresistible – there always seemed to be something to talk about on cocaine.

The Critical Gaze

BUT WHAT OF the art being produced by these young upstarts? Pulling the bigger picture into focus, much of what came out of Goldsmiths in the early years might best be described as a form of Neo-Conceptualism. Moreover, what set these artists apart was their ability to exploit quotidian objects to great effect. Through their use of prefabricated objects and found imagery they were able to reposition the everyday as a work of art – a form of street-level alchemy whereby the ordinary was transformed into something extra-ordinary or, at the very least, uncanny. This was by no means a recent phenomenon in the history of art but young British artists achieved it using the unlikeliest of materials, such as blood, dead flies and kebabs. They aimed for a certain truthfulness to materials, choosing to leave objects unsullied by artistic tinkering, seeking instead a wholesale purity whereby a spade was a spade and a cow was a cow.

The number of artists making art from reproduced imagery and basic objects would invite a new form of criticism capable of accommodating the abundance of mass cultural references caught up in the mix. Being able to analyse the work of an artist whose influences were more likely to be MTV than Rembrandt would test the most experienced critic, as an artwork's meaning could only be accessed through an acknowledgement that the boundaries between high and low culture had imploded – a condition long anticipated by Pop.

Viewed through the postmodern prism, high art was assumed to be up for

grabs. Like the accompanying dance music of the day, works from the canon of art history could be sampled, plagiarised and reformatted. Art itself had become a medium, a palette from which artists could select at will. With a back catalogue of iconic imagery that had been widely reproduced and disseminated throughout the century, art was suddenly ironic. 'Modern Art', in particular, played out in the imagination as a montage of flickering images: Picasso at his easel, Pollock standing over a drip painting, Warhol surrounded by silkscreens and Superstars. Meanwhile low art, or any object rescued from the detritus of everyday life, could legitimately be launched into the upper stratosphere of profundity: hence the excitement surrounding Jeff Koons' stainless steel cast of an inflatable toy rabbit. The Nineties would see much in the way of cross-border traffic between elitism and kitsch, this being a world in which Adam and Eve might drop their classical pose and turn up at the party wearing T-shirts and jeans.

More cynical observers would denounce the work of young British artists as 'skip art' – quite literally art that was composed of junk. In fact, such a view helps us get nearer an understanding that artists were fast realising how their conceptual aims might best be served by whatever came to hand, no matter how cheap or disposable the material. This resulted in fewer trips to Atlantis (the predominant supplier of art materials in London) and more visits to the local hardware store where cheap tins of gloss paint and emulsion replaced prohibitively expensive oils and acrylics.

After that came the modification and repositioning of existing objects. With increasing regularity, everyday objects started to appear as part of installations – the very term 'installation' being viewed as a relatively new way of working, especially in Britain where it was still considered to be a radical mode of display. Installations soon appeared everywhere, whether they were photographic, text-based, sculptural, mixed-media or multi-media. Installation art even started to eclipse painting, sending numerous painters tumbling into the slipstream – their seemingly modest means of expression deemed tawdry by comparison.

While there had been a trend among the conceptual artists of the Seventies to film their performances, video hadn't really resurfaced until now within the more conventional art world. Working in a variety of other media, such as photography and sculptural installation, many artists were starting to produce short films, or film-loops. When video made its return around the mid-Nineties, partly through the accessibility of domestic recording equipment, emerging artists struggled to raise funds as they set about producing video installations often using floor-based TV monitors before moving on to full-blown projections.

Whereas previous generations of conceptual artists, such as Bruce Nauman and Vito Acconci, used video as a means of pursuing their sculptural concerns, younger artists found themselves transfixed by the camcorder for entirely different reasons. Having grown up on a steady diet of television and isolated trips to the cinema, their ability to unpick what was once an inaccessible medium proved irresistible as artists started to deconstruct the moving image, sampling and looping film clips along the way. One example of such a tendency was Douglas Gordon's *24 Hour Psycho* (1993) which slowed down Alfred Hitchcock's classic film, frame by frame, so that it played out over the course of day. No longer tied to painting and sculpture in the time-honoured way, new sources of inspiration came from every direction, most notably cinema. Michelangelo Antonioni's 1967 film *Blow Up* was a constant source of reference, as were films by John Cassavetes, Stanley Kubrick, Pier Paolo Pasolini and Martin Scorsese.

Other genres were up for grabs too. In 1994 I was invited by London Video Access, a state-funded organisation based in Camden who seemed to welcome artists and curators, to produce a programme of art film and video, supported by the Arts Council of England. In 1994 I curated my first video programme, entitled 'Speaking of Sofas', which included works by Tacita Dean, Sam Taylor-Wood, and Jane and Louise Wilson. In 1995, I produced another video programme, this time including material from Damien Hirst and Angus Fairhurst, Gary Hume, Sarah Lucas and the painter Peter Doig,

who sampled the closing scene from *Deliverance* with a canoe floating on a lake. The second programme, entitled 'A Small Shifting Sphere of Serious Culture', also included a porn film produced by Jake and Dinos Chapman.

A few months earlier, the Chapmans had clashed with an Italian gallerist who, on realising its shock value too late in the day, baulked at the thought of showing their controversial work. The eventual standoff resulted in a longstanding grievance, and the production of a Chapman video entitled *Bring Me the Head of . . .* (1995). This retaliatory work centred on a lifelike severed head with a long penis nose, said to resemble the much-despised dealer. Some professional sex workers were hired and the film was shot in the Chapmans' studio, where the penis nose was thrust in and out of all manner of orifices. Sold as a modestly priced VHS cassette, *Bring Me the Head of . . .* generated much excitement when first shown at Ridinghouse Editions, a publishing imprint set up by a reinvigorated Karsten Schubert in partnership with London dealer Thomas Dane. While the official version used women, the clip I wanted to use for my compilation was an outtake of a considerably more hardcore and sweaty version featuring a group of young men.

The Nineties were not without artistic buzzwords, such as 'hermetic', 'narrative', 'memory' and 'recontextualised'. Barely a day went by without a press release quoting Walter Benjamin and his seminal text, *The Work of Art in the Age of Mechanical Reproduction*. But behind all the theoretical posturing was an urge to look beyond the glacial passage of art history. No one seemed to care that much about the past, or about traditional concerns such as form and colour. Instead, everyone was seeking some killer conceptual idea – a sudden bolt of genius. Duchamp and Warhol mattered, whereas Matisse and Picasso did not. Electronic musician Richard James (aka Aphex Twin) mattered, as did the new Apple Mac Performa 400. Surprisingly, art criticism mattered, becoming a user's guide to a daunting constellation of French theorists and philosophers, including Roland Barthes, Jean Baudrillard, Gilles Deleuze, Jacques Derrida and Jacques Lacan.

Whereas art criticism at the beginning of the Nineties was associated with a style of writing that was both painful and impenetrable, this was countered by the emergence of younger writers who attempted to describe the significance of certain artworks in a matter-of-fact way. Aspiring writers such as myself took inspiration from American critics such as Hilton Als, Jack Bankowsky, Peter Schjeldahl and Dave Hickey, while one of the more revered writers in Britain was Stuart Morgan, for many years lead writer at *Frieze* magazine as well as an advisor to its youthful founders.

Born in Newport, Gwent, Morgan was one of the best critics of his generation. Everyone sought his recognition. Having been writing since the 1970s, he was among the first to interview Damien Hirst, for the pilot issue of *Frieze*, and his essays were eventually published in the book *What the Butler Saw* in 1996. He was incisive, witty, bold and very clear in his thinking. Most importantly, his writing was accessible to everyone. Whereas certain critics might use words as a form of torture, Morgan was both sensitive and to the point, his essays providing an insight into a broad range of artists from Louise Bourgeois to Chris Ofili, Richard Prince to Rachel Whiteread.

Aside from his close friends at *Frieze*, Morgan was on good terms with Lawren Maben, who ran the Milch Gallery from a squat at 64–5 Guildford Street. Morgan described the moment he first met Maben, when he overheard him in the gallery ranting about the ICA. Earlier that week Lauren had had milk bottles delivered across London with details of his next exhibition printed on the side; the ICA had just returned theirs saying they found the idea to be ecologically unsound.

Maben was a stocky, self-styled gay punk with a shaved head who arrived in London from New York having previously studied art in Toronto. After a succession of group shows held in Guildford Street, Milch closed down, only to reopen two years later in 1992 next to the British Museum in Great Russell Street. In 1993, it relocated once again to 5 Hanway Place, where Hamad Butt staged his memorable exhibition 'Familiars', featuring an outsized Newton's cradle with the steel balls suspended from cord reworked as large

glass spheres filled with toxic gases that would kill everyone in the room should the piece be activated. Needless to say, the opening was a typically crazed Milch affair, with people's anxiety growing as they found themselves pressed ever nearer the threatening glass balls. However, it was a 1992 opening at the Great Russell Street gallery that was, to my mind, one of the best private views held in London at that time.

The opening of 'A Modest Proposal' – the title taken from Jonathan Swift's satirical pamphlet suggesting how the famine-stricken Irish might eat their own children – was more like a hardcore party than a gentle art opening. The show featured works by Simon Patterson, who presented shiny tins of conceptually colour-coded paint, Douglas Gordon, who displayed the first of his mysterious typed letters, and Anand Zenz, who presented pinstriped suits whose stripe, on closer inspection, read FUCK YOU. The after-opening party was, I think, held in the basement – or at any rate, a basement – where I recall drag queens gliding through the throng handing out bottles of beer. Mayburn's anarchist tendencies permeated the dank air and a night of debauchery ensued, every corner revealing unexpected bursts of flesh, muscular arms, mystical black tattoos, nose rings and wigs.

Now seemingly inseparable from the club scene, Milch moved from venue to venue, retaining its basement activities as a means of supporting the gallery upstairs. However, what started out as an attempt at self-financing would eventually come unstuck, leaving only the nightclub; the gallery was regarded by artists as suspect, with widespread rumours of artworks and cash walking out the back door. After years spent in a twilight world of hardcore parties, Lauren was diagnosed as HIV positive and subsequently died in 1995.

Morgan's obituary in *Frieze* respectfully joined the dots of Mayburn's descent into oblivion: the running up of debts on his parents' credit cards to buy heroin, the breakdown of trust among friends, and the erosion of judgement in favour of an excessive lifestyle. At the time, no one would have thought that Morgan himself would soon become unwell and slip uncontrollably from one physical ailment to another.

It was at a Milch opening – Hamad Butt's to be precise – that I was verbally attacked by Morgan after a remark made by one of the gallery insiders about something I was supposed to have said. I was set up, but instead of arguing back I duly begged forgiveness, declaring that I hadn't done anything wrong. Stuart's lips twisted. My fate was sealed. In his eyes, I was to be despised, by him, publicly, right there and then. That night, on some dilapidated staircase in Soho, his temper rained down upon me with such force that for years afterwards I was left with a deep-seated queasiness – a feeling that only left me when some years later he came to visit me, offered me some unexpected praise, patted me on the back and left. I didn't have a clue what was going on, but after subsequent discussions I came to realise this was his way of saying goodbye. Not long after that he died, finally succumbing to Lewy body disease in 2002.

The Brand: Did you just say YBA?

DURING THE MID-NINETIES, young British art was packaged, branded and shipped abroad. As news of recent developments continued to travel far and wide, an influx of new faces from north of the border would help beef up the nation's reserves. New generations came through with each passing graduation show. There were now generations within a generation, forming new cliques and an expanded group dynamic. While the larger institutions continued to be dazzled by the onslaught of emerging artists, there remained few significant collectors within the UK. Typically, young artists still depended on sales to central European and American collectors. However, recent graduates leaving art school were encountering a far rosier picture than ever before. Although the warehouse shows of the early Nineties were long gone, the mid-Nineties saw the emergence of a highly motivated gallery network, particularly within London.

Where before there had been 'Freeze' and Building One, now there was the Saatchi Gallery and White Cube, as well as a host of commercial galleries willing to accommodate the recent surge in fresh talent, including Entwistle, Lisson, Anthony Reynolds and Frith Street Gallery. There was a noticeable rise in the number of British artists being invited to show abroad, as well as the number of overseas collectors and curators passing through town with a real sense of purpose. It was an important time for these young British artists, and they were about to be given a tag that would ensure their longevity and define them for the rest of their lives.

In 1994 I staged my second exhibition, 'Liar', which included artists Jake and Dinos Chapman and Cerith Wyn Evans. The show took place in a dilapidated building in Hoxton Square. Wyn Evans exhibited an exquisite array of new works, including a stuffed magpie holding in its beak a silk scarf baring a print of the artist impersonating the pierrot in Marcel Carné's film *Les Enfants du Paradis*. As their contribution to the show, Jake and Dinos covered a plinth with clay figures and protruding dicks, a sculpture that Cerith pretended to shag on the night of the opening.

As far as I could tell, the show was well received, even though I never got to meet any collectors, but curating wasn't my sole concern. I was still writing the occasional review for *Frieze* and as a consequence my presence was in demand. The private view cards that had been landing on my doormat with increasing regularity over the last few years were upgraded to official gallery dinner invitations. On such occasions, I would meet other writers who were far more important than me, such as Sarah Kent, who wrote for *Time Out*, and Stuart Morgan, whose star shone very brightly indeed. Over dinner I got to know gallerists, curators and Kunsthalle-types, and quite a number of beautiful young women. I was swept up in a glamorous new world. My lifestyle was becoming increasingly polarised: I still had no money and I would frequently find myself at home making roll-ups out of cigarette butts.

Although I had established myself as a young writer and curator, it still came as a big surprise when I was summoned to a meeting at the British Council offices in Great Portland Street, where I was invited to discuss a forthcoming exhibition to coincide with the XLVI Venice Biennale. Hard to imagine that a scruffy brat like me had somehow managed to ascend through the ranks and was now at the calling of such a noble institution, one that promoted cultural relations between Britain and other nations. It was during this meeting, towards the end of 1994, that we stopped saying 'young British artists' and started saying 'YBA'. In truth, we'd simply given up stumbling through the unabridged version and 'YBA' made for easy shorthand, but this was the first time I'd ever heard the term used in regular discussion. One of

By the time he was 28, Damien Hirst had already produced his spot and butterfly paintings, as well as the shark piece *The Physical Impossibility of Death in the Mind of Someone Living* (1991) and *Mother and Child Divided* (1993).

Sarah Lucas in her late twenties not long after she became known for producing provocative artworks such as *Eating a Banana* (1991) *Penis Nailed to a Board* (1991), and *Two Fried Eggs and a Kebab* (1992).

General Release, Venice, 1995. Left to right, back row: Gary Hume, Elizabeth Wright, Cerith Wyn Evans, Jake Chapman, Tom Gidley, Adam Chodzko, Fiona Banner, Dinos Chapman. Front row: Louise Wilson, Jane Wilson, Ceal Floyer, Jaki Irvine, Douglas Gordon.

East Enders playing in the rubble as new office developments spring up about them owing to the initiative of the London Docklands Development Corporation (LDDC). During the nineties, the East End would be transformed beyond all recognition. *Magnum*

Margaret Thatcher eyes the prize. One Canada Square, the jewel in the crown of Docklands regeneration. Just as the building was nearing completion, the property market crashed leaving developers Olympia & York with debts of over $20 billion. *PA Photos*

Statistics alone can never do justice to the impact of the early 1990s recession and its toll on the local economy. London would grind to a halt as more and more shop fronts declared 'Closing Down Sale', notably those in Oxford Street, seen here in 1991. *Alamy*

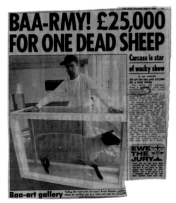

Damien Hirst's *Away From the Flock*
(1994), exhibited as part of his
Serpentine curated exhibition
'Some Went Mad, Some Ran Away'.
The Sun newspaper lambasted the
price, while the artwork was later
turned black when a member of the
public attacked it with ink. *The Sun*

A tense moment as Damien Hirst's original tiger
shark is lowered into its vitrine.

The author and Jay Jopling take a
break during an otherwise hectic day
in New York for the opening of Damien
Hirst's exhibition 'No Sense of Absolute
Corruption' at the Gagosian Gallery, Soho.

Rachel Whiteread, *Ghost* (1990).
Having spent three months taking
casts of a room in a derelict
Victorian terraced house, Whiteread
then pieced together sections of the
walls and ceiling to produce this
extraordinary sculpture.

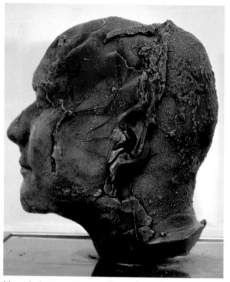

Marc Quinn's *Self* (1991). Eight pints of the artist's blood were poured into a mould before freezing. On the day of the opening, Quinn and his dealer Jay Jopling tore through the streets to install the work before it melted. *Rex Features*

A visitor to the 1993 Cologne art fair pauses to takes a closer inspection of one of Jake & Dinos Chapman's fuck-face sculptures.

First shown at the 'Freeze' exhibition, Mat Collishaw's *Bullet Hole* (1988–93) was one of the earliest examples of the YBA tendency to foreground disturbing imagery, later ascribed as sensationalism or 'shock art'.

Mat Collishaw

In Damien Hirst's fly installation *A Thousand Years* (1990) maggots would hatch into flies that were lured by the stench of a rotting cow's head toward an electrocution device.

Rex Features

The Physical Impossibility of Death in the Mind of Someone Living (1991) would become one of the most iconic artworks of the nineties. One of its more notable admirers was Francis Bacon who wrote positively about having experienced the work to a friend.

PA Photos

Tracey Emin's tent, *Everyone I Have Ever Slept With 1963–1995* (1995), is lined with the appliquéd names of over a hundred individuals with whom she shared a bed, platonically or otherwise.

White Cube Gallery

Standing outside White Cube at 44 Duke Street, St. James's, from left to right: Marc Quinn, Jay Jopling, Sam Hodgkin and Sam Taylor-Wood.

Johnnie Shand Kydd

BOROUGH OF KENSINGTON

GAVIN TURK
Sculptor
worked here
1989~1991

Gavin Turk's plaque entitled *Cave* (1991). Having presented the ceramic original high up on a wall as part of his final degree show at the Royal College of Art, Turk was then failed by his assessors.

A scene from Joshua Compston's 'A Fête Worse Than Death' held in 1993. As part of their contribution, Angus Fairhurst (left) and Damien Hirst (right) dressed as clowns and set up a stall selling spin paintings for £1.

Alamy

Tracey Emin and Carl Freedman during the installation of *I Need Art Like I Need God* at the South London Gallery, 1997. *Johnnie Shand Kydd*

Cerith Wyn Evans in full effect. *Johnnie Shand Kydd*

Dressed in period costume on location during the filming of John Maybury's 'Love is the Devil' - Gary Hume, Angus Fairhurst, Sarah Lucas and Georgie Hopton. In the background, Richard Deacon's photograph of George Dyer, Francis Bacon's lover.
Johnnie Shand Kydd

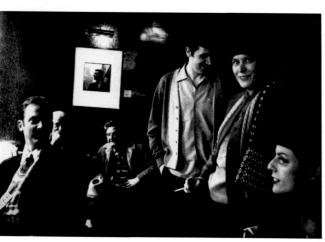

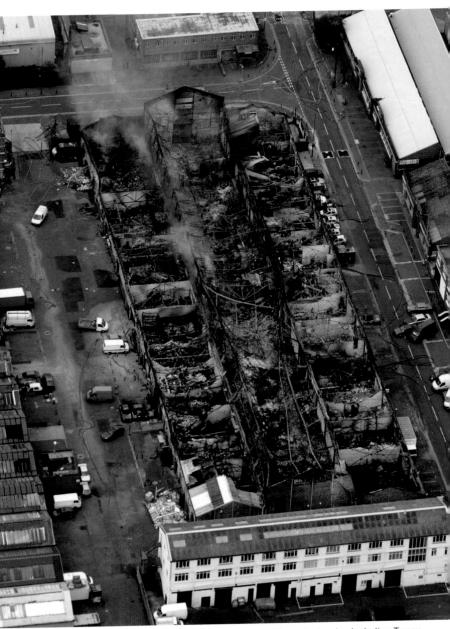

The aftermath of the Momart fire in Leyton, which saw a great loss of artworks, including Tracey Emin's tent and the Chapman's sculpture *Hell* (1999–2000). *Rex Features*

the distinctions to be made here is that YBA was not a result of the 'Young British Artists' shows taking place at the Saatchi Gallery. Instead, the term referred to an all-encompassing phenomenon that included a number of different artists from a variety of backgrounds. The term went beyond those who took part in 'Freeze' and included subsequent waves of British artists such as Jake and Dinos Chapman, Tracey Emin, Chris Ofili, and Jane and Louise Wilson.

The winter of 1994 would turn particularly bleak when news started to circulate that Leigh Bowery had died of Aids on New Year's Eve. In an instant, London lost one of its greatest artistic talents. Leigh was irreplaceable. One felt an enormous sympathy for his family, his wife Nicola and close friends. What seemed to make his passing all the more sad was that Bowery was starting to win the affections of a wider and more appreciative audience. Thanks to his band and famed portraiture work for Lucian Freud, he found himself at the centre of an adoring art world. It just didn't feel right that he wouldn't be around to enjoy the rest of the party. It took some time to focus on anything else, but as the year started to get into gear it was time to return to the gallery circuit and attend the fizz that surrounded the newly branded YBAs.

In April 1995, 'Minky Manky' opened at the South London Gallery in Camberwell. Curated by Carl Freedman, the exhibition included Mat Collishaw, Critical Décor, Tracey Emin, Gary Hume, Gilbert & George, Sarah Lucas and Steven Pippin. That Gilbert & George were included in the line-up would underscore how the integrity of their work – especially the earlier drinking sculptures – remained intact in the eyes of the younger generation. Meanwhile, Steven Pippin was something of a newcomer. Born in 1960 in Redhill, Pippin resembled a scientist, having been previously photographed wearing a white lab coat. In recent years he'd produced a series of images by converting unusual objects, such as bathtubs, passport photo booths, washing machines and entire rooms, into pinhole cameras. Having harnessed a projection of the outside world inside a given object, he would then develop a negative image onto photographic paper, which would later

go on display as the outcome of all his efforts. In one instance, Pippin filmed himself converting a toilet bowl in a public convenience into a camera. Having previously inserted photographic paper inside the bowl before making it lightproof, he developed the print by flushing developer through the water cistern. Pippin also produced incredibly complex devices that often took the form of circular steel benches with a mysterious mechanical object at their centre. Works such as *Cosmos* (1995) was just such a device used to display a vinyl record of Albert Einstein describing his theory of relativity being played inside a rotating glass sphere containing a vacuum, thus rendering the recording inaudible.

One of the highlights of 'Minky Manky' was Tracey Emin's tent – *Everyone I Have Ever Slept With 1963–1995* (1995). Standing at just over two metres high, its innocuous blue exterior gave way to an illuminated interior lined with the appliquéd names of over a hundred individuals with whom Emin had shared a bed with since childhood. While it included the names of former boyfriends, such as punk poet and artist Billy Childish, with whom Tracey had a passionate relationship between 1982 and 1987, it also referred to more innocent overnight stays with people such as her grandmother and old pals. On a more harrowing note, there is also mention of two numbered foetuses, a reference to Emin's earlier abortion. Compared with much of her output, the tent remains a work of relative calm and great intimacy. For those who know Margate, the town where Tracey grew up, the sculpture recalls the Shell Grotto – a local folly situated under someone's back garden in a row of otherwise insignificant terraced houses. The Shell Grotto consists of a series of under-ground chambers carved out of chalk and decorated with thousands of tiny seashells, the insides of which are signed by courting couples from the first half of the nineteenth century. Within its womb-like interior, one is surrounded by a host of names like stars in the sky, which in many ways recalls the experience of lying in Emin's tent with its own constellation of memories.

While Emin's tent was well received at the South London Gallery, it wasn't until some years later that it would cause a media sensation as part of

Saatchi's collection at the Royal Academy. But at the time of 'Minky Manky', Saatchi hadn't bought anything by Emin, who claimed to be a deliberately withholding her work in a campaign against the man whose advertising company had propelled Thatcher into power. For now the tent would be acquired by private dealer Eric Franck for £12,000.

Come spring, I was in regular meetings with Ann Gallagher and her team, which included young curator Clarrie Rudrum, to discuss our Venice exhibition which had since been given the title 'General Release'. Ann had recently taken up the post of exhibitions officer, having previously worked at Anthony Reynolds. I already knew Ann; she was much liked by everyone and could always be found at openings. Even though she now worked for a government organisation, she continued to speak the same language as everyone else and was instrumental in bringing such an ambitious project to the table. Working alongside her colleagues, Andrea Rose and Brett Rogers, Gallagher would play a key role in determining the shape of the exhibition inviting myself and James Roberts, one the star writers at *Frieze*, to write essays for the accompanying catalogue. With his long dark hair and unassuming manner, Roberts proved to be an essential ingredient in the formation of 'General Release', having previously made his reputation as an excellent writer and curator of several YBA group shows, most notably 'Wonderful Life', held at the Lisson Gallery in 1993. Soon to be editor of *Frieze* magazine, Roberts was a rare talent who could be counted on to keep his head while all around were losing theirs.

'General Release' would be held in a hired church called the Scuola di San Pasquale. The final list of artists consisted of Fiona Banner, Jake and Dinos Chapman, Adam Chodzko, Matthew Dalziel and Louise Scullion, Ceal Floyer, Tom Gidley, Douglas Gordon, Gary Hume, Jaki Irvine, Jane and Louise Wilson, Elizabeth Wright and Cerith Wyn Evans. 'General Release' was the first state-sponsored YBA outing of its kind. I was very excited to be involved and incredibly pleased when I learnt that the British Council would be paying for me to attend the opening of the Venice Biennale.

THE BRAND: DID YOU JUST SAY YBA?

Venice is a big deal, a momentous occasion. I first discovered this back in 1993, when I'd scraped together the money to attend. This was the year when Damien Hirst caused a controversy with his latest sculpture, *Mother and Child Divided*, in which a cow and calf had been split down the middle and presented in formaldehyde tanks, the mother being sizeable enough that you could walk down the middle and view the poor creature's internal organs. In order to complete this work, Hirst had pulled off a dazzling feat of technical wizardry, which extended to his ability to ship animal carcasses from Brixton to the heart of Venice. At the time of the opening, one of the tanks leaked and the entire exhibition, housing works by countless artists from all over the world, had to be temporarily closed. When the exhibition finally opened to the public, gobsmacked reporters swamped Hirst's installation. It was quite unlike anything they'd seen before. It's an incredibly powerful work to behold, both from afar and close up, and the cow's innards glistened and turned under the bright lights. In many ways *Mother and Child Divided* was the perfect work to plant in the middle of a Catholic nation, especially in Venice with its concentration of churches and classical frescos. Given the work's religious connotations, it was equally compelling to watch the reactions of the Italian public; they were quite literally stunned.

Venice is a Mecca for art world professionals; its draw is akin to that of the Cannes Film Festival for the movie industry. For one week in June, the local airport is mobbed and the hotels are fully booked. It's hard not to imagine the Venetians rubbing their hands with glee at the amount of money about to be deposited into their bank accounts. Among the first to arrive are the artists who proceed to install their work, followed by the mass rank and file of the international art world who descend for a series of official events spanning several days. The number of openings averages out at about one an hour, including early morning brunch, afternoon drinks, and dinners held in palazzos. Events take place all the time. During the afternoon, visitors trudge over the gravel paths in the Giardini where the most important exhibitions are staged in the international pavilions. Each pavilion – these being large purpose-

built galleries of varying design that bask among the leafy trees – belongs to a nation or continent. It remains a major achievement for an artist to be selected to represent their country in one of these pavilions. The other main attraction is the Arsenale, and it was here in the Aperto section – a space where particularly cutting-edge work is likely to find its place – that Hirst had previously exhibited *Mother and Child*. The Arsenale is like one giant exhibition mounted across a series of sheds and warehouses. Crawling from one exhibition to the next in the extreme heat can prove a little gruelling, to say the least.

When I returned to the Venice Biennale in 1995 courtesy of the British Council, the YBAs, as they were now known, were making their presence felt. The Hague Bar still proved the place to be, and after a few drinks I headed through the back streets to the square opposite La Fenice opera house, where a number of people remained seated outside after finishing their dinner. Just as I got there, I saw a high-spirited Christian Nagel sitting at the next table to the journalist Anthony Haden-Guest, who then twitched in his sleep and fell off his chair.

Meanwhile, the YBAs, by now a recognisable gang, were congregated on the steps of the opera house. Angus Cooke, who was in town with partner Jonathan Caplan, was wearing a blue and white sailor's cap. Cooke was an extraordinarily gregarious character whose changeable moods made him simultaneously hilarious and startling company. In mid-conversation on one occasion, as he was shaking my hand, his trousers suddenly dropped round his ankles, apparently by accident, but he carried on talking as though nothing was wrong. At a function earlier that evening, Angus had been introduced to the mayor of Venice, whereupon he remarked that his official ring looked very pretty. From the steps of La Fenice, Cooke was now shouting out to bewildered passers-by 'Venice the Menace!' – a somewhat obscure reference to the character in the *Beano*. I'm reminded of Sarah Lucas, who walked down a popular street in San Marco one night chanting a rephrased version of John Lennon's song, 'All we are saying . . . is give pizza a chance!'

THE BRAND: DID YOU JUST SAY YBA?

Reports of badly behaved Brits were coming in thick and fast. Cerith Wyn Evans was keeping a relatively low profile since breaking his leg the week before in an incident that he reported to the hospital as a case of 'disco damage'. Meanwhile, Adam Chodzko and Jake Chapman found, of all things, a Christmas tree in the street. After larking about with it for while, they decided to launch it into the water from a small bridge, but there was no splash. The tree had landed, not in the water, but on a passing gondola. It had fallen on some dreamy newlyweds who were frantically struggling to fend it away. All hell broke loose down below as Chapman and Chodzko ducked behind the bridge. Out of the corner of his eye, Gary Hume, who was innocently walking up ahead, saw a gondola laden with a Christmas tree pull over, whereupon an enraged gondolier jumped out and started screaming at him until Jane and Louise Wilson came to his rescue.

The Wilson sisters were the first people I'd met when I arrived in Venice. They were wearing identical shades, smart mini-dresses and Patrick Cox shoes. 'Hi Gregor. Where are you staying?' Jane stared at me through dark glasses. 'Well, I'm in a hotel somewhere round here, I think,' I replied, holding my luggage in one hand and a map in the other. Jane's directness made me a little anxious. Louise looked at me while eyeing her sister and said, 'I reckon he's in that hotel with everyone else. What do you reckon, sis?' There was a pause before I asked if they were going to the 'General Release' show, which was about to open that evening.

Later that day, I heard through the grapevine that Jane and Louise had had a spat with their landlady, who kicked them out of their hotel. That was when it dawned on me. Of course, they wanted to stay in my room. Later that night Jane turned to me and said, 'You don't mind, do you Gregs?' 'Well, erm, I was . . .' Louise ended the sentence for me. 'Good. We'll go back to your place after we've finished our drinks.' It was three in the morning.

In Venice, there are very strict regulations regarding unregistered hotel guests. Peering round a corner, we could see the hotel manager filling out

paperwork at reception. He was guarding the entrance, making it impossible for us to sneak in unnoticed. Having been out drinking all night, we were jittery and swaying. We made a botched attempt to rush the stairs, but the hotel manager caught us and called us over. He eyed us with deep suspicion. Head in hands, I tried to explain why I was trying to smuggle Jane and Louise into my bedroom. He was reluctant to let us pass but eventually took pity. I was asked to sign them in as the manager presented me with two slips of paper, adding '. . . and your passports, please.'

I turned to Jane and Louise, who looked back with open palms. They didn't have their passports, but for some inexplicable reason they had London bus passes instead. 'You're joking,' I muttered, as they handed over two red plastic wallets. I asked the manager to consider that in England a bus pass is perhaps more important than a passport. We were back to square one, and my head went straight back into my hands as he said that bus passes were unacceptable. Finally, we wore him down and made our way upstairs to bed.

While the main purpose of going to Venice was to see the art, memories of the exhibition blended in with those of catching the last boat home at sunrise, being served the perfect Negroni, walking through St Mark's Square in the dead of night, and getting completely lost in the warren of little backstreets and canals. On the last day, we had a huge bunch of flowers that we didn't know what to do with, so we handed them over to an elderly couple who welled up with tears, providing a happy ending to an otherwise excessive outing.

'General Release' further extended the reach of British art overseas and communicated the most recent manifestation of YBA, a phenomenon now perceived to be inclusive of artists from locations other than London. Two years before, Matthew Slotover had curated a group of artists in Venice's Aperto section that included not just Damien Hirst with *Mother and Child Divided*, but two artists from Glasgow School of Art, Christine Borland and Julie Roberts, as well as Georgina Starr from the Slade School and Steven

Pippin who studied at Chelsea School of Art. Slotover's selection also included Vong Phaophanit, who was born in Laos and spent time in Brighton as part of Red Herring Studios. While it was a very different show, 'General Release' two years later also brought together a mixed bag of artists from both sides of the border, as well as Irish artist Jaki Irvine. The Goldsmiths hegemony was gradually disintegrating, thanks not least to the inclusion under the YBA umbrella of those from the increasingly hip and happening Glasgow School of Art.

One of the more notable artists to hail from Glasgow at this time was Douglas Gordon, whose video installation *24 Hour Psycho* had already been the subject of much discussion. One of many Scottish artists who caught people's eye – along with the likes of Roderick Buchanan who also hailed from Glasgow School of Art – Gordon made an impact very early on by posting a series of anonymous letters with a single puzzling sentence saying 'There is something you should know', or 'I am aware of what you have done'. People would receive these jarring letters out of the blue, and the artist was canny in often targeting a select mailing list of art world insiders. For some, receiving one of these letters may have recalled the moment when a cautionary note is left for a suspect killer in Hitchcock's *Rear Window*. Gordon was fascinated by Hitchcock and his work was punctuated by references to the master of suspense. Early works also included wall texts with suggestive lines reading 'We Are Evil', or 'I believe in nothing'. Providing good company along the way, a number of Scottish artists were to play a key role in the development of YBA.

Patterns of discovering artists were beginning to change as curators and galleries started to look further afield. It was no longer a given that being a Goldsmiths graduate was enough. Indeed, few YBAs would emerge from Goldsmiths after 1989; Gillian Wearing and Sam Taylor-Wood, in 1990, were among the last to graduate from the famed BA degree course, although the Wilson sisters graduated from the Goldsmiths MA course in 1992. Many of those belonging to the post-'Freeze' generation were graduates from the

Royal College of Art: along with the Chapman brothers, Tracey Emin graduated from the Royal College in 1989, Gavin Turk in 1991 and Chris Ofili in 1993. Even though she would be often mixed up with the Goldsmiths set, Rachel Whiteread had graduated from the Slade School in 1987. Gary Hume seemed to straddle both 'Freeze' and post-'Freeze' generations, having come from Goldsmiths before making the leap as his style of painting underwent drastic revision. Cerith Wyn Evans was another exception. Being that bit older and having belonged to what might be termed a lost generation of artists, Wyn Evans was able to achieve a generational leap. Even though there were subtle shades between generations, by the mid-Nineties all these artists were being packaged together.

At times the term YBA seemed a little too all-encompassing, and in the light of the big YBA round-up shows that were starting to get off the ground, it was becoming clear that there were marked differences in the work; there no longer seemed to be any clear common denominator. Was YBA open to interpretation? In order to find out who fits the bill consistently, it's worth reviewing the line-up of artists who took part in some of the biggest YBA group shows of the Nineties. These might include '"Brilliant!" New Art from London', held at the Walker Art Center, Minneapolis (1995), 'Full House' at Kunstmuseum Wolfsburg, Germany (1996), 'Live Life' at the Musée d'Art Moderne de la Ville de Paris (1996), and 'Sensation' at the Royal Academy of Arts, London (1997). Reviewing these exhibitions to see who appears the most, the highest scorers are Jake and Dinos Chapman, Mat Collishaw, Tracey Emin, Sarah Lucas, Gillian Wearing and Sam Taylor-Wood. Damien Hirst, whose YBA credentials are indisputable, could have participated in any one of these exhibitions had he not given up on group shows once he became established, opting instead for the concentrated solo exhibitions which are generally considered more important for an artist's career. What this little survey tells us is that the YBA hardcore came from London and the majority attended Goldsmiths College. As history pulls away from YBA this becomes even clearer.

THE BRAND: DID YOU JUST SAY YBA?

That YBA would become such a high-profile term from the mid-Nineties on seemed unlikely, but it stuck. Some say that in its most cynical guise the term was a state-sponsored marketing exercise adopted by the British Council. For all its sins, it helped people identify with a new generation of artists and a new breed of art. The term would later see its equal in the music industry, where it went hand in hand with Britpop under the all-encompassing label of Cool Britannia which would later be proffered by New Labour to promote a nation at the height of its groovy powers.

After 1994, the term YBA entered the mainstream. Here it became synonymous with a band of artists whose antics were epitomised by the Machiavellian Hirst, who was largely perceived by the media to be racking them out while raking it in. Hirst continued to grow into the role of enfant terrible, causing a public outcry over his use of animals. *Mother and Child Divided* sealed his fate. Hate mail from animal rights campaigners, upset artists and disgruntled members of the public steadily poured into the White Cube office. In one instance the police were summoned upon receipt of a letter containing a carefully taped razor intended to slice the finger of whoever opened it. For me, it was clear that there had been a shift in public perception. The artists I hung out with, who had previously been relatively unknown, were now being referred to as YBAs. This meant something, not just about their work, but about them.

The Atlantic

THE ATLANTIC BAR and Grill near Piccadilly Circus, or just plain old Atlantic, would come to embody everything that was new and exciting about London in the Nineties. It was the decade's quintessential big bar and it signalled a shift in the city's fortunes. As the Atlantic lit up again, so did London; the old world was dusted off and put back in order.

The Atlantic was one of the few West End bars where you could legitimately buy alcohol until three in the morning. Pubs closed at eleven at night and the only other option was to go clubbing, which cost an arm and a leg and always seemed excessive when all you wanted was another beer. Thanks to the Atlantic, it was possible to stay up past midnight in luxurious surroundings without being labelled a freak. Overnight, it became the epicentre of fashionable London nightlife. Stepping into the Atlantic was like walking into a film set. With the help of designer David Connor, former nightclub entrepreneur Oliver Peyton transformed the Art Deco ballroom beneath the Regent Palace Hotel into a magnificent bar and restaurant with a sumptuous VIP cocktail lounge named Dick's Bar.

The main bar and restaurant had high ceilings, creating a tremendous feeling of space. The whole place had a feeling of opulence, the sound of distant cha-cha music recalling an era when people would swing along to the Charleston. One walked down the curving staircase to find the floor heaving

with people; girls in dresses and men in suits, fat cats and cleavage. It was all very decadent, everyone trying to live up to the glamorous surroundings. There was an area just outside the restaurant where we'd usually take up residence under a large light-box by Angus Fairhurst of a killer whale in midair performing before a faceless audience at an anonymous Seaworld. As time went by the walls started to fill with works by contemporary artists such as Douglas Gordon, Liza May Post and Korean-American artist Michael Joo. Just before the Atlantic's official opening in 1994, Mat Collishaw had staged an exhibition in one of the coffee-coloured dining rooms where he smashed a replica of the Rokeby Venus, recalling a suffragette action of 1914. In 1997, Sam Taylor-Wood made a film here entitled *Atlantic*, which later became a three-screen video installation featuring members of the art world as extras. With their art on the walls, and a food and drinks tab to boot, young artists started to descend on the Atlantic, eking out secluded corners and losing themselves among the throng.

Anyone who went to the Atlantic during its heyday will recall how it was a meeting place for people from all walks of life. It wasn't just a handful of individuals who made this place happen, but a large swathe of London's hip society. It was as though everyone had been waiting for such a place to exist, and now the whole city was exploding with delight. People came alive at the Atlantic, running from bar to bar; even, by some accounts, having sex in the toilets. Meanwhile, in Dick's Bar, any number of art world people could be found huddled on sofas or slumped in armchairs, screaming for the music to be turned up so that everyone could dance. Everyone felt impulsive and played to the wings. It was like an adult playground and though it eventually died a slow death, for those who enjoyed its heyday it represented a golden moment in a golden age.

The Atlantic was most definitely the start of something: the beginnings of a city trying to get back on its feet again. While there were countless aspiring individuals in London, it had been a long time since they had shared the same space. Here was a gathering of people who hadn't been together since

punk or the early days of the rave movement – or hadn't ever been together at all. The Atlantic was a beacon of light on the London social scene. It was also a sign that entrepreneurship was now a shared experience across a generation. Making something out of nothing was not just the privilege of emerging artists, it also proved true of the Atlantic's young owner.

Oliver Peyton was a wonderfully personable man with a soft Irish accent who must have been made of steel to work such insane hours in this full-on, crazy place. In my youth, I used to go to one of Peyton's clubs in Brighton called Can, one of the earliest warehouse parties to be held in the UK. A few years later he was famed for having taken home £70,000 in cash from the last night of a London club he used to run called Raw. The Atlantic, opened in 1994, was his first restaurant business. I attended religiously, and once went every night over a two-week period. Getting in, however, could prove frustrating; huge crowds would gather around the door, but thankfully Peyton was good friends with Sadie Coles, who distributed VIP passes that took the form of a thin sheet of steel with a discreet logo.

Coles would eventually quit Anthony d'Offay to set up her gallery, Sadie Coles HQ, in Heddon Street in 1997. She employed Pauline Daly, a popular young curator and writer who was ubiquitous on the scene. In 1994, Daly and her then artist partner Brendan Quick curated a group show of young American artists entitled 'Rock My World' at the Independent Art Space (IAS), situated just off the King's Road in Chelsea and run by artistic ex-Etonian Max Wigram. (Between 1994 and 1996, IAS would become an essential gallery for a variety of independent projects.) I loved dancing with Pauline as her long hair swayed from side to side, reminding me of Edie Sedgwick in her heyday. She was really smart, witty and impeccably dressed. Meanwhile, Sadie was an unstoppable force. She had incredible presence of mind and was highly revered, especially by the artists she worked with. She travelled ceaselessly to America, back and forth, not thinking twice about spending a weekend in Los Angeles, or hopping on a plane to New York for an opening only to return to London the following morning. Extremely well

connected, she was destined to open one of London's top commercial galleries.

Oliver Peyton's sisters Siobhan and Marie helped with day-to-day operations at the Atlantic. They worked from a tiny office on the landing where Siobhan could be found most nights surrounded by close friends leaning against filing cabinets. Like the basement of Studio 54, the office became a place of refuge from the throng downstairs. Sat in that stark windowless office, it was entirely possible to lose all track of time. One of the great characters who worked at the Atlantic was Abel, a Moroccan man with a hoarse voice who spoke in speedy sentences that often ended in riotous laughter. He sported a little moustache and looked very dapper in a tight waistcoat and baggy trousers. As he flitted from table to table it became clear that everyone knew Abel. The Atlantic, like any other bar or club across town, was by no means immune to excess and I would frequently be accompanied into the gents' toilet by a bouncer who stood behind me just to make sure that I was taking a pee and not misbehaving with drugs.

Now a regular at the Atlantic, I often found myself stoney broke in the wee hours and stuck in the West End. There was the odd occasion when I woke up on the floor of Cerith Wyn Evans' Bloomsbury flat. One particular morning, I rubbed my eyes to find my host sat by the the front window. Immaculately dressed in Jermyn Street pyjamas and a scarf, Cerith wasn't just wearing any old slippers, but Gucci slippers, I was curtly informed. We decided to take a stroll down Oxford Street. Still penniless, I was ecstatic to find a five-pound note on the pavement. This was followed by a ten-pound note, then a twenty-pound note. Up ahead, a tourist was idly window-shopping with cash falling out of his pocket. Finally a conscientious old lady tapped the tourist on the shoulder and pointed to a bank note lying on the ground. As he looked back in our direction, I bundled Cerith into a passing taxi and we sped off to Kettners, a Soho restaurant and one-time haunt of Oscar Wilde, its extravagant baroque interior seemingly at odds with its fare of burgers and chips.

After our meal, we took a taxi to Greens, the latest art-world watering hole. Located in a Mayfair town house in Green Street, Greens was a fine old club run by a flamboyant young character named Orlando Campbell. Cerith and I sauntered in and ordered two unbelievably expensive vodka and tonics, proceeding to guzzle our way back into poverty. Finally, we decided to leave our comfortable leather chairs and brace ourselves for the cold night air.

As we were leaving we chanced upon Lucian Freud, who was just arriving. Cerith had been one of Freud's former models and knew him well. 'Lucian!' he announced, twirling his hand in honour of the great man's entrance. Freud smiled nervously, but was nevertheless welcoming. Sensing our predicament, he invited us to join him. An ice bucket and champagne landed on our table and in an instant our fortunes were reversed. Freud's piercing eyes fixed on me as I began to tell him that I'd spent months bored out of my skull, working behind the ticket desk during his Hayward Gallery exhibition in 1988. Of all the works on display, I told him, I particularly admired *Two Plants* (1977–80), a labour-intensive painting of tiny leaves depicted in neurotic detail. He told me that he associated this very painting with one of the most depressing periods of his life. I thought it best to shut up. Another bottle of champagne arrived and, just as we were getting into the swing of things, in walked Damien Hirst.

Hirst, accompanied by a friend, walked straight over to us and both sat down with a degree of self-assurance that left me wondering whether this encounter had been prearranged. It felt like something out of *West Side Story*. Here I was, sitting with two of the most important artists of the day as though I were moderating a settlement between two rival gangs. I was entering an art-historical moment. Hirst sat opposite Lucian, lit a cigarette and started to pick his brains. How had he survived the art world for so long? Freud's response was carefully gauged, very matter-of-fact; he wasn't giving anything away and more or less shrugged off the question. Damien's pal then started to snipe at Freud as though he were some old fuck, more or less

saying he should depose himself and relinquish all power. I snapped back at him, saying he was ageist, at which point a brief shouting match ensued, momentarily bringing everyone in the room to a standstill.

Eventually things calmed down. Freud wanted to get back to his studio, so we departed, one disorganised band of drunks. Outside, the collector Peter Fleissig – a pony-tailed, perplexing, yet noteworthy figure at the time – was stepping out of a cab. 'Peter!' exclaimed Cerith. He went to hug Fleissig and missed, smashing his head on the kerb. Not for the first time, I ended up in the accident and emergency ward of a central London hospital with Cerith who, swab on head, once again asked the duty nurse to report the cause of injury as 'disco damage'. He added, 'Tell me, does my X-ray show any sign of a heart?'

After taking Cerith to hospital, I took a taxi to the Atlantic and rejoined Damien Hirst and his friend, having found them engrossed in a discussion about God and death. As the discussion started to grow lively, a waiter carrying an ice bucket politely interrupted us. He nodded to a nearby table. Two city boys had sent over a bottle of champagne. One of them got up and strode over to Hirst saying, 'Just wanted to say we really like what you do and wish you well for the future.' It was at that very moment that I realised how famous Damien really was. We knocked back the champagne and launched into an endless round of Sea Breezes before setting off on our way home. I emerged from the subterranean world of the Atlantic into broad daylight, the sun rising over Piccadilly. It was a gin-clear day. As I stood looking up at Eros, blinking, I thought to myself, thank God Dunkin' Donuts is open.

Gilded Gutter: Farewell to old Bohemia

A SLEAZY NEIGHBOUR to all that surrounds it, Soho was never one to give the impression that it would be the next up and coming area. Since the eighteenth century, this little enclave had become a haven for wave after wave of refugees, including fleeing Greek Christians and French Huguenots. The subsequent carnival of artists and revolutionaries who came to settle here saw off the more respectable families and contributed to the area's reputation for all manner of social impropriety. By the 1800s, the area was rife with prostitution, occupied by music halls that helped pave the way for the revue bars and clip-joints that took root during the post-war period.

By the 1970s, Soho found itself at the centre of Britain's sex industry, thanks in part to a corrupt local constabulary who came under scrutiny during the 1980s. Walking through Soho during the late Eighties, I remember seeing a naive German businessman being whacked in the face after leaving a strip parlour for not having paid the extortionate bar bill that accompanied a couple of glasses of champagne and a brief exchange with an exotic dancer. Soho was a dirty place, a centre for a criminal underworld that was widely known for its connections to sex and drugs.

For artists, however, Soho was rich in cultural heritage. Throughout the Fifties and Sixties, little bars and restaurants such as the Colony Room and Wheelers had become associated with the likes of Francis Bacon and Lucian Freud. This gave Soho a certain fascination for the younger generation, who like Bacon seemed hell bent on testing the precariousness of adult life.

Images of artists such as Bacon, who recklessly indulged in excessive drinking binges and spent nights frittering away cash in casinos, held an elusive appeal for younger artists, who were eager to rediscover life in the gilded gutter.

As we reached the mid-point of the Nineties, the younger generation of artists had asserted their ownership of Soho. A new late-night trawl was established: either the Groucho Club or Atlantic until midnight, then the recently opened Soho House until three; and after that, until eight in the morning, the Venus Emporium, a mere stone's throw away.

The Venus Emporium was perfect in every way. The polar opposite of the Atlantic Bar and Grill, in my view it was one of the best watering holes in Soho ever. A dreamy, smoke-filled pit that sold cans of lager with images of Page Three girls on the side of the tin, Venus was a bona fide dive bar in the true sense of the word. It was located on the corner of Frith Street and Old Compton Street, beneath a dusty old sex shop, its shelves yawning with porn. To enter involved throwing a knowing smile at the man who sat, bored and expressionless, behind the counter. Just inside was an anonymous-looking door. One press of the buzzer, and the latch clicked. Smile, buzzer, click, and down a steep flight of basement stairs into a mass of post-club maniacs, sex workers and transvestites.

For a fleeting period during the winter of 1995, Venus was the place to be. The owner was a stocky Irishman. Blunt and to the point, he was fiercely proud of his latest enterprise. I met him early on, having staggered in there on a tip from a French chef who promptly downed a bottle of GHB as soon as we arrived. I went back a few days later and met the owner, who was full of beans having just put up some posters from a travel agency to cheer the place up – Greece, Athens, Malta. In one area of the bar stood a pool table that was an obvious source of pride. The bar itself consisted of an old kitchen counter and some eco-nasty fridges. And that was it really, a makeshift bar with a pool table.

Illegal bars were a great tradition in Soho until Westminster Council, with the controversial Dame Shirley Porter at its helm, went on the rampage and

closed them all down. Located in shady basements or on the floors above minicab offices, they were the kind of places where one would lose all sense of time. Sometimes they charged a few quid to get in, and most sold booze, as well as other substances, from under the counter. At the time, crack was just a small cloud on the horizon. Other late-night watering holes included the Spanish dive bars up in Hanway Street, a dark backwater alley behind Oxford Street and Tottenham Court Road; these were, on the whole, far more civilised and legally licensed. The Venus Bar, however, was in a league of its own. After rolling out of the Groucho or Soho House, the only other option in the immediate vicinity were the minicab offices in Cambridge Circus, which were really shifty venues, basically shooting alleys, or Hanway Street where the bars were sometimes difficult to enter without membership and, given their acceptability, quite dull.

Venus became the haunt of choice, being right there on Old Compton Street, a dark, dank basement with a twisted form of democracy, especially around the 'winner stays on' pool table. Looking around, you could always spot a pimp. Abigail Lane would be chatting to Damien Hirst, while Pete Burns (the lead singer with Dead or Alive) pouted in the corner with his inflated purple glitter lips. On the other side of the room leading international curator Hans Ulrich Obrist would be talking to Cerith Wyn Evans while Anthony Fawcett, who had been in the art world since the 1960s, would introduce people, as he always seemed to be doing, to a young Japanese woman. Having spent all my taxi money on more beer, I would bide my time until the underground reopened.

Some years later, Mat Collishaw wanted to use an illegal dive bar as the location for a photo shoot. Along with Tracey Emin, we went out one evening to track down just such a bar in Soho. We eventually found what we were looking for in Great Windmill Street, high up on the top floor of an old house. At the top of a flight of stairs we entered a dark room reeking of bleach. It was early evening, practically first thing in the morning by dive bar time. The room was empty except for two Jamaicans. One seemed to be in charge of the bar

while the other would occasionally open up a little window and peer onto the street below. Emin and I sat round a small table drinking beer while Collishaw, in an attempt to explain the kind of seedy location he was looking for, showed the barman his portfolio of photographs of naked boys taken in Naples. I wondered how our Jamaican friend would interpret these images.

Meanwhile, the other barman continued to peer through the little window. I had a feeling that something was wrong; something was coming our way. Suddenly the other man lurched back from the window. 'It's them! It's a raid!' Tracey looked at me. I remained rooted to the spot, beer in hand. There was a slow booming sound as the front door was repeatedly hit by a battering ram. I looked over at Collishaw, 'Er, Mat. Why don't we get out of here?' I started down the long flight of stairs and as I reached the ground floor it occurred to me that I was trying to escape through the same door that was being rammed – not such a great idea, I thought. Time was slowing down. Boom! As I slid to a halt in the hallway I could see the doorframe splitting. Boom! The door was going to go at any moment and the first thing that the police would see would be me running toward them. BOOM! The door flew down the hallway like the wing of an exploding plane and landed at my feet. The next thing I knew I was being arrested and pushed against a wall as a stream of uniformed policemen piled up the stairs to be greeted by two Jamaicans, Mat Collishaw and Tracey Emin.

Out on the street it was a freezing winter's night. The police took my details and let me go. I stood across the road, stamping my feet to keep warm. Finally, out came Collishaw. 'What did the police make of your work, Mat?' I asked. More to the point, where was Tracey? We waited and waited, for about an hour. At which point we grew so tired of having nothing to do but wait outside that I went up to a policemen guarding the entrance and told them, confidentially of course, that the lady was with us. 'The girl in there is not mixed up in anything, really. She's OK.' 'I know she's OK, sir,' replied the policeman with a rather cheeky swagger. 'She's bound to be fine in a room with twenty police officers.' Eventually, Emin was released and emerged into

the street. She was a little shaken at first, but by the time we made our way down Shaftesbury Avenue she was laughing. As it turned out, a friend had given her a gift – a toy bear dressed as a policeman – that she kept in her bag. While being searched, a policeman had found her cuddly toy and looked at her as though to say, what the hell is this? Emin looked up at the officer and smiled one of her toothy grins. 'He's my little friend.'

The Venus Emporium would later spawn Venus 2 in a basement behind Leicester Square; same sort of operation, same stocky Irishman, same tins of beer with beaming breasts. Somehow Venus 2 took the wind out of the original venue in Old Compton Street, which came to be referred to as Venus 1. Memorable as the whole Venus scene was, everyone's fascination with the place started to wane. Two venues were confusing, especially when people who were trying to meet one another ended up in the wrong place. After the demise of the Venus Emporium, there was no natural successor. The Groucho Club was becoming pissed off with artists and their cohorts getting wrecked all the time. Greens would eventually close down, while Soho House asserted its status as a membership club and adopted a 'sod you' door policy that saw everyone being turned away who wasn't a member.

There was a move to revive the flagging fortunes of the Colony Room with a rota of celebrity bar staff like Jay Jopling and Sam Taylor-Wood, but overall the buzz started to seep out of Soho, and it began to take on a different guise. Soho had once been a receptacle of memories, recalling images of Francis Bacon standing in empty doorways, but its former film-set appeal was rapidly being dismantled to make way for a brand new production that had little to do with artistic romanticism.

The transformation that gripped Soho during the mid-Nineties was indicative of the years ahead as London, along with the bodies that governed it, came to recognise the merits of the creative industries in the wake of the crash. A number of communication companies had settled in Soho, partly inspired by the rapid rise of design collectives such as Tomato, established in 1991, whose youthful affiliates had gone on to produce campaigns for

Adidas, Levi's, MTV, Nike and Pepsi. Graham Wood of Tomato, who was well known to all at *Frieze* through his friendship with editor and designer Tom Gidley, was producing award-winning videos bearing his signature use of 'ambient' or out-of-focus text.

One of the by-products of Tomato was the band Underworld, who dominated the mid-Nineties music scene with powerful electronic anthems that would have everyone singing along to the repetitive chant of 'lager, lager, lager'. Global products still needed to be branded and there was an emerging youth market, if not in the UK then elsewhere. The way a product was promoted started to assume ever greater significance, especially when it came to the launch of something cool and niche. The sudden influx of design and communication agencies to Soho would play a defining role in its regeneration. In many ways, this was the computer generation coming of age, the arrival of creative young geeks who had grown up using Quark Express. Collectives such as Tomato helped to define the look and feel of the Nineties as their design aesthetic started to filter through various advertising campaigns, music videos and the idents on terrestrial TV.

Another factor that would impact on the changing face of Soho was its sexual orientation: within a very short period of time it went completely gay. Whereas before there might be said to be a homosexual bias, the emergence of the so-called 'gay village' in the Nineties came about as Soho, with all its associations with the sex industry, started to clean up its act. In the aftermath of the crash, many local businesses had folded or been moved on, allowing the 'pink pound' to seize the initiative and take charge of Old Compton Street. It was surely a sign of a boom-bust economy that the gay community, in the absence of any families to support, had enough disposable income to allow likeminded businesses to flourish in an area formerly associated with heterosexual strip joints.

There was also a change in the make-up of the restaurants and shops. For some reason I thought that Soho, of all places, might resist the oncoming tide of consumerism. But no sooner had the thought crossed my mind than

one or two chain restaurants started to appear, initially sticking out a like a sore thumb. Nevertheless, this all added up to an improving picture for London as normal service was resumed in the surrounding shops and business, especially on Oxford Street which had been badly hit by the crash. The capital was starting to haul itself out of the doldrums, but into the bargain came the death of old Bohemia. As Soho went digital, I experienced the demise of London's oldest artistic quarter. Artists started to spend more time in the vicinity of their Old Street studios, and I no longer felt the impetus to hang out in Soho night after night. Our business, it would seem, was now in the East.

Bones on a Plate: The scene heads East

BY 1996, CLERKENWELL, an area directly to the east of Oxford Street, had found itself at the centre of the London art world. There were two reasons for this. First, Angus Fairhurst and Sarah Lucas took a studio on the top floor of an old workshop on Clerkenwell Road. Secondly, St John Restaurant – which originally opened at the end of 1994 in nearby St John Street – was about to come into its own. While Angus and Sarah threw open the doors of their studio, St John represented unexplored territory.

A short walk from the cast-iron gates of Smithfield Market, St John Restaurant was situated in an old smokehouse used until 1967 for smoking ham and bacon. The atmosphere as one walked into St John was one of clinical sparseness, as though it were a cross between a butcher's and an old English dining room, with a stainless steel bar set against high ceilings and whitewashed walls. A flight of industrial metal steps ascended into the main restaurant, where solid wooden tables and chairs covered in thick white linen created the air of an establishment that was both radical and traditional. Unlike the Atlantic, there was no art, just a long line of coat hooks running along the walls. The menu promised 'nose-to-tail eating' and listed unexpected animal parts, including some old English rarities such as squirrel, pig's intestine, and Old Spot chop. For its sheer eccentricity and culinary perversions, the art world would seize upon St John as its own.

Most nights chef Fergus Henderson could be spied in the kitchen working away in his blue and white apron, occasionally lifting his thick round specs

to wipe the sweat from his bright red face. Lifting a ladle from a steaming pot, he might take a sip and let out an expression of wide-eyed delight. There was always something of another era about Fergus, a jolly fine chap whose day was punctuated by mid-morning seed cake and Madeira, followed by lunch, high tea and supper.

Fergus, who co-founded St John with Trevor Gulliver, would become a much-loved regular on the art scene along with his vivacious wife Margot, who was unstoppable at parties with her high kicks and flailing ginger hair. It took Margot no time at all to befriend all the artists and gallerists in town. There was also the wonderfully spirited Jon Spiteri, a slight, bespectacled chap who worked as general manager having come from the French House in Soho where Fergus had established a forerunner to St John in the upstairs dining room. Jon would eventually move aside to allow the ever-charming Thomas Blythe – who meets and greets to this day – to take the reins.

Evenings now started at St John with a large plate of roasted bones from which one could scoop marrow with a long metal stick, followed by an impromptu party at Angus and Sarah's in their oblong studio with windows on both sides. As soon as they moved in, Angus laid a hardboard floor and covered the strip-lights with multicoloured plastic. There was always the odd artwork lying about, books, photographic lamps and a sofa. Finishing touches included speakers hung from the ceiling and a temperamental CD player that became the centre of attention as the evening wore on. There were always arguments about what to play next, whether it be The Specials, Roxy Music or anything by David Bowie.

Over the coming months, a string of impromptu parties was held at Angus and Sarah's studio, as well as film screenings on a huge TV set donated by Dave Stewart of the Eurythmics; an avid collector of works by Angus and Damien, Stewart once commissioned Hirst to make artworks for the cover of his solo album *Greetings from the Gutter* (1995). The television that Stewart donated was so unwieldy that it took four people to lug it up to the top floor. One night, Angus staged a performance in the studio of his band, Abandon

Abandon. As the front man, Angus, standing tall on stage, seemed composed and highly focused. He would sway back and forth with a microphone but never sing. Pauline Daly danced throughout, Gary Hume was on guitar and another young artist, Philippe Bradshaw, pretended to play a drum kit. It was surreal. The accompanying music consisted of the opening bars of well-known pop songs looped back to the beginning and played over and over again, very, very loud. Meanwhile, the band gave an impression of what it was like to appear in a pop video without so much as uttering a word or making a sound. The place was packed with artists, curators, gallerists and members of the Groucho Club. The opening bars of Nirvana's 'Smells Like Teen Spirit' would strike up but never reach the moment when the drums kick in and the melody begins.

Fairhurst's band would become a vehicle with which to explore the notion that a recognised structure – such as a pop song – might readily be tripped up and thrown into a Möbius curve of absurdity. In this way the band was central to Fairhurst's fascination with what in its reduced form might be described as cybernetics, in particular feedback and closed circuit loops. Such concerns might also be found at the heart of an audio work entitled *Gallery Connections* (1991 – 96). Having rewired two telephones headsets, Fairhurst was able to call two London galleries simultaneously so they picked up the phone at the same time. Hence the Royal Academy found itself connected to the Tate Gallery, Victoria Miro to Waddington's, the Lisson Gallery to Anthony d'Offay, and so on. With everyone the receiver of an incoming call, each party goes on to dispute the fact they'd called the other until some deduce there must be something wrong with the phone. Others, having declared the name of their respective gallery in the manner of a jaunty hello, simply pause, say nothing, then hang up. Remaining mute throughout, Fairhurst recorded these encounters, producing a transcript that was first published in *Frieze* magazine in 1991. In many ways, Fairhurst's band was as an extension of projects such as these, as well as his work in other media, which included collage, drawing, photography, video and sculpture. Abandon Abandon would perform on many different occasions throughout the

Nineties, most notably in a dark vacant building in Soho where the volume was so thunderously loud that people found themselves returning to the outside world completely disorientated.

Pop music was now regularly being referenced in the work of young artists. This was, after all, a generation who had grown up with the rock revolution of the Sixties and Seventies, and ingested a plethora of titillating new pop videos since the Eighties. Alongside Fairhurst's activities, there were other art bands such as Martin Creed's Owada, who made their first appearances in 1994 when the artist showed up in a truck outside an opening at the Independent Art Space in Chelsea. Parked directly opposite the gallery, just a few feet away from the front door, the plastic tarpaulin along the side of the truck was rolled back to reveal a three-piece band with Creed on vocals and guitar, Keiko Owada on bass and Fiona Daly on drums (later to be replaced by Adam McEwen). All three played their own instruments, and the music was tight, simple and very precise. They proceeded to perform a live set in the street, and when the police finally arrived they drove off.

Working with the band, Creed found a way to apply his structural concerns to a music score. Like his work in other media, such as his sculpture *Work # 88* (1994) consisting of a sheet of A4 paper scrunched up into a ball, both the lyrics and the score were highly reductive, amplifying the notion of having little to say. As with his neon sign *the whole world + the work = the whole world* (2000), Creed proposed an equation in which the importance of 'the work' is zero. What did all this nihilism add up to? In Creed's case the answer was invariably nothing, or an affirmation that nothing is something. The sentiment expressed in Creed's more orthodox practice also found its expression in Owada, whose playlist included songs entitled 'I Like Things', 'I Can't Move' and 'I Don't Know What I Want'. One Owada song started with Creed counting the band in, '1, 2, 3, 4 . . .', but rather than stop there, he proceeded to count all the way through to one hundred. As an encore, the band returned to pick up where they left off and proceeded to count from 101 to 200.

Nights at Angus and Sarah's studio had a habit of descending into absolute chaos. Casual conversation at the beginning of the evening would give way to dancing and mayhem. Cerith Wyn Evans struck mind-boggling poses in his underpants, his arms twisted vertically above his head like a thorn bush. Pauline Daly would sway her hair, while Philippe Bradshaw went ape, or at least bore an uncanny resemblance to one by the end of the evening. Throughout, Russell Haswell growled at the top of his voice 'Say you're a human toilet!' Russell, or Russ as he more commonly known, was an ardent hedonist. He had a shaved head and always wore an outlandish Adidas tracksuit, dark blue with bright yellow stripes. One of his stunts was to intentionally allow one of the lenses from his dodgy sunglasses to pop out as he was talking, which happened with increasing regularity the more he drank.

Russ worked as the Chapmans' studio assistant and made an indirect contribution to their work through his puerile and often pornographic sense of humour, which was nevertheless absolutely hilarious. He was also a DJ with a penchant for banging techno and Japanese noise music. For Russ, being a DJ was an aggressive physical act. He played music so loud that it no longer made any sense, and under his influence speakers and amps would literally explode. At a studio party held by Wolfgang Tillmans, a packed room was subjected to a barrage of noise followed by the abrupt sound of needles skidding over vinyl as Russ tore records off the turntable and threw them against the wall. He was a hardcore maverick. Russ was top.

Philippe Bradshaw was another wild one, the kind of man who would place an unopened box of fireworks on a bonfire and casually walk away. Bradshaw wore chunky leather jeans and had wild shaggy hair. He had a penchant for rave music and was ecstatically happy much of the time. With his girlfriend Andrea Mason, he had a son named Fila, after the sportswear manufacturer. I first met Fila when Philippe and Andrea brought him into Dick's Bar at the Atlantic not long after he'd been delivered. As collaborative artists, Andrea and Philippe would drive into the country searching for

Second World War bunkers. For most people, these foreboding edifices reek of modern warfare and piss, and the bunkers are littered with used porn magazines. Andrea and Philippe would photograph these neglected concrete relics and turn the images into fridge magnets, or spend their days fitting stained glass windows into the machine-gun slits and planting wispy flags atop.

By now, the scene had its own momentum. While the YBAs were becoming increasingly associated with hedonism and excess, no one from the outside world knew the half of it. Nights on the town no longer ended with the cry of last orders and clang of the pub bell, but the inevitable cry of 'let's go back to mine'. We were becoming more and more adept at supporting ourselves in the pursuit of staying up late. Just around the corner from Angus and Sarah's studio, a late night supermarket sold bottles of vodka under the counter. Where there's a will there's a way, and everyone was finding a way to keep the party going.

As things went East, I found myself playing further afield. Living in West London meant I had to cross central London in order to get home. One night I shared a taxi with Sadie Coles, who fell asleep on the back seat while I sat upfront taking in the empty city. We drove past the junkies at King's Cross before picking up speed along Euston Road and diving into the underpass, watching the reflection of the overhead lights strobe across the car bonnet. On Marylebone Road we'd pull up at traffic lights alongside yawning drivers, the warm blast of air from the car heater helping to soften the comedown, then straight up the Westway and down the winding streets to Notting Hill, to bed and the maddening sound of the dawn chorus.

FN: A death in the family

AS A JOBBING writer, now contributing to all sorts of publications, it was one of those jarring moments that I thought would never happen. I had just received a call from *Time Out* asking me to write an obituary for Joshua Compston, a friend who ran Factual Nonsense gallery, or FN as it was otherwise known. I knew that he had died recently, but it seemed very odd to be asked to write an obituary when I was still mourning his loss. Regardless, it had to be done, and over the coming days I sat in my flat and struggled to write two tiny paragraphs, detesting every second of my assignment.

Joshua's body lay unattended for four days. His close friends, who lived in an artists' block across the street, assumed he was out, which wouldn't have been unusual for Joshua who often burnt the candle at both ends. They noticed a light had been left on in the gallery, day and night. If Joshua had stayed at the gallery then he'd normally turn all the lights off before climbing onto a makeshift bed above the picture store. It was odd that he'd left his lights on. As the days passed, people grew more and more concerned that something was wrong. At one point the landlord entered to turn off the light, before returning the next day to pick up a fax. There was still no sign of Joshua. Nor was there any sign of him when his former girlfriend, Leila Sadeghee, came round to pick up her laptop and noticed his briefcase beside the office desk, raising speculation that Compston may have run off to South America, a threat he had made on several occasions as a means of escaping debt. The fatal discovery was made late on Saturday night after his

stepfather requested a closer inspection of the premises, including the platform above the picture racks.

Aged 25 years old, Joshua Compston died on Wednesday 6 March 1996. He will be remembered as a brilliant young man whose sheer ebullience founded a vibrant art scene in Shoreditch. In 1992, Compston moved to Charlotte Road – then considered a quiet backwater. After graduating from the Courtauld Institute he established Factual Nonsense; not so much a gallery, as an artistic ideal. Stickers bearing the 'FN' logo soon appeared on lampposts, buses and tubes. In the summer of 1993 Compston organised 'A Fête Worse Than Death', featuring artist-run stalls the length of Charlotte Road, and Damien Hirst and Angus Fairhurst dressed as clowns. A flurry of flamboyant press releases announced another event – a week of activities in a local pub with guest performances by artists such as Tracey Emin and Leigh Bowery, and artists serving drinks behind the bar. Compston went on to curate 'Other Men's Flowers', an edition of artists' prints that included works by Gary Hume, Gavin Turk and Sam Taylor-Wood. The edition was launched in a derelict building with no roof. Compston's great skill was as a catalyst and, having put the local area on the map, he embarked on his most ambitious 'FN' production – 'A Fête Worse Than Death 1994'. This time Hoxton Square was filled with artist-run stalls; there were video installations, performances by artists and the Beijing Opera, as well as live music by Minty and the Ken Ardley Playboys. In 1995, Hoxton Square was reactivated as the site of 'The Hanging Picnic' – an esoteric festival with artworks hung from the railings and trees. Recent ventures included the 'Jack Duckworth Memorial Clinic', a service aimed at curing people of addiction to TV soaps by introducing them to the world of art and culture – a typical example of his flair for bombastic enterprises. Joshua Compston touched

many people with his energy and wit; his untimely death leaves the London art world stunned.

Rather than the exhibitions and events held at his gallery, Compston is perhaps most likely to be remembered for 'A Fête Worse Than Death'. As a very real manifestation of the way in which many of the young artists at the time were supportive of one another, and operating in an almost collegiate fashion, 'A Fête Worse Than Death' brought out the entire London art world for the equivalent of a village fair in the heart of the city. On the morning of Saturday 31 July 1993, fifty trestle tables were set up around the junction of Charlotte Road and Rivington Street, in what was then considered a backwater of Shoreditch. As yet, there was little evidence of the trendy design studios, bars and coffee shops that would eventually descend on the Shoreditch and Hoxton area. At the weekend, the area was completely dead and Compston seemed to have the run of the place. He had spent the previous weeks enthusing the artists, many of whom had studios within easy walking distance, and the stalls that appeared that day ranged from the absurd to the surreal.

As part of their contribution, Damien Hirst and Angus Fairhurst dressed as clowns and set up a stall selling little paintings. Using an inverted electric drill and a piece of wood onto which they could fasten sheets of paper, Fairhurst and Hirst were able to recreate a once popular children's game that consisted of washing up bottles filled with paint and an old record player cranked up to 78 rpm. A spin painting bought at the fete cost £1 and was signed by both artists on the reverse. For an extra 50p the artists would reveal their spot-painted bollocks, an elaboration on the part of their make-up artist for the day, Leigh Bowery.

Artists who participated that year included Adam Chodzko, who presented his pubic hair exchange, and Gary Hume, who dressed as a Mexican bandit and sold tequila shots on a sand-covered stall. Gavin Turk's 'Bash a Rat' invited people to clobber a rat made out of old socks. Dropped

down a grey plastic drainpipe set at an angle, the rat shot out of the other end as punters tried to hit it with a baseball bat. What at first seemed the simplest of tasks proved to be virtually impossible as, one after the other, people mistimed the rat's exit, venting their frustration with wild scythe-like swipes.

One of the more unusual entrants that year was an artist called Rod Dickenson, who hinted at having taken part in the production of the mysterious crop circles that had appeared without explanation in fields around Britain. The phenomenon was blown up in the media as having something to do with UFOs. Meanwhile, it took Dickenson only a few seconds to debunk such theories when he produced a plank of wood with a length of rope running from two holes drilled at either end. Slinging the rope round his shoulders, he leant back to lift the plank before pressing it down on the floor, using his foot to illustrate how he could push the wheat back and by repeatedly doing so develop whatever pattern he liked. Having taken the wheat from these fields, Dickenson then set about baking 'crop circle bread', which he sold from his stall.

John Bisard and Adam McEwan offered 'Advice About Absolutely Anything', while Tracey Emin gave 'Essential Readings' about the future from people's palms. Dressed in a schoolgirl uniform, Gillian Wearing was accompanied by a mysterious accomplice known as The Woman with Elongated Arms, who hugged people as Wearing took Polaroid photographs. The local pubs were open all day and the nearby Tramshed building was filled with more traditional fairground attractions. The event was an immense success and the day ended with people dancing in the street, while Compston was carried aloft by his compatriots chanting 'Long Live Joshua!'

'A Fête Worse Than Death' had come to epitomise a generation gripped by a profound sense of togetherness. Other events would follow, including the second Fête Worse Than Death held in 1994, as well as a continuing series of more conventional openings at the Factual Nonsense gallery. But as the Nineties trundled on, Joshua fell foul of his own inability to manage his financial affairs. While proficient at addressing other people's woes – on one

memorable occasion, he wrote a letter to Thames Water on behalf of Gary Hume, with the result that a bill that arrived at his studio for approximately eight and a half thousand pounds was written off meanwhile Compston, forever the writer and visionary, struggled with the basics.

I once encountered Joshua at his wits' end. In confident, though despairing tones, he informed me that he didn't even have the money to organise an event that would generate money. He pointed out that I simply didn't face the same problems. Being a writer, all I needed was a desk and a bit of space, whereas he had to bear the associated costs of running a small business. I pleaded with Joshua to think long and hard, that there must be a solution. If only we could have come up with an idea there and then, but I sensed that Compston had been down this path a million times before. He could have approached anyone for money, but the fact was he already had, and all forms of benevolence had been exhausted. I don't think anyone thought that Compston's problems would become insurmountable in the way that they did. If only he had hung on a little longer and found his footing in a more affluent art world. But for the time being most of Joshua's immediate friends were struggling to get by.

On the morning of Compston's funeral, a congregation gathered outside Factual Nonsense. A memorable photograph taken at the time would later appear on the front page of *The Ditch*, a local magazine published by Gordon Faulds. Taken from a rooftop, looking down onto Charlotte Road, the photograph shows everyone milling around Joshua's coffin, presently resting outside the gallery. Gary Hume and Gavin Turk had painted the coffin after a William Morris design. Among the pallbearers were local architect Andrew Waugh, Angus Fairhurst and Max Wigram, who had established the Independent Art Space in Chelsea. Wigram did his best to take charge of proceedings as the casket was heaved into the air.

The coffin was packed with personal effects that were deemed to have been far too important to Joshua during his lifetime to leave behind. By all accounts the pallbearers had to mask their discomfort under the combined

weight as they lurched down Great Eastern Street and then Commercial Street; Hume put his back out. Led by a mournful New Orleans jazz band, Joshua literally stopped the traffic as his funeral procession made its way to Spitalfields Church where the coffin was temporarily laid to rest outside. Gilbert & George, for whom he had worked as a model, looked on with expressions of great sorrow, providing the assembled photographers with an image that would dominate the press the following day. One of Joshua's old school friends, Ben King, made his way to the pulpit and delivered an uplifting speech, referring to a day spent rowing when they made a pact that one would speak at the other's funeral should such an occasion arise. King's speech brought back memories of Compston's amusing turn of phrase.

For some, Joshua was a difficult man, but for a great many others he proved himself to be an amazing character and no one could underestimate the impact of his death on those around him. At the time, word went round that he had died from drinking ether (liquid holophane), casting doubt on whether it had been a terrible miscalculation on Compston's part or suicide. The nature of his death, while later tagged as accidental, was initially undisclosed. It is true that Joshua kept an antique bottle of ether in his gallery, it being typical of him to hoard objects of morbid curiosity in his office. He had a fascination with the past. On one occasion he presented a Christmas cake, duly dishing it out with slices of cheese. As we were eating it, he proudly informed everyone that the cake had been made at the time of the Crimean War and had remained in a self-preserving state ever since. His gallery press releases smacked of past glories associated with the British Empire. As with most of his output, he would blend his colonial syntax with a twist of Pythonesque surrealism, often issuing completely unorthodox proclamations. 'We stumble across a museum, perhaps even just a peep show manned by Bob Marley, who in a fussy haze of miscommunication and slipping on the zebra crossing of articulacy and inarticulacy, attempts to sell us some dirty postcards of Art Brut personages, Pre Colombian symbols and piles of Madagascan produce.'

Joshua once sketched a map of Shoreditch showing me the streets and alleys where he wished to erect barricades so that the area might be sealed off from the outside world. His business plan for the second 'Fête Worse Than Death' in 1994 is peppered with headings such as 'Llamas, Goats, Pigs, etc', or mention of the group Long Pig, who were described as 'a thundering, confused menace of a band. Bass and drums provide a pounding, sludge like ground over which the rantings of singer S. Bill career like the shards of a pint glass smashed on a dismal Saturday night.' I once captured a typical conversation with Joshua on film, in which he outlines his vision for the future: 'I want everyone to wear coloured shirts with a Gold FN logo here on the collar.' I asked him why he thought everyone, especially artists, should wear a uniform. 'So we can look onto the future. Look onto wild freedom, look onto unequivocal change, the possibility of social slippage . . . start again. We'll see, we'll see.'

To create a picture of the kind of world Joshua would have us inhabit, I ask you to imagine the following. It's a bright sunny morning in London, not a cloud in the sky. Having barricaded itself off from the outside world and fighting an isolated war against those who would rather watch soap operas, Shoreditch is free at last. Squinting in the daylight as they emerge from garrets and workshops, artists brush plaster dust from their uniforms and proceed to greet one another with firm handshakes. The war-ravaged streets are lined with FN bunting as artists once again set out their stalls in time-honoured tradition. But then, much to everyone's consternation, the drone of lumbering bombers can be heard in the far distance. Surely this can't mean another raid! Then comes wave after wave of airborne formations spelling out the FN logo. Victory is ours!

Battleships fire salvos off the Suffolk coast and cheers ring out as Compston, wearing his familiar white Nehru jacket, steps up to address the nation. Tapping a large hexagonal microphone, the local public address system sparks into life and a mighty voice booms down the corridor of Charlotte Road. 'Comrades!' Hats fly into the air as people ascend to even

greater heights of jubilation. Thanking his compatriots on the road to freedom, having lost many along the way, Joshua proceeds to attack his repressors. What right had they to even question such a visionary? What barbarism! After a tangential statement about the merits of traction engines and how such machines, belching noise, dirt and foul odours, prove popular with young and old alike, Joshua looks into the skies once more calling for people to rebuild and start afresh, for tomorrow belongs to Factual Nonsense! At which point everyone launches into a rendition of the FN anthem as people stand to attention and rejoice across the homeland.

The evening before he died, Joshua attended the Jean-Michel Basquiat opening at the Serpentine Gallery. Many were struck by the coincidence – the New York graffiti artist died prematurely of a drug overdose in 1985. Compston was last seen in public later that night at the Barley Mow pub in Shoreditch.

With Compston's passing, the art world lost a remarkable young man. The abruptness of his death would leave behind a mere sketch of what could have been. One of his more lasting legacies might be said to have been the role he played in the reinvention of a formerly rundown pocket of London. It was Joshua, along with the artists who lived in Shoreditch, who would ultimately put the area on the map. FN events such as 'A Fête Worse Than Death' were truly memorable occasions that ushered in the birth of a new artistic quarter. Like many people, I expect, I find it impossible to walk around Shoreditch nowadays and not be reminded of Joshua. If he actually came bombing round a corner I'd probably say 'Hi' as though nothing had changed. I just expect him to be there, part of the brickwork, making his way up and down the corridor of warehouses on Charlotte Road like there was still much work to do.

In the immediate aftermath of Joshua's death, there followed a crushing low. No one could stop talking about it. Not long after that, I found myself struggling to write Compston's obituary for *Time Out*. Finally emerging into the daylight, I went to visit Angus Fairhurst at his studio. We were sharing a cup

of tea when the phone rang. Angus picked up and said it was for me, which seemed highly unusual; I didn't think anyone knew of my whereabouts. Sally Long-Innes, an old friend of mine, had somehow managed to track me down so she could break the news that another of my close friends had passed away earlier that morning. I just couldn't hack it. I fell into a deep depression lasting two weeks before deciding to hit the town wearing a sarong. I drank a whole bottle of tequila, which somehow put things into perspective and helped clear the fug that had descended over me. A few weeks later, I got paid for a catalogue essay and decided to buy a ticket to New York.

FN: A DEATH IN THE FAMILY

Manhattan, Return: Hirst at Gagosian

THE WEIGHT OF my depression was lifting as I ascended into the skies above Heathrow. It was May 1996 and I was flying out to see Damien Hirst's solo exhibition at Larry Gagosian's gallery in New York. 'No Sense of Absolute Corruption' took place in SoHo, this being before Gagosian took over a massive space in Chelsea. Even the drive into Manhattan seemed cleansing as I headed into the mass of bright lights. With darkness descending, I put on my best outfit and headed out into the night.

The strict door policy at the opening lent the evening the air of an Academy Award ceremony as queues formed outside and people pleaded to be let in. Several celebrities attended, including Anna Wintour and David Bowie, who took turns to congratulate Damien on what was unquestionably a great success. Suave and sophisticated as always, with his manicured grey hair and sharp suit, Larry Gagosian greeted people of immeasurable wealth as they made their way toward him through the throng. Bemused New Yorkers looked on, saying they hadn't seen anything like this since the Warhol days. The place was packed.

Jay Jopling was on top form and clearly enjoying the evening, which was great to see, especially as the city was awash with rumours that Hirst had left White Cube to join Gagosian. Even though this wasn't true, people naturally assumed that Larry, who was well on his way to becoming one of the biggest contemporary art dealers in the world, wouldn't take long to consume all of Damien. The show itself was loud and noisy, a carnival of new works featuring

a huge ashtray filled with cigarette butts, an inflatable beach ball held aloft by a blast of compressed air, dissected cows, and spin paintings that rotated slowly on the wall. The spin paintings were a recent development for Damien, having emerged from the first 'Fête Worse than Death' in 1993. Hirst had later enlarged on the idea and designed a machine that would allow him to pour paint on circular canvases measuring over two metres in diameter.

After the roaring success of the opening, we all decamped to the after-show party which was being held at a club called Pravda. When we got there, the bar manager was standing outside looking tense. He cast his eye over the throng, consisting mostly of Brits, who were becoming increasingly angry. As yet, no one had been let in and there was already a large crowd waiting outside. One young girl was in charge of the guest list and it struck me that Pravda simply weren't prepared for this many people. The manager returned with some assistance and announced, 'OK, everyone whose surname begins A to J report to this lady over here, K to Z please stand over there.' It was like being back in the dole office.

There were so many people at the party who knew each other from London that it was difficult to imagine having ever crossed the Atlantic. In attendance were Damien, his wife Maia Norman, his mother Mary, and pals such as actor Keith Allen, chef Charles Fontaine and Alex James from Blur. Then there was Hirst's technical crew, headed by Hugh Allan and his wife Rachel Howard, who for many years painted the spot paintings; Jay Jopling, along with White Cube staff Honey Luard and Julia Royse; and plenty of hangers-on to boot. The party had all the attributes of a busy night at the Groucho.

The following day, we spent the afternoon drinking in a bar called Lucky Strike on Grand Street. It seemed only natural that the Brits would reconvene in a pub. Coming from London, there's always something about the light in New York, the way it filters through the blinds, an expansive quality that breathes life into the darkest of hangovers. Passing cars rocked the steel plates in the street outside. There was an ease back then, which meant you

could order another beer, light up and let the day wash over you without a concern in the world. In the absence of mobile phones there was no one to bother us or call us away.

Alex James picked up his cigarettes from the bar and flicked one into his mouth without skipping a beat. He looked better on a hangover, with his scruffy dark hair and Britpop features. Damien was on top form, regaling us with stories about installing the exhibition and the previous night's opening. Ashley Bickerton dropped by, along with one or two other stragglers from London. I looked around me, and realised I was happy. The depression that had threatened to overwhelm me in London was beginning to lift.

But, as they say, bad news often comes in threes. Upon my return to London, I checked my answerphone to discover yet another friend of mine had died. David was a pal from Notting Hill with whom I had first met Tracey Emin at a party in King's Cross. I was later told that he'd weighed down his backpack with bricks and jumped in the Thames. I took a deep breath before calling Tracey, who like me was just getting over Joshua Compston's passing and was taken aback by the latest shocking news.

As we consoled each other over the phone, it struck me that art and mortality seem inextricably linked. Our own mortality in the face of art forms the basis of a complex relationship. The life and times of many dead artists are kept alive through their work, writings and reproductions, and in the minds of those who sense art is of the utmost importance. I'm one of the lucky ones. There have been occasions when I've walked into an artist's studio and encountered a work of such striking importance that, failing some future catastrophe, it will almost certainly outlive my physical presence on earth. To experience the conception of a great work of art and to actually be there at the time of its making, is, for me, a life-affirming experience.

MANHATTAN, RETURN: HIRST AT GAGOSIAN

More Drugs Than Milk:
Welcome to Shoreditch

I COULD HARDLY believe my eyes. I had just agreed to rent a flat with a bedroom covering approximately four hundred square feet, not taking into account the adjoining rooms that occupied the entire second floor of a grand old warehouse. My new apartment was bright and airy, with white walls and a grey carpet. It was situated above a design company called SCP on Curtain Road, EC1, which meant I had to clamber over freshly delivered Tom Dixon furniture every morning in the lobby in order to get out. I was about to rent a vast room with big windows and high ceilings for about the same price as my pokey little flat in Notting Hill. I couldn't wait to become a fully paid up participant in 'loft living' – a term hailing from New York, and now being applied to those residing in converted warehouses in the East End.

The first wave of lofts had been concentrated on Docklands in the late Eighties, where the old warehouses had been completely overhauled in an attempt to attract Yuppies. Arty types such as myself bypassed Docklands completely and headed straight to the low-rent haven of Hoxton, where many artists had been living for some time. Thanks to the likes of Joshua Compston, the area was beginning to gain a reputation as a bohemian enclave – a reputation that would grow as more and more creative types moved in. It didn't matter that my new apartment was infested with rats or there was no hot water. Not that I even knew this at the time – I was just happy to have arrived in Shoreditch. I spent my first night in a bed surrounded by cardboard boxes. The next morning I ventured outside,

stretching in the morning air after my good night's sleep, whereupon I spied out of the corner of my eye a muscle-bound man with a shaved head, yawning like me. Accompanied by a pit-bull terrier, he wore tons of gold jewellery and T-shirt saying 'All Americans Are Wankers'. This was my next-door neighbour.

Moving from Notting Hill to Shoreditch in the mid-Nineties was not as simple as moving from one area of London to another. It was more like moving from England to Poland. When I started living there toward the end of 1996, Shoreditch was pretty much unchanged from my first visits to the area, when Joshua Compston roamed the streets. However, to actually live in this place was a completely different experience from dipping in and out. There were no shops, no supermarkets, nothing in the way of life support except a few old pubs. The only outlet resembling a supermarket of any kind was the twenty-four-hour petrol station on Shoreditch High Street. Yet to aspire to its present glory, it consisted instead of antique pumps and a 1950s grey-tiled hut that offered a very poor selection of sweets, fizzy drinks and crisps, as well as the occasional Scotch egg. It looked like something from an old television show.

One day, the garage was bulldozed after an entire juggernaut full of petrol was emptied into an underground storage tank that had cracked and was spilling fuel into the water table. This posed a very real threat not just to the local area, but to the nearby financial district, the so-called 'Square Mile'. As a precaution, traffic was rerouted and the northern tip of the City, directly to the south of Shoreditch, was evacuated, just in case our local garage blew up. The City had every reason to be jittery. In 1993, the IRA had detonated a car-bomb in Bishopsgate causing immense damage. From my girlfriend's flat overlooking the city, I saw the devastation only a few hours after the explosion and was speechless at the sight of entire streets reduced to rubble, the ceiling insulation of windowless office blocks blowing in the breeze. A press photograph of the destruction, originally offered by Mat Collishaw, would eventually be used on the cover of the publication accompanying the YBA

group show 'Brilliant!' at the Walker Art Center in Minneapolis, raising an eyebrow or two in the direction of the British Council for allowing such a negative image of Britain to be used in this manner. The IRA menaced London throughout the early Nineties. Bomb scares became the norm, and traffic was constantly being redirected as entire neighbourhoods were evacuated.

Even though it was a few minutes from Old Street roundabout, just to the east of Clerkenwell, and a short walk from the City, Shoreditch had few working streetlights. Most nights a gloom would descend over the dark brown brickwork and nestle between the old warehouses, lending the place the air of a Jack the Ripper movie. It was as though the old London fog hadn't budged from this spot, a location, right in the city centre, that had somehow been neglected and forgotten. There were no cashpoints, the nearest being on the corner of Goswell Road some miles away, and no trees except those in Hoxton Square. Even though I practically lived in the City, the centre of the civilised world, there was no television reception. However, what really concerned me was that I was living in an area where there were more drugs than milk. As well as attracting artists, the low rents had also attracted dropouts and drug addicts caught up in the local heroin racket: drugs were everywhere, while milk was a scarce commodity. With no local shops, I was forever staring forlornly at cups of black tea. I asked a dealer one day who lived in a warehouse connected to my fire escape if he had any milk. He looked at me as though I was completely nuts.

If the area wasn't completely consumed by drugs, it was certainly soaked in alcohol. There were several old Victorian pubs about the place with lock-ins where tired old landlords took money off you regardless of who you were; artist, off-duty policemen, office worker, builder or local bum. Over the next couple of months I sank ever deeper into the slippery bowl of excess otherwise known as the Shoreditch Triangle, hemmed in by Shoreditch High Street, Old Street and Great Eastern Street, the area that Joshua Compston had suggested we barricade off to the world. At the weekend the streets were

empty and there was something incredibly liberating about being able to walk through Hoxton down to the City without seeing a soul.

The most convenient pub at the time, and in many ways the best, was the Barley Mow, right next door to where I lived. Within a short space of time I was on very good terms with the landlords, Ian and Iris, who knew all the struggling artists from the adjacent studios and lofts. I spent many a cold night at the Barley Mow, especially as the old warehouses had no central heating and were like refrigerators in the winter. It was the only place where I could stay warm, and it became a front room of sorts. When I had no money, Ian would feed me on fried eggs and chips and ply me with Bull's Blood wine. When my boiler went down, he gave me the keys to the pub so I could use the upstairs bathroom. Iris was Ian's partner. They often made out that they couldn't bear to work alongside each other and would take turns to work alternate shifts. Iris was an old girl always to be found leaning against one end of the bar. Wearing a white roll-neck jumper, she'd flick her sandy wedge of hair, and casually burn my ears off with the crudest jokes I've ever heard.

Although she had run the Barley Mow for several years, Iris had never been to Hoxton Square, a two-minute walk away. I offered to take her once but she shrugged saying, 'It sounds lovely Greg, really it does, but . . .' She wasn't one to be bothered; such a trip would serve no other purpose than to take her out of her way.

I encountered a number of characters living in Shoreditch. Given that everyone was living in squat-like conditions, a genuine sense of community flourished as people simply had to get to know one another in order to get by. Living in Shoreditch, you felt completely cut off from the outside world. No one would come out to you because they couldn't even find your address on the system. After all, these warehouses were never supposed to be domestic apartments. For the most part people were living illegally in what the local council had down on their books as workshops or retail units. Artists invariably occupied a floor high above the street. There were no buzzers in those days, no hope that the front door would conveniently click open.

Instead, standing in the street below, you had to ring the person you were going to see on your recently acquired mobile phone. After a while they would appear at a window high above and drop the keys down in a sock so they wouldn't get damaged.

When I moved to Shoreditch, girls were still a mystery to me. I was such a devotee of the art scene that I had become a hedonistic nerd and for much of the Nineties I avoided relationships. Very early on I made a ridiculous vow to myself that I would never go out with an artist. Given my track record of turbulent relationships ending in disaster, my pledge was partly born out of the belief that not only would this confine me to one person with a limited set of friends, but if I split up with said female, then my social life as I knew it would be over. I always remember my friends being very straight and conservative when it came to relationships. Unlike New York, where many artists were openly gay, those associated with YBA were deeply heterosexual. No matter how many times they seemed to change partners, they were always with someone; everyone that is except for Tracey Emin, who like me seemed to go without for long periods of time. One day in 1995, however, I had a date with a young girl living in nearby Ladbroke Grove who kindly invited me round for dinner; the ensuing scenario vividly illustrates my priorities at the time.

That summer, Jay Jopling had asked me to do the rounds of the student degree shows in London to see if there were any new artists worth pursuing. As payment, I received a Gavin Turk plaque, one of the plastic editions. I was thrilled to be the owner of a circular piece of blue plastic that read 'GAVIN TURK, Sculptor, worked here, 1989–1991'. Based on the kind of heritage plaque that one sees all over London, they came in two different versions. The original version was in ceramic and was entitled *Cave* (1991). Gavin originally presented his plaque, dedicated to himself, at the Royal College of Art to mark the end of his two-year MA course – a celebration of his own importance as expressed through his Manzoni-inspired alter ego. While it seemed a good idea at the time, Turk failed his course because of this piece

after his end-of-year assessors took exception to what they viewed as an example of Turk's petulance.

I was very grateful to Jay for giving me an edition of Gavin's plaque. I held it in my hands and studied it carefully, before banging a nail into my bedroom wall. It was very pleasing to know that I owned number five in an edition of a hundred. It was the first serious artwork I ever owned, and I found myself staring at my plaque for hours.

While my date was cooking on that fateful evening I took a peek into the bedroom of the young artist with whom she shared the flat. The room belonged to Darren Almond, who was working as a gallery technician at the time but who would eventually be represented by White Cube. Peering into his bedroom from the hallway I noticed that he too had a plastic edition of Gavin Turk's plaque. I was seized by curiosity as to its number. Could it be earlier than mine? As the smell of fast-approaching food wafted down the hall from the kitchen, I tiptoed into his room, carefully took the plaque off the wall and turned it over. Number forty-eight! Hardly as impressive as number five.

Feeling ridiculously proud of myself, I carefully placed the plaque back on the wall and took a step back to see if it was properly aligned. Then wooosh! Like a shot, the plaque slid off its pin and fell behind a radiator. I leapt over to try and retrieve it, but it was caught in a piece of curled-up old wallpaper. All I could do was slide the plaque back and forth, the radiator's mounting brackets making it impossible to ease it out sideways. I heard a call from the kitchen: 'Dinner's nearly ready!' I had to act fast and took one last big wrench. I finally had it out and in my hands, but I could barely open my eyes.

The blue surface was covered in scratches, revealing the brilliant white plastic beneath. Thank God Almond was out for the night, but what was I going to do? I had a brainwave. I went into the kitchen and said I was popping out to buy more wine. I then slipped back into the hallway, picked up the plaque from where I'd stashed it by the door and ran back home as fast as I could. I was pained to remove my edition from the wall, but swapping my perfect plaque with Almond's seemed the only thing I could do.

On the way back, I leapt into an off-licence and grabbed a bottle of wine. Turning into the kitchen as though nothing had happened, I deposited the bottle on the table, whisked back into the hallway, picked up my plaque and carefully positioned it on Darren's bedroom wall.

When I got home that evening I sat in my room, staring not at number five in the edition but number forty-eight, which was damaged beyond repair. Over the months ahead, I thought about every conceivable way of repairing the plaque and somehow sneaking it back into Almond's bedroom without anyone noticing.

With the art world cut off to me as a viable gene pool, Shoreditch offered a sexual awakening. I was beginning to experience a schizophrenic separation between my private and public life. While I played host to a string of international artists, thanks to my curatorial work, at the same time I was going it alone and befriending a whole new set of hedonistic night owls. I had an irrational fear that certain friends of mine, especially those in intellectual and institutional circles, might jump to the conclusion that I was slumming it if I told them the truth about my Shoreditch nights.

Even though a number of artists now lived locally, including Abigail Lane, the Chapmans, Mat Collishaw, Gary Hume, Gavin Turk and the artist duo Tim Noble and Sue Webster, I found myself bypassing the artistic community and throwing myself in at the deep end. London was opening up to all sorts of new experience, especially in the East End with its illegal bar and club scene, as well as the pub lock-ins and weekend warehouse parties. While Shoreditch was sleazy as hell, it nevertheless allowed for a bohemian existence that simply wasn't to be found elsewhere, not in Paris, not in Berlin, and certainly not in Notting Hill. There was always something going on, friends to be found at all hours holed up in some corner of 'The Ditch'. You could go anywhere you wanted, for as long as you wanted, and always encounter a familiar face.

Charlie Wright's International Bar on Pitfield Street didn't look like much. The use of the word 'international' above the door made a spurious claim for a brutalist brick-built East End boozer, one of many that dotted the area, none

of them touched since the 1950s. However, once inside, surrounded by the warm glow of fruit machines, it felt like a New York speakeasy, or so I thought. Charlie's, as it was locally known, represented the front line between the white middle-class kids from Shoreditch and the working-class population of Hoxton. For the most part, hardened alcoholics and Africans from the surrounding estates frequented the bar. I held my thirtieth birthday there and danced until dawn with Gillian Wearing and Tracey Emin, having carried enough loose change to feed the jukebox all night. One evening, John, the mild-mannered African bar manager, a fine figure of a man who always seemed to be laughing, took me to one side and in all seriousness pointed to the old bombsite over the road saying, 'One day, a student hall of residence will be built right there.'

It seemed impossible to believe at the time, but he was proved right. Where scrubland and rubble once existed, came wine bars and restaurants, although not even John – given the undesirability of the area just a few months before – could have predicted the subsequent arrival of a nearby Holiday Inn. The gentrification of Shoreditch became so intense and so rapid that the entire area seemed to be resurrected overnight. Rents soared as trendy bars opened at the rate of one a week. By the late Nineties young people were flooding into the area in search of the hip Shoreditch lifestyle. The hardware shop at the top of Curtain Road was inundated with an influx of architects, designers and fashion students keen to lay their hands on decorating materials.

Rat stories were always a good indication of how long someone had been living in Shoreditch. Gary Hume and Don Brown once managed to get into the basement of the abandoned Victorian power station just behind Hoxton Square, now known as the Circus Space, used to pump power down into the neighbouring financial district. There they discovered an underground conduit, an empty tunnel that once carried electrical cables down to the City. When the construction team began laying foundations for the Holiday Inn on a plot of land that had been undisturbed since the war, one day they drilled

without knowing it right into the conduit from the power station, which ran underneath. The earth started to seethe as hundreds of rats began to pour from the cracked pipe. The workmen had struck one of the biggest rats' nests in London, and the builders downed tools and fled the scene. Grown men, literally shaking, refused to return to work as they relayed their experience to the motley crew assembled in the Barley Mow.

After the mass breakout, rats started to appear in greater numbers across Shoreditch. I remember once making my way down Curtain Road towards Liverpool Street station, totally engrossed in a book, when above the pages I saw a white cat ahead of me. The street was completely empty and as I continued to walk and read, I noticed the cat was hopping up and down. Then came the sudden realisation that I was tailing a huge albino rat, with flaky skin and blood-red eyes. I froze to the spot as it turned to look at me. Ousted from its nest, or just so old that it wanted to die, I decided to give it a wide berth. Another night, on Bethnal Green Road near the old goods yard, a gang of us pulled over in a car to observe a swarm of normal-sized rats huddled around something much larger. At the centre was a king rat. That thing was the size of a dog, I swear. Had I not seen it with my own eyes, I would refuse to believe that such a beast could exist.

One afternoon in 1996, while walking up Hoxton Street, I was asked to stand back by a young man looking up at a crane. Suspended in midair was a large designer hut that was being hoisted on to the roof of the former Shoreditch Electricity Showrooms, a modernist building with high ceilings and tall glass windows on the ground floor. The man who stopped me was Seng Watson, an architect and designer. The proud owner of the hut, he had also taken control of the entire building. We got talking and he took me on a tour of the empty premises. Upstairs were a number of wood-panelled rooms which he planned to convert into two-bedroom flats. When I asked how much he intended to rent these apartments out for, he said about £60 a week. I laughed, saying he'd never get that, this being a time when anyone could buy property in the area for peanuts.

MORE DRUGS THAN MILK: WELCOME TO SHOREDITCH

In the coming months, Seng proceeded to transform the downstairs hall into one of the trendiest bars in the area, itself known as the Shoreditch Electricity Showrooms. Along with the opening of the Lux Centre in 1997, in which I played a part, the area started to come up in the world. Even the streetlights came back on. Sunday nights were spent at the Blue Note in Hoxton Square where Goldie, the resident DJ with his gold teeth and heavy neck chains, invented drum and bass, blasting out electronic beats so loudly that I could feel the vibrations while lying in my bed in nearby Curtain Road. From my front window, I looked out onto Alexander McQueen's studio. One night I watched the young designer as he dressed various models in outfits in the run-up for London Fashion Week. Even Hoxton Street now seemed fashionable after The Verve had chosen it as the location for their seminal video to promote their latest release, 'Bittersweet Symphony'. Shoreditch had become the talk of the town and it regularly featured on the cover of *Time Out* as a trendy destination.

In time, artists and the creative industries that surrounded them would be credited with having been directly responsible for the redevelopment of Shoreditch. In many ways artists were the storm-troopers of gentrification, the first wave of individuals who could be counted on to take over the most basic industrial units and bring them back to life. Young artists, especially those starting out in the world, required little more than physical space; it was sometimes enough that the building was under lock and key. Over time, they would introduce running water and basic electrics so they could put on the kettle and have a cup of tea. In order to save money, many artists I knew chose to live in their studios, installing basic showers and small cold-water sinks. Mattresses started to appear behind hastily erected stud walling constructed from plasterboard sheets, and a kitchen would evolve some-where in the corner. Shelves would go up for coffee jars and tins of food before the long-awaited arrival of a fridge. Once the television was in place, the artist's studio had become more like a multifunctional home. But just as the place was becoming habitable, landlords had a canny knack of

introducing service charges and the like, or doubling the rent. Booting out the artists, the space would then be passed on to a group of designers or affluent young architects. Once the landlord had had enough of them the entire building would be emptied out and redeveloped into apartments. Many artists would suffer at the hands of merciless property developers, but the more successful would finally dig in. Some ended up buying a property.

As the seasons changed I took out a stepladder and taped up my windows in preparation for the cold winter winds. Listening to the radio, I sensed a growing optimism sweeping the nation that things might be changing for the better, not least because the Tory government seemed to be losing its grip on power after a string of sleaze allegations. John Major's 'Back to Basics' campaign, an otherwise uninspired attempt to restore morality to modern politics, had spectacularly backfired as the media tore into the hypocrisy that plagued the Prime Minister's own cabinet. Men in suits, previously upheld as fine figures of authority, were sent to jail for perjury, while John Major was later exposed for his extramarital affair with Tory MP Edwina Currie. In marked contrast, the old Labour party had emerged from its musty pupa with an energetic young leader, Tony Blair. Changing its name to New Labour, the once notoriously discordant party underwent its own form of trendy gentrification and began to reposition itself as a serious contender for the next year's general election. Moreover, they seemed to be speaking the same language as the rest of us. For a brief moment it seemed as though the entire nation was brushing off the cobwebs in anticipation of far-reaching political transformation.

After the rise of Shoreditch, which over the years has been transformed like no other area of London, I found myself walking down the same stretch of road where I'd once spied a king rat. My companion stopped, dumbfounded, pointing to the scaffolding surrounding the old Jewish synagogue at the top of Brick Lane. 'Look at all this development. It's out of control! No wonder the artists can't afford to live here any more.' I started laughing. What my friend didn't realise was that Rachel Whiteread was

renovating the synagogue, while young artists Tim Noble and Sue Webster were refurbishing the warehouse directly behind with the help of architect David Adjaye. The image of the struggling artist, working away in an East End garret, would soon be changed for ever.

Turner Prize: The roaring Nineties

TO BE INVITED to a Turner Prize dinner held at the old Tate Gallery in Pimlico, at the time the only Tate Gallery in London, was a big deal. The first time I received an invitation, in 1995, I gasped in disbelief and immediately called my mother. The Turner Prize had been established through a combination of public and private funds, and I had been watching it on television at regular intervals since 1991, when sponsors Channel 4 broadcast the event for the first time. Without question, it would prove instrumental in communicating the rise of young British art to an increasingly attentive public, while ushering in an age of corporate sponsorship that would dominate the art of the Nineties. From its outset the Turner Prize proved a model for how a public institution, reeling from Thatcher's cutbacks, might actively seek corporate sponsorship and publicity. Sponsored by Tate patron Oliver Prenn in 1984, the first award went to Malcolm Morley who, having lived in America since 1958, wasn't even around to collect his prize. The American investment company Drexel Burnham Lambert became official sponsors until 1989, when they – along with everyone else, it would seem – went bust. There would be no prize ceremony in 1990.

Having become director of the Tate in 1988, Nicholas Serota negotiated the handover of the prize to Channel 4, who agreed to produce short documentaries on each of the shortlisted artists and broadcast the award ceremony. Under Serota, the terms and conditions of the prize were reassessed. Before 1989, it could be given to anyone who worked in the arts,

Serota himself having been nominated in 1986 for the reopening of the Whitechapel Art Gallery. By the time the Turner Prize bounced back in 1991, it was decided that the £20,000 prize would only be given to an artist under fifty years of age whose recent work was deemed by a small panel of judges to be sufficiently outstanding. Given the prize's foundation as a response to ever-decreasing state support, it may seem ironic that the artists who stood to benefit the most were the YBAs. What started life as an initiative pitched from the heart of the art establishment, would serve as a barometer for the creative surge that swept the board in the Nineties.

Rachel Whiteread was nominated in 1991, but remained seated as the more established sculptor Anish Kapoor went to collect the prize. In 1993, Whiteread was nominated again and this time won, becoming the first female artist to be awarded the prize. The assembled diners were jubilant and there was a tangible sense that the award was gaining a real sense of purpose, especially in view of the unfolding drama surrounding Whiteread's *House*. This was perhaps one of the most extraordinary and controversial projects of the YBA era. Constructed at 193 Grove Road in East London, in the shadow of nearby Canary Wharf, it found itself at the centre of a debate involving a local authority, the media, the Tate and the House of Commons.

House involved the casting of an entire Victorian terraced house in concrete. Along one side of Mile End Park, a whole row of houses had already been demolished to make way for a green corridor that would extend towards nearby Victoria Park. In order to secure the last remaining house left standing, the London-based arts organisation Artangel – who commissioned Whiteread's piece – applied to the London Borough of Tower Hamlets with respect to taking over the building prior to its demolition. However, it wasn't long before the project met with fierce opposition, notably from Liberal Democrat councillor Eric Flounders who claimed to be speaking for the local community when he condemned the project as utter rubbish.

Ex-docker Sydney Gale and his family, who still lived in the house, initially rejected offers of alternative accommodation, the local authority finally

announcing they would move out at the end of July. Throughout August and September work went on in earnest as new foundations were laid and casting began. But precious time had been lost. Anxious that the completion date was perilously close to the end of the lease, Artangel went back to the council to try and obtain an extension. Having cracked open the outer walls, the project was finally unveiled to the public six days before the lease expired on 25 October. There it stood: a magnificent cast of an entire house with all the attributes of solidified air, redolent of distant memories and frozen time. Here was a monument, not to the Great War or colonial repressors, but to the basics in life, the mundane, the journey from cradle to grave.

Under pressure from the government, Tower Hamlets eventually granted an extension to the lease, but the destruction of the house was inevitable. On 12 January 1994 a digger was sent in and the building was torn down. Once the concrete blocks were removed and the land turfed over, that was it. No more house, no more street.

Even though the Turner Prize was derided from every corner – and especially from within the art world, which resisted the idea of artists being subjected to a competition – it soon became a vehicle that would help validate a younger generation who simply refused to stand in line and wait their turn. In 1992 Damien Hirst found himself on the shortlist but the prize went to Grenville Davey, who produced smooth, curvy minimalist sculptures. Many found the decision hard to believe, especially as Hirst's ICA show – which ran from December 1991 to February 1992 – had been extremely well received. It was Hirst's first ever institutional show and included an array of spot paintings, vitrine works and shelves of encapsulated fish. It also included the seminal work *I Want to Spend the Rest of My Life Everywhere, With Everyone, One to One, Always, Forever, Now* (1991), consisting of two upright sheets of glass forming a T-shape above which a lone ping-pong ball was suspended on a jet of compressed air.

While Davey's career did not progress, Hirst would have to wait until 1995 when he eventually found himself at the podium, winner's cheque in hand.

That Hirst won the prize the second time around seemed to many long overdue, but others were convinced that the whole thing was a fix, the Tate having been sufficiently embarrassed by its earlier decision to make amends at the expense of the other shortlisted artists, who might understandably bear a grudge. Hard to imagine that Hirst might lose the Turner Prize twice, an honour previously bestowed on Lucian Freud who, having been nominated in 1988 and 1989, failed to win on both occasions.

For as long as the prize has been in existence, it has courted criticism, not only from a sceptical public, but from various media pundits. People have criticised the prize for being intentionally provocative, for not having enough women on the shortlist, for having too many women on the shortlist, and for there being too few artists of colour and not enough painters. Throughout the Nineties several complaints were levelled at the prize, leading to a series of public outcries. That the prize occasionally finds itself at the centre of heated debate is partly because it is a victim of its own success. As the Nineties went on, both the audience figures for the accompanying Tate exhibition and the televised broadcasts would steadily rise.

The award ceremony itself was a black-tie event, making the evening infinitely more interesting if only to see the young artists of the day, who might ordinarily wear jeans and T-shirts, decked out in formal attire and dickie bows. Upon entering the towering Duveen galleries one could sense the excitement emanating from the hubbub inside. Against a backdrop of sumptuous landscape paintings, a battalion of waiters delivered supper to those lucky enough to have secured a seat. Put it down to naivety, but the art world was much smaller back then and people were less inclined to play down their views. Many got drunk and chose to vent their feelings about who should win and who, in their most profound opinion, should not. There was quite an atmosphere as people clattered through dinner in anticipation of the final announcement. In 1994 Charles Saatchi, himself a Tate patron in 1984 when the prize was conceived, stood at the podium and pondered what young artists had been putting on their cornflakes in the morning in

order for them to be doing so well in the big wide world. One hoped the word he was searching for was sugar, not cocaine, as some muttered under their breath.

The event would peak during the Nineties, with large numbers of people flying in especially for the occasion, lending the evening an air of international significance. A media sensation was guaranteed the following day and the winner was invariably granted a slot on the front page of the newspapers with a taunting strap line reading something along the lines of 'who on earth would pay this much for that?' The television cameras panned the room and people basked in the glory of knowing that absent friends were watching events from afar. They even used to watch it in the Barley Mow with everyone crowded around the television. Soon after the winner's cheque was presented, coffees were knocked back as hardened smokers braved the cold riverside air for one last cigarette. Chauffeur-driven cars waited outside, three deep against the kerb. Meanwhile, a gang of us would jump into a taxi and head across town, each of us determined to attend at least one, if not all four, of the artists' parties being held that night. Fleeing the scene, it felt like the Roaring Nineties were in full swing.

In 1996, Sam Taylor-Wood's Turner Prize party was held in Abigail Lane's loft. The cocktails were individually named after Taylor-Wood artworks and at a makeshift bar in the corner people were calling out for a 'Killing Time' or an 'Atlantic'. Everyone descended on Abigail's loft that night. It had all the ingredients of the quintessential Nineties London party, hosted by White Cube and with countless YBAs in attendance. Alex James was present, as were Jarvis Cocker and Steve Mackey from Pulp. It was a big splash of a party; people arrived directly from the prize ceremony, tumbling out of a lift with a sliding lattice door.

Thanks to the Turner Prize there was now widespread public recognition of what everyone was up to. As we zipped across town from party to party, taxi drivers started to take an interest in contemporary art and were all too happy to share their views. Even my mother knew what I was on about when

I mentioned White Cube, or that I was going out to meet Tracey Emin, or flying off to Berlin to see an exhibition by Sarah Lucas. If my mother knew what I was up to, then it was a sure sign that the outside world wasn't exactly clueless.

Eating Out: Art, restaurants and fame

IN 1996 FLORENCE hosted the Art Moda Biennale, which consisted of several collaborations between artists and fashion designers. One of the more successful partnerships that year was that between Helmut Lang and New York artist Jenny Holzer, who exhibited pulsing digital display boards in a conical grey hut. Damien Hirst's collaboration with Miuccia Prada resembled a small city farm with real animals housed in a white shed and a single large black dot on the wall. Elton John, another featured 'artist', was credited with having curated a show, rather gushingly entitled 'Metamorphosis', that included a variety of stage costumes and a video projection of a live performance. I was a cynic, and to me it looked like a stuffed parrot perched on a piano with the TV left running in the background. But the Art Moda Biennale provided yet another excuse for me to hop on a plane and be at the centre of the action. Armed with our new mobile phones, we were able to coordinate our movements with military precision, descending on a bar or restaurant at a moment's notice. That evening, Maia Norman and I sauntered past two armed guards into a full-blown banquet in search of Damien, who was inside talking to David Bowie. Thereafter, I spent much of the night running around bars, at one point pulling up to have pasta with Jarvis Cocker who was in one of his more downbeat and philosophical moods, mulling over the future of Britpop.

It was becoming clear that some of the artists I knew were not just in the company of celebrities, but had become celebrities in their own right. Hirst

in particular was a national icon and seemed to have no problem whatsoever operating in celebrity circles. It was no longer the case that he courted famous people; instead they were beginning to court him. Several young artists I knew were gaining a reputation for dining out in the most exclusive restaurants, and were not averse to stepping out in Gucci suits. On the way to Florence, Hirst and his entourage had been invited by Miuccia Prada to go on a supermarket sweep of the company's headquarters in Milan. By the time they hit Florence, everyone was dripping in brand new outfits, wearing amazing black suits and beautiful shirts, brand new leather shoes and belts.

On the last day, hung-over, we made our way to the airport. Being something of an anti-hero, Jarvis, sporting a checked Prada hat, didn't like to make a big deal of his fame. He was, after all, the singer of 'Common People'. Security at Heathrow was still intense after the airport had been targeted by IRA mortar attacks in 1994. Given the heightened state of alert, it came as something of a shock when Cocker's metal hip replacement (he'd fallen out of a window in his youth) set off a metal detector as he passed through customs. A massive celebrity in the UK at the time, featured on countless magazine covers, Jarvis had already caused a stir on the plane. Young fans had been coming up to him constantly, asking 'Are you Jarvis Cocker?' To which he'd dryly reply, 'Yes, I am the Jarvis Cocker.' Frozen to the spot, he coyly looked up at the customs officials and pointed to his hip. It seemed like an outrageous fashion gesture. Lights flashed above his head as British holidaymakers turned to each other, asking 'Isn't that Jarvis Cocker?' It was a Kodak moment, a snapshot of fame. Here was Cocker, desperate to pass through Heathrow unnoticed, accompanied by Damien Hirst and friends, with lights flashing, alarm bells ringing, and everyone's trolleys piled high with brilliant white Prada bags.

Hirst's entrée into the world of pop music can be traced back to his promotional video for Blur's hit record 'Country House' in 1995. (Coincidentally the video for the band's earlier hit 'Parklife' was shot in River Way, the street where Hirst once lived with Carl Freedman and Billie

Sellman.) Ever since then, Hirst had been instrumental in bringing Britpop and YBA into ever closer proximity, chiefly through his expanding social network and nights spent at the Groucho. He was eager to work on bigger projects, such as pop promos, that in turn might lead to full-blown film productions. But Hirst's attempts to extend his credentials in this field were thwarted soon after he screened his short film *Hanging Around* at the Hayward's 'Spellbound' exhibition in 1997. Shot in Richard and Judith Greer's home in Notting Hill, the film starred Eddie Izzard and Keith Allen and was universally panned. It was the first time that people, who might otherwise claim to be fans of Hirst, appeared visibly let down. Later, the band Fat Les – led by Keith Allen and featuring Blur's Alex James, Joe Strummer and Hirst – also fell by the wayside after the release of 'Vindaloo', a hooligan-style rant released to coincide with the 2000 World Cup. Miraculously, it went to number two in the charts and came to characterise 'lad culture', as epitomised by the yobbish interaction between Allen and Hirst. The follow-up single 'Naughty Christmas (Goblin in the Office)' came and went, and people began referring to Fat Les as Fat Loss. While success in the music and film industry would elude Hirst, however, there were other avenues to explore, especially those that might enable him to piggyback on his widespread fame. By now a wealthy young man, Hirst sought to invest his money in restaurants.

On the surface the Atlantic Bar and Grill was a runaway success, and its owner, Oliver Peyton, was becoming well known as a groundbreaking restaurateur. Every new venture he opened called for an art world celebration, partly through his involvement with Sadie Coles who had successfully managed Peyton's liaison with the YBAs and a number of other international artists. In 1995, a year after he opened the Atlantic Bar and Grill, Peyton launched Coast on Albemarle Street. At the time, Peyton's latest offering was a very slick operation with an extremely expensive menu. Decked out with designer furnishings, the interior was bright and airy thanks to the large windows that overlooked the street, which made for a noticeable change from the nocturnal world of the Atlantic. Nowadays, there's a tendency to take

such restaurants for granted, but at the time it was a new development in the otherwise languid and old-fashioned world of London eateries. For the long back wall, Peyton commissioned Angela Bulloch to produce one of her drawing machines, whereby a marker pen is guided along vertical and horizontal axes, activated by the sound and movement of the assembled diners. It was a smart piece to bring to a restaurant setting.

Peyton then got involved in the opening of Mash, just behind Oxford Circus on Great Portland Street, which housed a microbrewery with large fermentation tanks on open view. Mash had a lounge seating area on the ground floor and an alcove surrounded by backlit photographs that had been cleverly manipulated by American artist John Currin. Instead of his more familiar paintings of busty women, Currin had taken five old-fashioned advertisements depicting people playing golf, tennis, white-water rafting, riding a sleigh and frolicking on a beach. In each case, adoring women surround a central male figure. Whereas the men are seen to be smiling, Currin had artfully erased the joyful smiles of his female admirers with hand-painted grimaces and sneers so they seemed resentful or vaguely terrified by the man in their midst.

Whereas most restaurant owners nowadays might target footballers or models, in the new London scene it was artists and their coterie who were considered the bright young things. Without really noticing it at the time, artists were being wheeled out to bring added kudos to a place, to make it hip and happening. Maybe their presence would help attract other young people with spare cash. Suddenly in demand, art featured in all the right magazines and the artists were seen posing in cool portrait shots. In 1996 Peyton invited a number of special guests, including several art world figures, to the Manchester opening of his latest venture Mash & Air. Mash was the name given to the restaurant, while Air was a cocktail bar situated on the top floor. A number of us assembled at King's Cross station in the early afternoon and were handed first-class tickets for the long journey ahead. I hooked up with Mat Collishaw and promptly proceeded to get so trashed on the free champagne that graced the tables of our private carriage that I have no recollection of the restaurant

itself. What I do remember, however, was the long line of cars that greeted us at the station to take us to the restaurant, and the sudden rush to leave as soon as word went round that the last train to London was about to depart. Staying overnight in Manchester was not an option.

At the end of 1996, Quo Vadis in Dean Street was relaunched under the auspices of Marco Pierre White, who took care of the catering, while Damien Hirst agreed to look after the art. The coming together of Hirst and White generated much discussion about the comparisons to be made between these two tempestuous individuals. Both hailed from Leeds, although White bore no trace of a Northern accent. Aged thirty-three, he had become the first British chef, as well as the youngest in the world, to win three Michelin stars. Unlike Hirst, White cast himself as a roguish toff who preferred to hang out with the upmarket players who frequented his restaurants. Like Hirst, however, he had a reputation as an enfant terrible who took great pleasure in producing unusual dishes such as pig's trotters cooked with a blowtorch – a shock tactic of his own that he performed on television.

In the upstairs bar, Hirst displayed one of his large glass vitrines filled with stainless steel medical implements. Included as part of the 'Damien Hirst Collection' were several works by his contemporaries, among them Abigail Lane, Angus Fairhurst, Mat Collishaw and Sarah Lucas, as well as American artist Sean Landers who was represented by a huge painting of a clown rowing a boat in high seas. White would work his magic on the ground floor in the restaurant, while Hirst had free rein of the bar upstairs.

In the restaurant, the service was immaculate thanks to a host of tiny Frenchmen wielding enormous trays that narrowly missed everyone's heads. Many of the artists whose works adorned the walls were given a tab as a form of payment. Having spent a few hours drinking cocktails upstairs, it was quite conceivable that I might be invited to join an artist's table downstairs where we'd order whatever we fancied. For a period, free dinners at Quo Vadis were my main form of sustenance. In the years ahead, White and Hirst would

memorably fall out. In retaliation, Hirst removed all his artworks, only for White to set about making his own replacements.

Not long after the launch of Quo Vadis, Hirst immersed himself in designs for a new restaurant based in Notting Hill that would be entirely themed around his work. Whereas before, certain artists may have depended on one or two restaurant owners such as Oliver Peyton buying their work and hanging it on the wall, the roles were now reversed as Hirst set about constructing the equivalent of a large installation in which people would eventually eat. Pharmacy would be filled to the brim with medicine cabinets and other artefacts designed by the artist. Shortly after it opened there was a dispute with the Royal Pharmaceutical Society, who deemed that the name of the restaurant, as well as the items on display, might confuse people in urgent need of medical treatment, not a Cough Syrup cocktail. Rather than change the interior, it seemed easier to change the name Pharmacy to Army Chap, an anagram. Problem solved.

Surely nothing could stand in the way of such an inspired venture? But it wasn't long before the business started to falter. Pharmacy had been set up in partnership with Matthew Freud, nephew of the artist Lucian Freud and widely acknowledged to be a shining light in the world of public relations. Along with Hirst, other partners included Liam Carson from the Groucho Club and Jonathan Kennedy, a business partner of Freud's. In the planning stages, it all must have made perfect sense. Hirst would design the most extraordinary interior, while Carson, Freud and Kennedy would round up the A-list celebrities. However, nine months after it opened, Pharmacy was sold to the Hartford Group, an investment company launched on the Stock Exchange that would eventually be rescued from bankruptcy in 2000. Damien was furious about the sell-off as the restaurant took a turn for the worse. In an interview with Gordon Burn for the *Observer* in October 2001, he vented his frustration at Matthew Freud, leaving the lasting impression that the two were seriously at odds.

As for me, I only went to Pharmacy once and can't say I recall seeing any

food, let alone being in the mood to eat. Although the interior looked OK, it didn't feel like a normal restaurant. The service was already so bad that Hirst had been rumoured to hand out takeaway pizza to appease exasperated customers. Meanwhile the air of exclusivity, on which such an establishment must surely depend, eroded as the place began to empty and anyone could walk in and find a table. The inevitable took place in 2003 when the restaurant finally closed down. But what would become of the art? Who owned it, the restaurant or Hirst? Rather cannily, Hirst had an agreement in place whereby all his artworks and design effects, everything down to the wallpaper and match books, were itemised as loans, making it possible for him to retrieve the entire contents of Pharmacy and consign the whole lot to Sotheby's in 2004. The sale would realise £11 million, with much of the proceeds going to charity.

In the Nineties, there was no way around celebrity. It was central to a venue's success. If there was no celebrity appeal, then people just wouldn't go. Fashionable restaurants were afflicted by a dependency on celebrity culture as though the attendance of famous people might in itself guarantee longevity. Investors with no prior experience seemed to ignore the fact that people – and especially celebrities – are incredibly fickle when it comes to restaurants. The idea of opening a stylish restaurant with art on the walls was a good one, but it was optimistic to assume that such ventures could survive on fashionability alone. For those who courted the in-crowd, there followed the inevitable cycle whereby A-list celebrities would be followed by those on the C list, then the bridge and tunnel brigade, after which came a period of rejection followed by closure.

The key point, one which people seemed to forget, is that it really helps if the food and service are excellent. With the benefit of hindsight, one wonders whether any of these people – Freud, Hirst, Peyton, White – would do it again. Any attempt to answer such a question conjures up the spirit of the age. No one seemed to care about the future, they just wanted to rush headlong towards it. The entrepreneurs of the day were optimistic, and no one wanted to dwell on the past or return to the deep cultural crisis in which

Britain found itself at the start of the decade. Besides which, much of this was new territory, an exhilarating ego-driven gamble in which hundreds of thousands of pounds were invested.

Yet they ultimately struggled to survive. Mash and Quo Vadis remain open at the time of writing, owing to their central London location and the imposition of tighter management controls, but the good times are long gone. In their heyday, these restaurants were epicentres of fashionable London nightlife, heaving with glamorous people having the time of their lives. Who could have guessed what the future held in store?

At the time, though, everyone wanted upward mobility, and it seemed London finally had the momentum to punch through the gloom left behind by the recession. The economy was starting to pick up as investors began speculating on the property market. House prices were on the rise, which meant homeowners were feeling better off and more carefree about their personal finances. Imported goods were being snapped up by consumers who charged everything to plastic, running up huge debts while encouraging the credit card companies to launch a ceaseless campaign to sign up the entire nation. The creative sector was booming, and trendy website design companies were becoming the talk of the town. The music industry was also on the up as the world started to acknowledge that there was something truly unique about the bands coming from England. And for the first time in ages British fashion was on the map, thanks to young designers such as Stella McCartney and Alexander McQueen.

To add to the excitement, it was by no means insignificant that the combined efforts of London's young dealers, such as Jay Jopling and Sadie Coles, were beginning to generate new business. The cross-fertilisation of art with fashion and music would attract the occasional big spender who wanted to rub shoulders with the bright young artists of the day. New buyers not only came from the world of media and pop music, but also from banking, law and property. Little by little the phenomenon of the young British collector was also beginning to find its feet.

On New Year's Eve 1997, with glass in hand, one couldn't have felt more optimistic about our combined cultural initiative, especially when viewed from Pharmacy restaurant, which memorably launched that night. Ducking under a large model of Hirst's DNA and easing oneself into a pill-shaped bar stool, the future looked very bright indeed. Surrounded by reflective glass cabinets containing pristine medical supplies, one couldn't help but think that the future had finally arrived and all was well with Christendom. Hirst and his acolytes were at the helm and there seemed no end to the possibilities that this generation might achieve. Stubbing my cigarette out in a medical dish, I surveyed the world as I knew it. There was wall-to-wall glamour as women wearing medical gowns designed by Prada teetered about the place in high heels carrying trays of drinks. What better way to escort me into the next world, I thought, as one of the girls shimmied over in my direction and presented me with a close-up of her cleavage and another glass of fizz.

Champagne Supernova: New Labour, Cool Britannia and Sensation

1997 WAS THE year when YBA came of age. Jay Jopling married Sam Taylor-Wood, whose first solo show had been at White Cube back in 1995. Young artists were invited to show their work in the heart of the establishment while London was hailed the coolest city in the world. *Vanity Fair* paraded the headline 'London Swings! Again!' Although the infamous cover, picturing Oasis singer Liam Gallagher and actress Patsy Kensit lying in bed together, was dropped from the American edition, Britain's cultural standing in the world was gaining ground. British artists, DJs, pop stars, filmmakers, fashion designers, and finally New Labour, were perched on the crest of a wave. Not for the first time in its history, London could rightfully claim to be a fashionable metropolis.

In so many ways, 1997 was the year the Nineties had been waiting for: the apex of a decade that until now had been chiefly concerned with economic recovery. Political steps taken to assist the country's emergence from the recession were superseded by an overwhelming desire for change, a palpable public sentiment that had been present since the demise of Thatcher. Meanwhile, the question remained, how would recovery announce itself? What would it look like?

When Tony Blair came to power in May 1997, the country was seized by the prospect of positive transformation. Labour's landslide majority was widely perceived at the time as retribution for the cumulative sleaze associated with eighteen years of unbroken Conservative rule. Blair took up

office beaming and victorious, surrounded by adoring well-wishers waving Union flags helpfully provided by party organisers. Here was a Prime Minister who seemed to be an ordinary human being, an emissary for soft politics. No more daunting representations of political authority, no more confrontational speeches; a trendy vicar to some, a man of the people to others. For the media, Blair was a down-to-earth kind of guy, a hands-on politician who rolled up his shirtsleeves during speeches and played electric guitar in his spare time. He parked himself alongside go-getting entrepreneurs such as Richard Branson and designer Paul Smith. Shortly after entering Number Ten, Blair threw a party to acknowledge his supporters within the creative industries which was infamously attended by Noel Gallagher of Oasis. Years of Tory incompetence were swept aside and the slate was wiped clean. The new leader was young and groovy, and everyone breathed a sigh of relief.

1997 also saw the creation of a new term that would summarise all that was emanating from London's fashionable scene. 'Cool Britannia' paid homage to the excitement generated by the worlds of Britpop and Britart, as well as fashion and design. The expression was not new – its first incarnation had been a recording by the Bonzo Dog Doo-Dah band in 1967; it then appeared in articles by Cosmo Landesman in 1993, in reference to a performance by U2, and Waldemar Januszczak in 1995, who used it in an article about the popularity of British art in America; and in 1996 the term was used to launch a new brand of Ben and Jerry's vanilla ice cream. Then in 1997 came the infamous *Vanity Fair* issue dedicated to the capital. By the time the term appeared on the cover of *Newsweek* magazine in 1998, the capital C capital B version was fully acknowledged the world over.

In many ways 'Cool Britannia' was the perfect catchall. While the term was never uttered by Blair himself, it came to be associated with the New Labour government, who were thought to have close ties with the creative sector. Pop and pageantry, avant-garde and establishment had intertwined, and there was an appreciation of British culture like never before. We loved our bright red buses, our heritage and the Union Jack, and we had finally

disconnected ourselves from America's cultural imperialism. Being Brit was cool, and there seemed no better place for an expression of national confidence than London itself, transformed in the minds of distant onlookers into an imaginary stage production.

The same year, John Maybury shot *Love is the Devil*, his film about the turbulent relationship between Francis Bacon and his lover George Dyer. Derek Jacobi took the lead as Bacon, while Daniel Craig (later to play James Bond) was cast as a well-toned Dyer. Meanwhile, the extras consisted of a host of YBAs, including Angus Fairhurst, Gary Hume and Sarah Lucas, all of whom found themselves under the spotlight wearing period suits and berets – my claim to fame being that the film opens with a wonderful shot of the back of my head.

During the making of *Love is the Devil*, everyone was whisked away to locations such as the Colony Room, Anthony d'Offay Gallery and the Café Royal, whose sumptuous interior would double as a backdrop for a dinner given in honour of Bacon's show at the Grand Palais, Paris. It was here that I was asked to greet and shake hands with Derek Jacobi, whose resemblance to Bacon was so uncanny that I was left speechless each time he entered the room. Come the fifth take, I couldn't help but feel I was doing something terribly wrong, at which point Jacobi placed his hand on my shoulder and with a soothing voice suggested I shouldn't be overly concerned by my performance. He paused, before fixing me in the eye and reminding me that film, of course, does cost an awful lot of money.

Meanwhile, things were starting to change at a more basic level. There were still more or less the same number of TV channels, but as an alternative there was Sky. In the pubs, beer was finally being served chilled instead of lukewarm, something of a breakthrough. An order of vodka and tonic now came with ice and a slice of lemon, without even having to ask. The big stores were open on a Sunday, which finally put to rest the Bible day blues when the high street fell silent and litter played in the empty shopping centres. For once, there seemed to be a retreat from the likelihood of political unrest and

the IRA threat receded as talk of a more active role in Europe rose to the top of the agenda.

London no longer looked like a relic from a bygone age, but had a bit of colour round the gills. Docklands sparkled at night, its skyline punctuated by the multitude of skyscrapers that I'd yearned to see proliferate when I first journeyed to the East End. The pubs and clubs in Shoreditch were starting to fill up; it felt as though you needed a weekend pass to enter the throng of revellers who paraded the streets at night. Important international critics considered St John to be one of the finest restaurants in the world, and the overall quality of food and service in London was finally improving. St Paul's Cathedral had been given a good scrubbing, as had several other buildings all the way down to Trafalgar Square, adding to an air of conviviality which suggested a metropolis that truly wished to welcome its visitors, not terrify them like some down-at-heel tramp. London was lifting its face out of a basin of cold bright water and there was much to celebrate. What was more, no one seemed to care how badly we behaved. In our own way, the artists I was hanging out with had become so well known it was as though they had unofficially been handed the keys to the city. I found myself most nights venturing out into limitless social freedom.

Artists too were taking full advantage of the freedom to do effectively whatever they wanted. In 1997 I was invited to curate a show with young co-curator Kate Bush (not to be confused with the famous recording artist) at the Institute of Contemporary Art on the Mall. The ICA's reputation for groundbreaking shows of young artists, such as those by Damien Hirst, Anya Gallaccio and the Chapmans, had made it a place of considerable importance. We had decided to present a vision of an art exhibition that, to the uninitiated, didn't seem to contain any art at all. We invited Polish artist Piotr Uklanski to install one of his disco dance floors, an exact replica of those seen in *Saturday Night Fever*, and we loaned a fabulous sculpture by LA-based artist Jorge Pardo which consisted of two plywood chairs and a coffee table. We also presented round wheelie seating by German artist Tobias

Rehberger decorated in multi-coloured string, and a video of someone having their hair cut, by London-based artist Hilary Lloyd.

While these works alone may have been viewed as contentious, further objections were raised surrounding the inclusion of a Pulp pop video, shown as a massive projection, and a television advert for Tango, a brand of soft drink. However, all of this would be eclipsed by our decision to show a fully working toilet by Sarah Lucas, standing alone in an elegant upstairs gallery.

In 1917, Marcel Duchamp submitted a urinal to the Society of Independent Artists at the Grand Central Palace in New York. The presiding committee declined to put it on public display, deciding instead to hide it behind a partition wall. Himself a committee member, Duchamp resigned in protest over the incident and his urinal entered into legend as one of the most controversial artworks ever made. Duchamp's 'assisted readymade' would set a precedent for future generations of artists who were given the artistic licence to incorporate existing objects into their work. The readymade was widely adopted by the Pop and Conceptual artists of the 1960s and 70s, as well as being firmly embraced by the YBAs, many of whom cited Duchamp as a major influence.

Whereas the original urinal had been artfully displayed on a plinth, lying on its back so Duchamp's cryptic signature 'R. Mutt' was clearly on view, Sarah Lucas went one step further when she started to work with actual fully operating toilets. In doing so, Lucas removed any trace of the word 'assisted', preferring instead to leave her toilets as one might expect to encounter them in everyday life. In 1995, she had presented her sculpture *One Armed Bandits (Mae West)*, which consisted of two elements – a white vest stretched over a chair with a plaster arm wanking a candle and an upright toilet with a chain suspended from a cistern. Perhaps as a reference to male chauvinism the seat was left up. By 1998, Lucas was filling entire galleries with toilets cast in polyurethane resin, or decorated with cigarettes. On one occasion she took a memorable photograph of a toilet with the question 'Is Suicide Genetic?' daubed on the inside in shit-coloured brown paint. For her 1996

solo exhibition of the same name at Contemporary Fine Arts, Berlin, Lucas presented a fully operational toilet for the first time. Impressed, I asked if the work might travel to London to go on show the following year as part of the exhibition I was working on at the ICA.

To install the work meant plumbing it in to the building's existing water supply and running pipes from a hole in the corner to a toilet standing proud in the centre of the gallery. The following day, I was working in one of the downstairs galleries installing Uklanski's dance floor, when someone came up to me and whispered in my ear, 'Saatchi's coming.' It was typical of Charles Saatchi to come round to see a show the day before the opening. This meant if he saw anything he liked, he could snap it up before anyone else. I brushed myself down and went to greet him at the front door. He seemed very laid back and mild mannered, and I was impressed by his knowledge of the artists in the exhibition, many of whom were relatively unknown. We made our way to the upper galleries, and as Saatchi turned the corner into Sarah's room his face visibly lit up. There it was, the toilet, plumbed in and ready to go. Saatchi was amazed. He looked at it from every angle, smirking, sometimes letting out a grunt of mild amusement. It occurred to me that he hadn't quite grasped the piece in its entirety. 'You know it flushes?' I said. He looked at me quizzically. I urged him to have a go. He stepped up to the toilet and tentatively pressed down the lever. The pipes began to gurgle and water started to swirl round the basin. At which point Saatchi looked at me wide-eyed with astonishment and mouthed the word *wow*.

Saatchi's influence seemed to reach its zenith in 1997. For artists in London, the highpoint of the year was the 'Sensation' exhibition at the Royal Academy of Art. 'Sensation: Young British Artists from the Saatchi Collection' will go down in history as the ultimate YBA show. It was no secret that an exhibition planned by Norman Rosenthal, director of the Royal Academy, had fallen through and that 'Sensation' had been the result of a last-minute call to Charles Saatchi about a replacement show. Yet it ultimately paid off in spades; no other exhibition would capture the spirit of the age in quite the

same way. Among those featured in the show were Jake and Dinos Chapman, Mat Collishaw, Tracey Emin, Damien Hirst, Gary Hume, Michael Landy, Sarah Lucas, Chris Ofili, Sam Taylor-Wood, Gavin Turk, Gillian Wearing, Rachel Whiteread and Cerith Wyn Evans.

En route to the West End in the back of an East End minicab, I reflected on what had already been an extraordinary year. Aside from the political upheaval surrounding the May election, astonishing scenes of public mourning had followed the death of Princess Diana. As my taxi made its way across town, I found myself lost in a world of flashbacks. Scenes of a jubilant Tony Blair outside 10 Downing Street were followed by Elton John singing 'Candle in the Wind' at Diana's memorial service; a nation simultaneously united through a landslide political victory and grief. Images of national events blended with those from the art world. In April, Tracey Emin had opened her solo exhibition 'I Need Art Like I Need God' at South London Gallery, while in May Sarah Lucas opened 'The Law' in an abandoned office building in Clerkenwell. Both shows played with the rawness of real life, Emin with her embroidered tapestries crying rape and Lucas with her tabloid papers lining the walls of a nicotine-stained room in a work called *Chuffing Away to Oblivion*. I awoke with a jolt as the taxi finally pulled to a halt and a mental image I'd been holding of Diana morphed into Myra Hindley.

The opening of 'Sensation' was electric, made all the more special by an air of star-studded adulation. Held as it was at the Royal Academy, 'Sensation' validated the YBAs, the majority of whom had yet to show in a major public institution, and certainly not one in the UK. It also announced a shared aesthetic: sensationalism. Here were a group of young artists whose work seemed to mirror the tactics of the more scandalous British media. While this may have been hard for certain artists to swallow, especially those who didn't want to be pegged to 'shock art', the exhibition's title hit the nail on the head. It doubled as a banner headline, a statement and summation of all that was raw and to the point. The title also let slip that the artists concerned were preoccupied with a form of visual attack not entirely

dissimilar to the language of advertising; recalling Saatchi's own campaigns, especially those punchy one-liners that had smoothed the path to Thatcher's political victory. Both the artists and Saatchi were perceived as self-styled entrepreneurs, hotshot risk-takers who took things to the limit. Hitting its audience square between the eyes, 'Sensation' took London by storm.

The Royal Academy exhibition was a field day for the British media. For once, the heat wasn't so much on Damien Hirst, who could always be counted on to cause a stir, but Marcus Harvey, whose portrait of Myra Hindley, imprisoned for life for the murder of five children in 1966, was composed of hundreds of children's handprints. That children had been used to produce a large canvas of a notorious child-killer caused an unprecedented public outcry. It wasn't long before the work was vandalised by protesters in two separate incidents; blue and red ink was thrown at the work, and on another occasion it was pelted with eggs. Tracey Emin's tent would also court controversy. In its present setting at the Royal Academy the work was seized upon by the media as an example of the artist's perceived sexual promiscuity.

'Sensation' gave every impression that Saatchi had owned YBA outright since the word go. Some of the key works in the collection, however, such as Collishaw's *Bullet Hole* and Emin's tent, were only acquired for the collection in the immediate run-up to the exhibition. Realising that he had one or two holes in his collection, Saatchi decided to acquire Emin's tent on the secondary market from Eric Franck, who had previously acquired the work for £12,000. Saatchi paid £40,000. These works certainly helped flesh out his collection, and by placing *Bullet Hole* and Emin's tent alongside Hirst's shark and Harvey's portrait of Myra Hindley, Saatchi could rest assured that his collection would be the talk of the town.

Looking back, the opening of 'Sensation' was, for me at least, one of life's staging posts. Walking around the exhibition gave me the willies. It was like seeing old friends, stuffed and wheeled out on public display. There was Rachel Whiteread's *Ghost*, Sarah Lucas' *Two Fried Eggs and a Kebab* and

Hirst's shark, which looked a little the worse for wear, begging the question, how long would it last? In 1993 Saatchi's curators had decided to skin the original shark and stretch it over a fibreglass mould. (In 2006, Hirst would start work on preparing a new shark for its present owner, American collector and hedge fund billionaire Steven A. Cohen, who acquired the work for a reported $8 million.) Walking from gallery to gallery, I found myself constantly bumping into people. Everyone was there – all the artists, the dealers, writers and curators, and all the collectors on the periphery who, while not as big as Saatchi, might be said to be following in his footsteps.

As I turned around, I received a jolt: there was Hirst's fly piece, *A Thousand Years*. I considered how much I had changed in the seven years that had elapsed since our first encounter. This was the artwork that had given me the impetus to remain involved in the art world. Much had changed since then. I was now a relatively well-known face in art world circles. I knew all the young artists who had once intrigued me from afar when I used to work in the Royal Academy bookshop, next door to the gallery in which I now stood. In the interim, I had become consumed by the art world. I had given myself entirely to endless private views and nights on the town; even now, I was in the middle of another lost weekend.

As I watched the flies buzz around Hirst's vitrine, I saw a different me reflected in the glass. My hair was shorter and my face was drawn. I was in my early thirties, which seemed incredibly old, especially as many of the artists around me had achieved relative success in such a short period of time. For me 'Sensation' was a jarring experience. While much of the work in the show remained strong, it, like me, had aged.

As everyone left the opening and gathered on the steps outside there was much excitement in the air. Artists and friends started to crew up as they had done for years, as they would do after any opening, only this time we were standing outside the Royal Academy. Instead of wondering which grotty old pub to go to round the corner before getting the last tube home, we soon found ourselves in the heart of the West End. It was like a party political

victory of our own. The unimaginable was happening, history was being made, and I finally had a few quid in my pocket. Photographers snapped away as stars and artists made their way through the throng.

We had a choice of bars to go to: the Atlantic, Groucho, Colony, whatever we felt like. London was in the palm of our hands. Eventually, Mat Collishaw, Tracey Emin and I slipped off to a secret post-opening party being held in a suite at the Metropolitan Hotel and attended by, among others, Damien Hirst and Jarvis Cocker. As the evening progressed, I found myself getting very drunk. For a moment I stood swaying at a window surveying a blood-red sunrise over Hyde Park, and it occurred to me that we'd never had it so good. But just as things couldn't have seemed more perfect, Tracey fainted, falling flat on her face with a thud. As Sam Taylor-Wood helped her back on her feet, an uneasy feeling passed through the group. The whole scene didn't look right and the rest of us were too out of it to be of any assistance. It was time to leave.

It seems only too tempting to compare the zenith of 'Cool Britannia' with an incident that took place many years later, like a distant echo bouncing back across time. On Christmas Day 2003 the British space probe *Beagle 2* broke through the Martian atmosphere and roared across the red skies. Sadly, no one would ever hear the nine-note signal composed by members of the band Blur and intended to be broadcast from the planet's surface. Moreover, no one can be sure what became of the miniature spot painting by Damien Hirst that accompanied the mission, painted in chemically tested pigments to withstand the rigours of space travel.

Shortly before the spacecraft's launch in 2003, Hirst boldly declared that if Martians really did exist and had eyes, they would love his artwork. What happened to *Beagle 2* is unknown but we can be certain that the mission didn't go to plan. Some speculate that it hit the surface then bounced into a crater from where it was unable to transmit signals over a great distance. Even if it burnt up in the atmosphere, though, there's an outside chance that Damien's artwork might still survive. Maybe one day *Beagle 2* will be

discovered on the Martian surface, or an exploratory robot will come across a piece of debris that turns out to be his painting, slightly scorched but otherwise in good condition. This was a deeply symbolic moment, a sign of just how far we had come, that artists such as Hirst and Blur had helped sponsor the national space programme. I wonder if this is the last we'll hear of this extraterrestrial masterpiece, the first artwork to reach Mars. At a cost of £45 million, the image of *Beagle 2* careering across the Martian skyline must surely stand as the ultimate champagne supernova in the sky.

Far Out East: Life in Brick Lane

FLIPPING THROUGH THE selection on the jukebox in the Golden Heart, I was surprised to find the national anthem nestling between Abba and Steely Dan. Intrigued, I punched the corresponding buttons and, sure enough, the room began to fill with the familiar drum roll that summons national pride. Then, from behind the bar, I heard a high-pitched sound rising above the music. 'They did it!' The emphasis on the word 'they' suggested that this was important information that the whole world needed to know. Again, but this time even more deafening and prolonged: 'Theeey did it!' I heard an enraged voice from behind the bar mutter, 'Who put this on?' The implications of what was being said dawned on me. 'They killed her!' Given the Cockney accent, *killed* sounded more like *keeled*: 'Theeey KEELED 'er!'

I looked round to see Sandra Esquilant, the landlady, her arms flapping in the air. She was wearing a twinset and pearls with a fashionable designer edge, a wedge of dark hair swept across her face. She looked classy but a bit odd. It occurred to me that I had put on the wrong record. For some reason, I hadn't noticed the Diana photographs on the walls, peering from behind the flowers and scattered in a variety of silver frames along the windowsills. A Diana portrait had even usurped the Pope's rightful position above the till. Sandra placed her hands on the beer pumps and glared at me. Wagging her finger she rolled her eyes, saying, 'I tell ya, *they* bloody did it!' Sandra was utterly convinced that the royals had assassinated Diana. 'It was an inside job, simple as that,' she reminded everyone in the pub, before

pushing her glasses back and pulling the plug on the jukebox. The national anthem ground to a halt.

The Golden Heart had once been smack in the middle of a dead zone. No one came to the area unless they were lost or had business with the fruit and vegetable market, but when that had closed down the area seemed even more bleak than ever. While the antique streets behind the Golden Heart presently number among London's most beautiful, back then they still retained an association with slumland. The buildings were polluted and the only commercial activity in the area was generated from the wholesale shops around Brick Lane. The Ripper murders were projected onto the faces of the drug-addled prostitutes standing in doorways and the winos who drank cheap booze at the foot of the Hawksmoor church.

The local Sunday market was a dodgy affair, with tramps selling insane junk and cockney geezers shifting suspect goods. Every weekend, the National Front handed out leaflets at the top of Brick Lane before charging down the street and smashing the windows of Indian restaurants in their own recreation of Kristallnacht.

Recalling the 1980s in Spitalfields and Brick Lane, my memory of the area is never in colour. It was seriously grim. However, the neighbourhood was kept alive in the minds of young artists through the work of Gilbert & George, who lived in Fournier Street just round the corner from the Golden Heart. They met Sandra very early on, and she still calls them Georgie and Gilbert. In their film *The World of Gilbert & George* (1981) there's a lingering shot over Commercial Street, a busy urban thoroughfare that takes the course of the original city wall to Aldgate. As the camera pans over a bleak urban vista, Gilbert & George describe all they see: 'Asbestos and Aldgate, Spitalfields and spire, branches and banks, ivy and iron, barbed wire and bushes, trunks and tiles, skylight and scrap metal, pigeons and pillars, pub and piles of wood, offices and old chimneys, markets and motorcars.'

Sandra and husband Dennis moved to the Golden Heart in 1978. Sandra is what punk ballerina Michael Clark once described as everyone's London

mum, or 'Mummy Cool' as she would have it. The first YBAs to get to know Sandra were Jake Chapman, David Pugh and Russell Haswell, who during the early Nineties lived in nearby Myrdle Court on the other side of Whitechapel High Street. As rents started to go up in the Old Street area, the Golden Heart began to swell with Shoreditch evacuees. All manner of people started to drop by, and over time Sandra's no-nonsense appeal would endear herself to an entire generation of artists. She fell in love with Gillian Wearing and Michael Landy, who eventually came to live together in a house just behind the pub. She loved Angus Fairhurst and Tracey Emin, as well as Carl Freedman and his then partner Rebecca Warren, a sculptor who was later nominated for the 2006 Turner Prize. She absolutely adored Sarah Lucas, whom she encouraged to pull pints behind the bar. Sandra made it her mission to know all the young artists, eventually earning a place in *Art Review* magazine's top 100 most influential people in the art world.

One morning in 1998 I woke up to find two burly bailiffs standing at the end of my bed. Not a pleasant experience, and one that served to remind me that Curtain Road had officially come to a close. Pissed off at our inability to pay the rent on time, the landlord was evacuating his tenants and it was time to move on. I and several other people from the building hired a van and moved to Wentworth Street at the bottom of Brick Lane. As we followed the path of the old city wall, down Commercial Street, turning off just before Aldgate and Whitechapel, we found ourselves parked in the heart of London's Bangladeshi, Indian and Pakistani communities. Saris billowed in the wind as young Bollywood wannabes sped through Banglatown. It was in this area that we would find Sandra and the Golden Heart.

Even though Shoreditch and Brick Lane are within spitting distance of one another, there remains a world of difference between the two. We were no longer to the north of the City but to the east. Whereas Shoreditch can be traced back to the West End through Farringdon and Bloomsbury, Brick Lane remains cut off to the west by a corridor of corporate towers that occasionally spill out their contents in the form of 'suits' who like a curry and a few pints

at the end of the working week. More than Shoreditch could ever be, Brick Lane is connected to the East End, through Whitechapel and Mile End to the sound of Bow bells.

Along with *Mute* magazine, a digital media publication, we took over a former garment sweatshop in a warehouse called Universal House. Paul Fryer and Mat Collishaw already occupied one half of the top floor, while Tracey Emin would eventually take over the other half. Meanwhile, Philippe Bradshaw converted a lavatory on the landing into a studio-cum-crash pad. In the process, the toilets were ripped out, leaving nothing for him to pee in – the result being the rows of milk bottles filled with urine that stood ominously by the record decks. Every time I passed Philippe's door, there would either be total silence, meaning he was asleep, or speed garage and manic laughter. I once opened the door to be greeted by a wall of sound and a wide-eyed Bradshaw filming three semi-naked women jumping up and down on his bed. His studio started to fill with pieces of coloured aluminium chain as he discovered a way to use each link as a pixel in a much larger picture. In time, he started to produce tapestry-like curtains of classical images made from lengths of chains suspended from the ceiling, on to which he would project his latest films. These elaborate installations were well received and soon gained the attention of New York gallerist Jeffrey Deitch. As his career started to take off, Bradshaw asked Mat Collishaw if he could borrow his studio, where he ended up employing teams of young people to help thread together the coloured chain. After a few months in residence, walking into Mat's studio was like walking into a tinsel grotto. Inside, I met Andrea Mason and photographer Justin Westover, proceeding to haul back layer after layer of chain curtains suspended from the ceiling as Philippe called out from the depths of the studio, 'I'm over here by the ping-pong table!'

On one occasion, I woke up after an afternoon nap and looked out of my window to see the street below rammed with police cars and fire engines. Some racist, homophobic maniac had set off a bomb on nearby Brick Lane.

The sound of the explosion had entered my dream but I had simply brushed it off and rolled to one side. Meanwhile, the entire façade of a nearby Indian restaurant had been blown asunder. Smoke and shattered glass spilled out onto the street and the emergency services had been called out in force. Thankfully no one was killed. As I went up to the roof to join the assembled residents of Universal House, it became clear that we were at the centre of a breaking news story. As it turned out, a handmade device exploding on our doorstep represented something of an opportunity for the artists living in the building as they started to film unfolding events. Sneaking out of the building and through the police cordon, I ended up ferrying small digital tapes down to the satellite trucks, running from one agency to the next, selling news footage to the networks who promptly uploaded our material and beamed it to the outside world.

Brick Lane turned out to be an even crazier place to live than Shoreditch. Like children with a tremendous amount of play space, we were constantly running around at night, hopping up and down in the goods lift and dropping in and out of each other's flats. We played very loud music and danced, played ping-pong and poker and got drunk, and did a lot more besides. One day, a few of us were idling away our hangovers in front of a huge jigsaw puzzle, our combined morning-after fug rendering us incompetent at snapping together the most basic pieces, when in walked Philippe. We stared at the puzzle in silence, fixated, until Philippe finally picked up a piece, ate it, and walked off. That put an end to that.

Soon after Tracey Emin arrived in Universal House, things began to change. We were no longer allowed on the roof, Mat was cajoled into going to bed early, and when an illegal rave club opened in the basement Tracey simply went downstairs to confront the owner. As she railed against the noise, we could hardly bring ourselves to tell her that we were regular visitors. Being used to warehouse living by now, we'd learnt to keep a low profile rather than draw attention to the fact that we were living in non-residential premises. Not so Emin. The nightclub owner, enraged and humiliated, contacted a

journalist. The result was a column in *The Times* about people living illegally in Tower Hamlets. A few weeks later we were visited by a local authority health and safety inspector and were ordered to redesign our flats, which would cost a huge sum of money. It was a nightmare. I spent the afternoon in the pits of despair and wanted to kill Emin. That was when I heard that Kate Moss was in her studio. It was becoming clear that Tracey had arrived.

Mad Tracey from Margate

'TRACEY SAYS SHE'S sorry she couldn't be with you tonight but she's on the blob,' The Northern accent of Paul Fryer, an acquaintance of Damien Hirst whom I'd first met at Green's, boomed over a sea of bewildered dinner guests. 'Thank you very much.' Fryer and Abigail Lane were collecting an award on behalf of Tracey Emin, who was not at home with her period, as had crudely been suggested, but in America. Digging beneath the surface of this media event, it transpired that the award was sponsored by key players in the world of sordid sex magazines and was an attempt to introduce porn to polite British society. Saucy French maids delivered drinks and page three girl Jo Guest stood on stage, passing prizes to people as they stepped up to the microphone. Standing at the podium, Paul and Abigail shook hands with the celebrity speaker and left the stage carrying a garish statuette resembling two erotically intertwined Oscars. Applause slowly returned to the room. I was in a foul mood that evening and glad to escape Alexandra Palace. Award in hand, the three of us took a taxi to The One and Only Sassa's apartment.

Sassa was now living in Herbal Hill on Clerkenwell Road, sharing an apartment in a brand new luxury development with an indoor leisure centre. Being a resident, Sassa therefore had round-the-clock access to a swimming pool, sauna and Jacuzzi. What better way to escape acrid summer nights than to float in the twilight world of an uplit pool? By the time we got there, there was already a party going on. I swam a few lengths before downing

more vodka and joining everyone in the sauna. I remember seeing Tracey's golden award glittering at the bottom of the pool that night. Someone had thrown it in as a prank.

I woke up the following afternoon on the sofa in Sassa's apartment. Sassa had been up for some time and was talking to Abigail Lane about an award. Oh fuck! Where's that award? I sat bolt upright. No one could remember bringing it upstairs. Sassa told me she had gone down and checked earlier that morning, but it was no longer in the pool. The phone rang. Sassa picked it up, said hello, and handed it over to me. It was Emin calling from America. What would I say about losing her award? 'Hi Tracey,' I said, nervously. Then I had a flash of inspiration. I would lie. 'Yeah, we went to the award ceremony . . . Yeah, it was OK . . . Nope. No, sadly you didn't win the prize, sorry. They gave it to someone else . . . can't remember who. We left after they made the announcement. Yeah, it was a good night . . . sure. So, when are you back?'

By the late 1990s Tracey Emin was truly at the top of her game, courting widespread attention in the media while at the same time retaining her status as an unstoppable solo act. She had even begun to eclipse Damien Hirst in the media stakes. Rarely a day passed without Emin featuring in the national press, either being written about, giving her view on some pressing matter of the day, or simply being photographed stepping out at a party.

While Emin's star was in the ascendant, the earliest indicators of her impending stardom were a mixed bag of articles in trendy magazines, and on one occasion that rather unorthodox award. It was her tent at the Royal Academy, *Everyone I Have Ever Slept With 1963–1995*, that brought her into the full glare of publicity for the first time. Any appreciation of the tent as a work of great intimacy, a fragile constellation of childhood memories and individual experience, would soon be eclipsed by the image of the artist as a loose woman. Stories of rape, abortion, masturbation and menstruation, once the headline news of Emin's past, would start to appear in the tabloid press, and from this point on the media became fixated by a woman who could provide just the kind of copy they were looking for.

Tracey's behaviour would become more dramatic as time went by. As public drunkenness goes, her performance on the night of the 1997 Turner Prize was nothing short of breathtaking. While the prize itself was awarded to Gillian Wearing, the official ceremony would be eclipsed by Emin's antics later that evening. After the televised award ceremony there was a live panel discussion that addressed the popularity of electronic media, such as video and computer art, and devilishly asked 'Is Painting Dead?' The camera fell on Norman Rosenthal, slumped in the corner of a sofa and visibly sporting lipstick kisses on both cheeks. He seemed to have every cause to celebrate, especially as 'Sensation' was proving a huge hit with the public (it would ultimately receive over three hundred thousand visitors). Rosenthal was surrounded by a gathering of invited guests including David Sylvester, Matthew Collings, the odd journalist, and young artist and Saatchi talent scout Martin Maloney. Mysteriously, Emin could be heard giggling in the background throughout, even though the camera had yet to settle on her.

As members of the panel attempted to answer the first of a series of critical questions, they seemed noticeably distracted at having to deal, on live TV, with a disorientated Emin. When the camera finally cut to Tracey, it immediately became apparent that she had an abnormal physical defect. A few days earlier, she'd broken her finger while climbing a wall in New York. She'd been rushed to hospital and her finger set in a long aluminium splint which created the impression that she was continually pointing at people like a mad witch. The explosive moment came when Emin decided to walk off set. In a slurred Cockney accent, she abruptly announced the following to all those assembled. 'Listen, I'm the artist here from that show "Sensation". I'm here. I'm drunk. I've had a good night out with my friends and I'm leaving now. I want to be with my friends. I want to be with my mum. I'm going to phone her and she's going to be really embarrassed about this conversation. It's live, but I don't give a fuck about it.'

Later that night I saw Emin in Dick's Bar at the Atlantic. She seemed scatty and unfocused, partly as a result of the painkillers she'd been taking

for her finger. She was slurring something about being late for a television interview. I thought to myself, surely she wasn't going to be interviewed at this late hour – it was past midnight. She didn't have a clue where she was, or that the interview had already taken place. She couldn't remember anything, not even storming off the set and taking a taxi to the Atlantic.

The following morning, Emin awoke to find herself plastered all over the press. She was front-page news, not least for her overt use of the word 'fuck' during a live broadcast. It may not have been quite the sort of fame that she had envisaged or wanted, especially with a raging hangover, but the phone rang off the hook as people gave an account of her performance with varying tones of approval. Weeks later, I got hold of a video of the broadcast and showed it to Tracey so she could see herself for the first time. She sat down, lit a cigarette and watched the whole thing. As I sat next to her and occasionally gave a pained squint, she looked on entranced. At the end she simply turned to me, looking rather pleased with herself, and said she didn't think she was that bad.

The public certainly seemed to warm to her. In 1998 Tracey, by now going out with Mat Collishaw, moved into Wentworth Street. One day, late for an appointment as always, she was briskly walking down Brick Lane when it dawned on her she was being followed by a man. She started to walk faster, but he called out to her, 'Excuse me miss! Excuse me!' She put on more speed, only the man kept up with her and his footsteps could be heard getting closer. She broke into a run, but he was still gaining ground. Now in a state of panic, she heard him come up right behind her and before she had a chance to scream, he laid his hand on her shoulder. To Emin's astonishment, she spun round to see a uniformed police officer gasping for air. 'Are you Tracey Emin? It's just that I'm a really big fan of your work.'

Emin's studio in Universal House was homely and sedate, far nicer than anything we had. It could boast a proper working bathroom. Her kitchen was amazing. The concrete floor was painted a fashionable red and in the middle of the room were two comfortable sofas, one red, one orange, that practically

glowed. She even had a tasteful coffee table with pretty things like flowers and neatly arranged magazines on it. Emin lived a completely different existence from the rest of us, who were still struggling to weld copper pipes and install plug sockets, often putting ourselves at risk in the process, and all to save a few quid.

And, unlike the other artists in the block, Tracey also had celebrity guests, Kate Moss being just one of many. One morning, I looked out of my Wentworth Street window on to a dreary, wet street to see two paparazzi sheltering under a doorway opposite. It was a real dead-end day, with just the occasional car passing through the spitting rain. I wondered what these two chubby little men were doing out there, as one of them took a peek at me through his telephoto lens. We'd heard through the grapevine that Madonna had taken more than a passing interest in Tracey's work, and that a meeting had been in the planning for a very long time. Now, one of my flatmates returned from buying a pint of milk in the local newsagent's and casually called out, 'Madonna's in the building.' She was indeed, visiting Emin accompanied by her daughter Lourdes.

Emin's notoriety was to take a yet further twist. In 1999, Tracey was nominated for the Turner Prize and quietly set about installing her unmade bed at what is presently referred to as Tate Britain. Surrounded by an assortment of empty tampon boxes, an ashtray, cigarette packets and discarded vodka bottles, this was to be Emin's most controversial artwork to date. Before arriving in London, *My Bed* (1998–9) had already been on public display at the Sagacho Exhibit Space in Tokyo in 1998. There, even more disturbingly, it came with a coffin and a hangman's noose suspended from the ceiling, lending the work explicit suicidal overtones. The bed was then displayed in New York at the Lehmann Maupin Gallery as part of Emin's exhibition entitled 'Every Part of Me's Bleeding' (or, as it was subsequently nicknamed, 'Every Part of Me's Bleeding Rich'). It wasn't until the bed arrived at the Tate and fell into the hands of the local media that the controversy hit home.

On 20 October, the 1999 Turner Prize exhibition opened to the public and the bed caused a national outcry. Four days later, the *Independent on*

Sunday ran a debate asking readers 'would you show your bed in public?' which pretty much set the tone from there on. Looking a gift horse in the mouth, an elated press took the piss in much the same way as previous generations of hacks had ridiculed Carl Andre's bricks. The bed was a sensation, more so than Emin's tent, which up until now had come to represent the epitome of bad taste. On the afternoon of Sunday 25 October, Emin got a call from the Tate saying there had been an incident. At 12.58 p.m., two Chinese performance artists leapt on the bed, half-naked, and staged a pillow fight. Gallery visitors, uncertain as to what was going on, started to applaud Xi and Chai as they took a swig from one of Emin's vodka bottles. At this, the security guards finally pounced. Emin was deeply upset when she heard the news and called me to say she'd cried as she'd started rearranging her work.

Despite this, Tracey's career seemed to demonstrate Oscar Wilde's observation that the only thing worse than being talked about is not being talked about. Another index of her rising profile was the guest list at her birthday parties. Throughout the Nineties Tracey had celebrated her birthday each year at the Walpole Bay Hotel in Margate, a sedate Edwardian retreat overlooking a bowling green and the English Channel. The evening culminated in a disco where Tracey would dance to her favourite music, while others slipped away to the various impromptu parties taking place in the upstairs rooms. In the run-up to her Margate bash, Emin would send out photocopied invitations scrawled with helpful suggestions such as the hotel's whereabouts on the seafront and the cost of a room. By the time she turned forty in 2003, basic travel information, such as train times from London, had been extended to include useful tips for those travelling by helicopter. For people taking private jets, she offered Manston airport, a mere ten minutes away by car. More and more celebrities or well-known journalists attended with each passing party. As Tracey's star continued to rise, she certainly found a way to eclipse her contemporaries through her increasingly public life.

Comedown: The fall from grace

I COULDN'T UNDERSTAND it. We'd all been having fun, drawing on tablecloths, eating, drinking, laughing and talking nonsense, when it suddenly dawned on me that everyone was getting really messy. The next thing I knew, someone had poured a bottle of red wine over me.

We had been having dinner upstairs at the French House while American artist Nan Goldin took photographs, a floppy piece of leather hanging over her flash bulb as she snapped away. Pop! Pop! Pop! Maybe it was because Nan was there that everyone felt the need to act up. Johnnie Shand Kydd took a snap of Gary Hume and Cerith Wyn Evans sitting at a small table, their heads pressed together in drunken communion. There was an atmosphere of complete inebriation.

An unpleasant feeling filled the pit of my stomach. It's strange how in the midst of such extreme behaviour I'd convinced myself that everything was fine. While being young helped us to physically stand up to all the abuse, surely this kind of excess couldn't go on for ever? Another bottle of red please, two Sea Breezes, one large brandy, and another. In 1998, after an opening at Sadie Coles HQ, we set off into the backwaters of Regent Street seeking a late-night bar. Carried along by a wave of camaraderie, we were laughing and joking when all of a sudden one of our number laughed so much that she squatted on the floor and cried out, 'I've shit myself!' She roared with laughter as tears streamed down her face, adding, 'It's gone too far!' It seemed funny at the time, but on reflection things really had gone too far.

By the late Nineties, an image had been constructed in the media of the quintessential YBA, largely defined by the antics of the Chapman brothers, Tracey Emin, Damien Hirst and Sarah Lucas, among others. To be a Young British Artist was to be ascribed the following attributes. A 'fuck you' attitude was essential, as was drinking excessive amounts of alcohol. Ideally, you had a working-class background and swore a lot. You spent your days in the Groucho Club or the Golden Heart where you'd stay up late talking to Sandra. You'd then knock up an artwork made out of toilets and dead animals that would be unveiled in a posh gallery and snapped up by Charles Saatchi for an obscene amount of money. You would appear drunk on television. You'd dine in all the best restaurants and not eat a thing. You'd go out on the town with Vivienne Westwood and Kate Moss, who thought you were a darling. You were photographed in a studio you hadn't visited in weeks wearing expensive designer clothes, looking charismatic and pulling faces. When interviewed, you'd talk about your roots and what it was like to be poor. Suddenly, your phone would ring and you'd have to be off. Constantly flying around the world, you'd stay in the best hotels and trash your room within seconds, leaving a trail of empty vodka bottles and suspiciously smeared mirrors. Whether it was true or not, the relentless media hype began to tar the YBAs. It didn't take long before people wanted to distance themselves from the excess.

Damien Hirst was famed for his excessive drinking and drug taking, prompting Norman Rosenthal to contact Maia Norman, Hirst's partner, following an encounter where he found the artist playing the piano naked in the Colony Room. Towards the end of the Nineties, Hirst experienced the first of several blackouts that would serve as a wake-up call – the drink and drugs were proving too much for his system. Moreover he was a father, a husband, an artist and a businessman. He decided to change his ways. By the end of the decade he had given up drink, drugs and smoking, and remains sober to this day.

In the years immediately following 'Sensation', there was a growing sense that the public was not so much turning against the YBAs as turning away.

Constantly in the media spotlight, the artists of the day had become caricatures. Moreover, as they became established, there was a fracturing from within, and the group mentality that had previously been the norm began to break down. The end of the Nineties was marked by a gradual shift in the social dynamic of YBA. Hirst, for one, was rarely to be seen mixing with other artists and his social huddle was now much more likely to be elsewhere among the glitterati. He was no longer joined at the hip with Jay Jopling, as he had been throughout the early Nineties. While Jopling's marriage to gallery artist Sam Taylor-Wood was widely applauded, those watching from the sidelines wondered how this might eventually impact on the scene. With increasing regularity, Jay and Sam started to appear in society magazines and they were now seen out and about with the likes of Elton John, Stella McCartney and Neil Tennant of the Pet Shop Boys. Peeling away from the pack, they set out on a path that saw them thrust into the world of the rich and famous, raising an eyebrow with those who struggled to see the connection between art and celebrity.

Towards the end of the Nineties, bits of the YBA atom started to fly off. As everyone began to slowly slip away into their own little world, the art kids were less likely to congregate as they had once done; instead, there was a tendency for smaller clusters of artists to go it alone. Certain pairings became nuclei of sorts, as was the case with Angus Fairhurst and Sarah Lucas, who were together for much of the Nineties and whose studio parties were catalysts for social exchange. New partnerships were formed as Abigail Lane eventually split from Michael Landy, who then started to go out with Gillian Wearing, who had previously split from Mark Wallinger. While none of these splinter groups were acrimonious in any way, or even visible to the general public – who would have required a magnifying glass to determine the difference between the YBAs – there was nevertheless a falling away of the hardcore.

Angela Bulloch, who had been a strong presence in the original 'Freeze' exhibition, would eventually distance herself from YBA. In her view, she said, the whole scene had become divisive, with the artists being more

concerned about money than anything else. She eventually moved to Berlin. Being good pals, Peter Doig and Chris Ofili opted to set up studios in the Caribbean, while Abigail Lane now moved in circles that inspired her to start a design agency called Showroom Dummies. Gary Hume married Georgie Hopton and retreated into a new house in Old Street, while Sarah Lucas and Angus Fairhurst would orbit the social scene surrounding Sadie Coles' gallery. Whether by accident or design, Tracey Emin had developed a remarkable ability to distance herself from people, partly due to her caustic tongue and hair-raising social skills that saw her increasingly isolated from her contemporaries. All the more strange seeing as she never took drugs and managed to work herself into a whirl purely through alcohol. 'Tracey, you just go on and on,' wrote the *Guardian* art critic Adrian Searle in 1999, 'in an endlessly solipsistic, self-regarding homage to yourself. Once I was touched by your stories. Now you're only a bore. Your art has become so closed and predictable . . . This tortured nonsense can't go on.' Only Cerith Wyn Evans remained connected to everyone, being the only artist to regularly receive invitations to all the gallery Christmas parties.

Meanwhile I had left my writing behind and, having decided to get my head down, was running a publicly funded space in Hoxton Square called the Lux Gallery. I was more than happy to have a paid job, while at the same time being totally gripped by the local scene with its trendy bars and all-consuming subculture. I rarely ventured 'up West' any more, having firmly planted my flag in the East End.

Aside from the fact that the artists were getting older, the demise of YBA was also brought about by an understandable amount of resentment from within the London art world. For many, YBA was a force that had gone unchecked for far too long, and the group would soon became a target for more militant strains of art agitators, many of whom adopted a neo-Marxist position. Voices were now poised to attack the phenomenon. Among them was the artists' collective Bank, which at one time or another consisted of Simon Bedwell, John Russell, Milly Thompson and Andrew Williamson.

Based in the East End, Bank had staged a series of memorable exhibitions such as 'Zombie Golf' (1995) and 'Cocaine Orgasm' (1996). Many of these were group shows that hinged on a striking juxtaposition of individual works. The Bank artists' own contributions to these shows could sometimes be overwhelming. For instance, walking into the exhibition 'The Charge of the Light Brigade' (1995), visitors were confronted by life-size sculptures of sabre-rattling cavalry on horseback bolted upside down to the ceiling. For their exhibition 'God' (1997) they included three lifelike figures impaled on huge crucifixes. As a collective, they worked under the slogan 'You can Bank on us!', alluding to the art world's preoccupation with money and the subsequent clash of hard cash with artistic integrity. While much of their output was tongue-in-cheek, they nevertheless struck a chord with those who felt that YBA needed a good dressing down.

Bank's chief form of attack was a tabloid-styled fanzine that put the fear of God into art world luvvies such as myself. Headlines read 'Art Snore Furore' – declaring all video art boring – or 'Chisenhale, Why?' – suggesting that a local publicly funded gallery was useless – while 'Crap!' alluded to the YBA group show conversely entitled 'Brilliant!'. They also rounded on critics of the day, claiming 'Stuart Morgan is Competent. Shocker!' and 'Sarah Kent – Stupid. Official!'

Perhaps the most damning attack was aimed at Simon Patterson, the Goldsmiths graduate who participated in 'Freeze' with his 'Richard Burton'/'Elizabeth Taylor' two-panel work. Patterson's *The Great Bear* (1992) was an iconic reworking of the London tube map, produced by replacing the names of stations with historical figures and famous personalities. Since then, Patterson had applied the same tactic to all manner of charts and maps, such as the periodic table of elements or star constellations. Bank rounded on what they saw as a well-worn strategy with the headline 'Patterson: One Idea, Eight Years'. It has to be said that their ability to turn on the art world for all the right reasons was both timely and piercingly accurate. Their attacks were largely well taken and invariably hilarious. In their heyday,

Bank were a necessary evil, a valuable deconstruction of the otherwise cosy world of YBA, whose founding members were deemed to have joined the establishment as part of some dark Orwellian tryst.

Then came Martin Maloney, an artist and curator who worked as an advisor to Charles Saatchi. Maloney painted brightly coloured figurative paintings in a cartoon-like manner that showed people in a sex club or a domestic setting. While his use of paint was luscious and seductive, the work had yet to be tested and received mixed reviews. Maloney also curated group shows such as 'Die Young and Stay Pretty' at London's ICA in 1998. In his role as pre-eminent trend spotter, Maloney would go one step further when he became the spokesman for a new development in British art called New Neurotic Realism (NNR).

NNR would attempt to reposition more youthful graduates in opposition to their overbearing predecessors. Struggling to gain recognition, it was decided that young artists should be rebranded, an exercise promoted by Charles Saatchi. That a single powerful collector should attempt to write the history books was ill advised, as many believed at the time. Regardless, Saatchi sought to promote his latest product through a series of exhibitions under the NNR banner, as well as producing a publication that left reviewers stumped as to why such a concept was in any way different from YBA. The difference, we were told, was that the artists associated with NNR were more concerned with collective ideas; these were not navel gazers like their YBA counterparts. Their work was the result of a neurotic process concluding in something more precious. They were swots with their hands raised in class wanting to know more. Above all they wanted to distance themselves from the bad boys and girls belonging to previous generations. Widely perceived as an attempt by Saatchi to market his collection through a trend that didn't exist, NNR was eventually consigned to the bin. While a certain empathy might be shared with young artists wanting to emerge from under the shadow of YBA, the needless maligning of the previous generation took its toll. But the knives were out. People had been chipping

away at YBA for some time. While NNR found favour with no one, not even those artists in search of a break, the negative effects would leave a bitter aftertaste.

By the late Nineties a surge of commentators began weighing in against YBA. In 1999, art historian Julian Stallabrass took it upon himself to deconstruct recent British art in his book *High Art Lite*, the title alone suggesting it was an art form devoid of any meaningful content, a useless commodity with a limited shelf life. He addressed the perceived dumbing down of art in the hands of these artists and the questionable strategies deployed at every level of a politically motivated art world to gain new audiences. Proposing that the artists were in cahoots with mass culture and consumer society, he concluded that the main protagonists in the YBA firmament were little more than well-paid court dwarfs. Soon after its publication, there followed a memorable spat between Stallabrass and young critic J.J. Charlesworth; they would snipe at each other using the letters page of *Art Monthly*, while all the while paving the way for a more cybernetic view of an increasingly corporate art world. Academics no longer took interest in art so much as the art system, choosing to set their sights on the contemporary art market, as well as the gallery structure and the perceived state backing of YBA which had since proliferated into the network of international museums and institutions, while looking an awful lot like government propaganda. By the mid-Nineties, the British Council had helped support an impressive number of YBA group shows worldwide, including Copenhagen, Baden Baden, Houston, Melbourne, Minneapolis, Paris, Rome, Sydney, Tokyo, Venice and Wolfsburg.

Around this time, I attended a lecture given by Simon Ford, a young hotshot writer who, rather than show a slide presentation of the actual artworks in 'Sensation', chose to illustrate the event through a series of paparazzi shots taken at the opening. I found myself cringing at the back of the room at the sight of so many of my associates posing for the cameras. That YBAs were now aligned with feckless celebrities would ultimately impact on their street credibility. Suddenly everyone was wagging the finger, intent

on finding ammunition to shoot down the entire invention. The vacuous interviews appearing in the media with artists turned celebrities, coupled with the YBAs' seeming inability to look outside themselves, helped fuel a retaliatory stance. Depending on who I was talking to, I now found myself having to play down the fact that I was about to meet Tracey Emin or admired the work of Damien Hirst. People were getting moody out there. Meanwhile, Matthew Collings, a high-profile pundit and YBA commentator, had gone sour on the whole thing and *Guardian* critic Adrian Searle talked in tones that suggested he was sick to the back teeth. With all this cynicism in the air the YBA bandwagon started to fall apart. But while it had been obvious all along that YBA would ultimately come to an end, it wasn't so much laid to rest as kicked in the balls.

Last Orders: In the firing line

IN 1999, THERE was a strange and unexpected return to the headlines of the now touring 'Sensation' exhibition, which in September 1998 had opened at the Hamburger Bahnhof in Berlin with little associated fuss. Soon afterwards, however, the headlines began to accumulate. In December that year, Saatchi auctioned 128 works from his collection, including some by artists showing in 'Sensation', which sold for £1,626,560 (over $2.6 million). The proceeds were used to set up scholarship bursaries at four London art schools. On 1 December, Chris Ofili became the first black artist, and the first painter in twelve years, to win the Turner Prize. When he walked up to the stage to collect his prize, he humorously said, 'Oh man. Thank God! Where's my cheque?' On 10 December a heap of manure was dumped on the steps of the old Tate gallery in protest at Ofili's work by a 66-year-old artist from Staffordshire who carried a placard saying 'Modern Art is a Load of Bullshit!', a reference to Ofili's use of elephant dung. In 1993, Ofili had sold lumps of elephant shit shaped like blocks of hash from a Brick Lane market stall.

Next stop for 'Sensation' was Brooklyn, where the exhibition soon found itself at the centre of political controversy. The storm that ensued recalled a period in the Eighties when Republican Senator Jesse Helms had exploited public anxiety surrounding contemporary art by rounding on works such as Andres Serrano's *Piss Christ* (1987), a close-up photograph of a crucifix suspended in urine. Helms had made it his mission to demand the withdrawal of funds from public institutions that exhibited work deemed to be

sacrilegious or morally depraved. The first indication that there might be a problem with 'Sensation' emerged on 16 September 1999, when William Donahue, president of the Catholic League for Religious and Civil Rights, issued a statement attacking the exhibition's 'beastly' exhibits: 'I know of no other enterprise, profession or industry that allows as many frauds to be perpetrated on it as the artistic community. No wonder Hitler was accepted as an artist: all he had to do was proclaim himself to be one and that was enough for the creative types to welcome him.'

The Catholic League called for a boycott of the Brooklyn Museum and wrote to the New York City Council asking for the museum's public funds to be withdrawn. On 23 September, Mayor Rudolf Giuliani declared the exhibition to be 'insulting to Catholics', saying that there 'is nothing in the First Amendment that supports horrible and disgusting projects' and that 'if you're going to use taxpayers' dollars, you have to be sensitive to the feelings of the public'. But this wasn't about Marcus Harvey's painting of Myra Hindley, which had caused such a rumpus in London, but Chris Ofili's painting *The Holy Mother Mary* (1996), a depiction with a lump of elephant dung hanging from one breast and cut-outs of female genitalia from porn magazines used as a decorative motif.

On 26 September, Catholic Cardinal John O'Connor told his congregation at St Patrick's Cathedral that he was 'saddened by what appears to be an attack not only on our blessed mother . . . but one must ask if it is not an attack on religion itself and in a special way on the Catholic Church'. Hillary Clinton, who at the time was running for the US Senate against Giuliani, stated the following day, 'I share the feeling that I know many New Yorkers have that there are parts of this exhibit that would be deeply offensive . . . I would not go to see this exhibit.' She then turned on Mayor Giuliani, saying, 'It is not appropriate to penalise and punish an institution such as the Brooklyn Museum.' The day after that, the museum's lawyer filed a suit seeking a preliminary injunction against the city. On 29 September, Republican Senator Robert C. Smith proposed that, in accordance with

Senate Bill S.1650, funds would be withdrawn from the museum unless it 'immediately cancels the exhibit "Sensation", which contains obscene and pornographic pictures, a picture of the Virgin Mary desecrated with animal faeces, and other examples of religious bigotry'.

Eyebrows were raised the following day when Mayor Giuliani alleged that Saatchi and exhibition sponsor Christie's were engaged in a conspiracy to sell the works for higher value by means of shock. Giuliani's comments did however serve as a reminder that Ofili's painting had gone virtually undetected by the media in London. On 10 December, yet another individual decided to offload horse manure, this time on the steps of the Brooklyn Museum, accusing Ofili's work of Catholic-bashing. By now the city council was trying to eject the museum's injunction in the King's County Supreme Court. And then the animal rights campaigners started to weigh in.

The People for the Ethical Treatment of Animals (PETA) and the Brooklyn Animal Defense League launched an angry attack against works by Damien Hirst. Ingrid Newkirk, president of PETA, claimed that 'this has nothing to do with freedom of speech or expression – it's about ethics . . . Hirst's work is the product of animal suffering, and it is no one's place to contribute to the death of sentient beings for frivolous reasons – even if it is called art.' As a precaution against physical attack, it was decided that Ofili's *Holy Virgin Mary* be placed behind protective glass.

On 1 October 1999, the City of New York withheld its monthly payment of $497,554 to the museum. At the same time, a group of writers acting under the name PEN placed an advertisement in the *New York Times* 'Defending Artistic Freedom in New York'. One of its signatories, New York gallerist Mary Boone, had been arrested on 29 September for 'illegal distribution of ammunition' at a Tom Sachs opening at her Fifth Avenue gallery. Another was Andres Serrano, the photographer whose image *Piss Christ* had caused a similar ethical debate in 1989.

Finally, on 2 October, 'Sensation' opened at the Brooklyn Museum of Art. Members of the Catholic League attended the opening, handing out sick bags,

singing hymns and praying. The following day, President Clinton let it be known that he supported his wife's position and that, regardless of the uproar, the Institution should continue to receive funds. Meanwhile, Republican presidential candidate George W. Bush sided with Mayor Giuliani, saying 'I don't think we ought to be using public monies to denigrate religion.' As a result of all the shenanigans in New York, the National Gallery in Australia decided at the height of the controversy to break off from the 'Sensation' tour, claiming that the events had 'obscured discussion of the artistic merit of the works of art'.

On 1 November, exhausted by suits and counter suits, the Brooklyn Museum was finally awarded a major victory when Judge Nina Gershon ordered the city to restore its funding and demanded that it back off, stating that it 'has now admitted the obvious; it has acknowledged that its purpose is directly related, not just to the content of the exhibit, but to particular viewpoints expressed'. On 9 January 2000, the 'Sensation' exhibition came to a close, not long after an incident when a 72-year-old man, egged on by his wife, attacked Ofili's painting with white paint.

As for me, the lifestyle of excess led by many YBAs was taking its toll on my own flesh and blood. A decade had passed and so much of it seemed to have slipped by in a haze. I didn't have much cause to celebrate my own achievements. At no point had I stopped to think about the future. Looking in the mirror one morning, I noticed my face was puffy and haggard from night after night of abuse. What had happened to me? It started to dawn on me that I couldn't go on like this. I had thrown myself into the art world wholeheartedly and what was coming out the other end was a middle-aged man with no children, a man who seemed to avoid adult responsibility at every turn and whose only saving on the scale of life was a sketchy trail of half-baked relationships. It occurred to me that I was too involved with the art world, and I might not be able to find my way out now even if I tried. I had chosen to live my life like a teenager, yet I was thirty-six years old and my forties loomed large. When was I going to get my act together? It was time to start passing up on a few parties and join the real world.

Childhood's End: Losing my religion

IN THE SUMMER of 2001 I found myself sitting on a hilltop admiring a large bronze cast of a gorilla carrying a huge fish under its arm. We were in a field in Devon which belonged to Damien Hirst. People lazed around in the long grass as children played around us, occasionally falling and hurting themselves, prompting their distracted parents to call out to them. There was a clear view all the way down to Ilfracombe and the sea. Earlier that day, we had driven through the countryside in a minibus until we'd hit upon a small track that wound its way through the trees before pulling up into a clearing and a huddle of stone houses. We'd arrived at Damien's country retreat where we stretched our legs after the long drive. All in all there were about twenty of us, artists, friends and musicians who'd come to see Angus Fairhurst's solo exhibition at Spacex Gallery, Exeter. As part of a local rock festival, Fairhurst's band had played the previous night, belting out the same chords over and over with Joe Strummer from The Clash on guitar. Many of us were hung-over as we walked into the nearby woodland to see an outdoor sculpture by American artist Michael Joo, a large stone bowl set into the side of a hill. A long golden pudendum extended from the centre, giving it the appearance of a cosmic satellite dish. After our stroll we returned to the main house where drinks were served on a trestle table. Suitably loosened up, we headed up the hill to see Fairhurst's gorilla, moodily surveying the landscape below from the knoll on which it had been placed.

After puzzling over its features, we retired for lunch in a row of small

marquees in a corner of a field where we helped ourselves to the most delicious food. After an enormous Sunday roast followed by fruit and desserts, we spread out in the grass and kicked off our shoes, admiring the English idyll that shimmered before us, and beyond it the calm and distant sea. As the afternoon wore on, Fairhurst somehow managed to climb on top of his bronze gorilla and stood on its head as children ran around the base calling up to him in excitement. Taking stock of my surroundings, it occurred to me that this was where all the money had gone, all those spot paintings and vitrines. Hirst had had the balls to pull it off. He had taken huge risks with his career, and his life, just to get to this moment. Sitting there, chewing on a piece of long grass, thinking about how far he'd come, it occurred to me that it was time to start looking out for myself. I had finally bought a flat, but I still didn't have a credit card. Luxury home appliances were few and far between – all I owned was an ancient computer and a 1970s TV set inherited from an exhibition, the colour constantly on the blink. I wore cheap and ill-fitting suits and my days were full of disposable memories. Throughout the Nineties, I had been supported by the generosity of these artists. I had no right to be ungrateful but it was time to get real.

When I had first set eyes of Hirst's fly sculpture *A Thousand Years*, over a decade before, I had made an inner commitment to pursue the art world and ended up travelling the same path as many of my artist friends. I hadn't wanted to skip a beat. I was a believer, a devotee, often so caught up in the thick of things that I was more than a casual observer. I may have missed the 'Freeze' exhibition – and thank God I missed 'Brilliant!' at the Walker Art Center, where I heard tell of actors wearing beefeater uniforms at the opening – but after that I missed very little and attended pretty much everything as though my life depended on it. I spent night after night in the company of these artists, and had spread myself across the board. I had no conflicting interests that might limit my social interaction with the art world. I had been on an incredible journey, and now I found myself coming out of the other side. The time was ripe for change.

Later that year I got a job as a Tate curator, which felt like a fresh start for the new millennium. I settled down into a proper job with a routine, with new concerns and preoccupations that heralded 'growing up'. At first, letting go of my recent past proved near impossible as I realised just how ingrained my lifestyle had become. Separation from my artist friends was not going to be easy. On several occasions I found myself suffering from cabin fever. I would leap up, desperately wanting to run out, hit the town and not come back for days.

It wasn't just me who was trying to calm down. It was as though everyone was waking up to the excesses of the last decade and slowly bowing out. Even the bands seemed to be winding down. Blur and Oasis, Pulp and The Verve, would never have the same drive in the next century as they did in the last. The artists seemed unable to share in the same mischievous fun, becoming cautious as they achieved an ever more snug relationship with the local media while at the same time being largely overlooked by international curators. The bacchanal was over and all that was left behind was spilt wine. Marriage, babies and a general falling away of interest took its toll on the scene, and the slightly worn packaging of YBA was eventually tossed out of the car window as the art world went in search of emerging artists in Berlin, Warsaw and Beijing.

Meanwhile London, once a dump, had been civilised. There was an air of affluence the like of which I'd never experienced before. At the end of 1999 the London Eye was raised on the banks of the Thames, creating a new landmark among glittering buildings. Designed by architects Herzog & Meuron, Tate Modern opened in May 2000, a cathedral for high art that would become one of the top four visitor attractions in London. While its holdings of works by YBAs were much criticised at the time for being notoriously slim (not even a Hirst spot painting), it was nonetheless an inspiration and confirmed Britain's place at the forefront of contemporary art. As the group dynamic of YBA came to a close, Tate Modern took over and helped secure the city's reputation as one of the art capitals of the world.

London could no longer be accused of being a provincial backwater. It belonged to the future. In a relatively short space of time the British public had come round to contemporary art, and for all the criticism, there was a sense of pride fostered by these home grown artists.

But for me, sitting on a hillside in Devon that day, the need for any further commitment on my part evaporated into thin air. The struggle was over. It was like reaching journey's end. All those years messing around in Camberwell, the Groucho Club, Cologne and New York, had been resolved. Like a cloud passing over the sun, the urgency that I'd previously attached to YBA passed. For me, it was over.

Epilogue: Hell

FROM THE TOP floor of Tate Modern it may have been possible to see the plumes of smoke billowing into the grey skies above the Cromwell Industrial Estate in Leyton. This was where Momart, a company charged with art handling, had its main London storage depot, the company's large white trucks often seen ferrying artworks across town to all the major galleries. In the early hours of 24 May 2004, a fire spilled into the Momart stores from an adjacent unit, apparently started by burglars trying to burn down a door. By around four in the morning the fire services reported a number of factories ablaze over an area the size of a football pitch. More and more fire wagons attended the scene, fifteen pumps in all, the smell of smoke being detected up to four miles away. After a number of inflammable gas cylinders were spotted nearby, the decision was taken to retire behind a two hundred metre perimeter. At the time, none of the firemen would have known what was inside. A sign reading Goldstar Removals, the name of the company leasing the premises to Momart, gave little away.

When the temperature of a fire hits around six hundred degrees Celsius, a phenomenon called 'flashover' occurs. As smoke and gases rise towards the ceiling, the air becomes superheated and flammable objects instantly burst into flames. The majority of the works stored in the Momart warehouse would have ignited in just such a manner. They would have vaporised, then turned into ash. A total of thirty-eight units were destroyed in the fire, including a café, a furniture factory and a car repair workshop. It wasn't until

several days later, when the fire was almost out, that experts were able to conduct an investigation into how it took place.

By midweek the extent of the blaze had become apparent, and people started speculating how it started. Many thought the stores were entirely unsuited for art storage, while others found the whole thing vaguely amusing. Word started to spread that the YBAs had been particularly badly hit. Moreover, a number of works by older generations of artists had been lost for ever. Barry Flanagan, Patrick Heron and Gillian Ayres all lost works, while much of Helen Chadwick's estate was obliterated. Many of the works being stored at the time were from the Saatchi collection. Chris Ofili lost two paintings, *Captain Shit and the Legend of the Black Stars* (1988) and *Afrobluff* (1996). Michael Craig-Martin, Angus Fairhurst, Sarah Lucas, Fiona Rae and Gavin Turk were also reported to have lost works in the blaze. Damien Hirst lost sixteen works, including spin and butterfly paintings, while the young artist Martin Maloney lost twenty works. Tracey Emin's tent, *Everyone I Have Ever Slept With (1963–95)*, also went up in flames.

People gasped in disbelief when they heard that Jake & Dinos Chapman's *Hell* (1999–2000) – a work first shown as part of the 'Apocalypse' exhibition at the Royal Academy in 2000 – had been lost for ever. The exhibition had memorably included a work by Italian artist Maurizio Cattelan, a lifelike model of the Pope being struck down by a meteorite. *Hell* was one of the key works in 'Apocalypse' – an absolute masterpiece, and an immensely complicated and highly intricate artwork. Two years in the making, it consisted of nine glass vitrines on trestle legs laid out in a swastika arrangement, in which five thousand hand-crafted figures engaged in a killing spree of biblical proportions. Nazis poured from a mountainous volcano and spilled into the surrounding vitrines like crazed bugs, running amuck in a landscape filled with mutilated figures and skulls on sticks, and in which atrocities were being committed on an industrial scale. Some of the Nazis frantically set about killing themselves in their own death camp, corpses were cast into pits,

victims trussed up with barbed wire and turned into human puppets, semi-naked figures caked in blood played with severed heads.

Hell was the perfect abomination, a truly mind-boggling work and an all-out assault on the senses. The Chapmans must have been driven to distraction as they struggled to bring this neurotically detailed piece into existence. That *Hell* should have been consumed by fire seemed to some a symbolically appropriate end to such a fabulously controversial work, but beyond the irony of immolation, there is no question that the loss of this and other works was a national tragedy. Charles Saatchi lost over a hundred artworks in the Momart fire.

Perhaps this is where YBA should end. Buried in ashes, somewhere out in the East End, not a million miles from where it started.

Thanks

AT THE BEGINNING of the Nineties I had no money at all. As Tracey Emin once observed, 'We were all really broke in those days, and then there was Gregor, who had nothing!' Throughout much of the decade it was artists who bailed me out. They were the ones who helped support me, even when they were on their uppers. More than anything, I'd like to take the opportunity to thank the artists, especially those who occasionally helped pay my way. I'll never forget what it was like to be in London during the Nineties. Depending on which way the wind blows, I wonder if the same spirit will ever pass through town again.

About the Author

GREGOR MUIR IS the director of Hauser & Wirth (London), one of the world's leading contemporary art galleries. Previously he was the Kramlich Curator of Contemporary Art at Tate where he curated several exhibitions and museum displays, and was responsible for numerous acquisitions of contemporary art for Tate Collections. Muir has curated YBA group shows such as 'Lucky Kunst' and 'Liar', as well as seminal video programmes including 'Speaking of Sofas' and 'Drugs' with Carsten Höller. More recently he curated 'London in Zurich' featuring a new breed of young artists from London, and 'Old School' held at Hauser & Wirth Colnaghi featuring works by contemporary and old master artists.

In 1997 he helped found the Lux Gallery in Hoxton Square in the newly emerging cultural quarter of Shoreditch. Muir has been a critic and writer for various publications such as *Dazed & Confused*, *Parkett* and *Frieze* magazine. His catalogue essays include *The Cauldron* (Henry Moore Institute), *Gary Hume* (Kunsthalle Bern/ICA London), *General Release* (British Council), and *In-A-Gadda-Da-Vida* (Tate).

Index